ACRYLICS
BOLD AND NEW

ACRYLICS
BOLD AND NEW

NICHOLAS ROUKES

WATSON-GUPTILL PUBLICATIONS/NEW YORK

Paperback Edition
First Printing 1990

Copyright © 1986, 1988, by Nicholas Roukes

First published in 1986 in New York by Watson-Guptill Publications,
a division of BPI Communications, Inc.,
1515 Broadway, New York, N.Y. 10036

Library of Congress Cataloging-in-Publication Data
Roukes, Nicholas
 Acrylics bold and new.
 Includes index.
 1. Polymer painting—Technique. I. Title.
ND1535.R68 1986 751.42'6 85-26541
ISBN 0-8230-0058-3
ISBN 0-8230-0059-1 (pbk)

Distributed in the United Kingdom by Phaidon Press Ltd.,
Musterlin House, Jordan Hill Road, Oxford

Manufactured in Japan

1 2 3 4 5 6 / 94 93 92 91 90

Edited by Candace Raney
Designed by Jay Anning
Graphic production by Ellen Greene

DEDICATION

Jose Gutiérrez began his career in the early 1930s as an artist's counselor for the Mexican muralists. In this capacity, he served as technical advisor, researcher, paint formulator, and teacher. Along with David Siqueiros, leader of the Mexican muralists, Gutiérrez founded the Experimental Painting Workshop at the National Politechnic University in Mexico City in 1945. This unique workshop attracted artists and students from all around the world. With great enthusiasm, they came to learn about the new synthetic painting mediums and studio techniques that were being developed at the Politechnic. In 1955, Gutiérrez created *politec*, one of the first acrylic paint formulations, an event that was to have a major impact on the new generation of muralists and easel painters.

Gutiérrez was an exuberant, yet gentle man who possessed a great warmth and sense of humor. He shared the findings from his research (and his prized formulas) freely with his students and colleagues.

This book is dedicated to his memory and inspiration.

ACKNOWLEDGEMENTS

I thank the many artists, manufacturers of acrylic products, museums, and gallery personnel that have aided my research for this book by providing material and photographs. I'm especially grateful to the artists that are featured in the monographs for their cooperation. I wish to thank David Bershad from the University of Calgary for his help. Also, a special "thank you" to the staff of Watson-Guptill: to Candace Raney, my editor, Jay Anning for design, and Ellen Greene for graphic production. As always, I'm indebted to my wife, Julianna, for her editorial assistance and moral support.

N.R.
Calgary, Alberta
September, 1985

Contents

TECHNIQUE EXPERIMENTS

Getting the Most Out of this Book

This book has two objectives: First to provide you with information about the many ways in which acrylics can be used as an expressive medium; and second, to serve as a guide for organizing and conducting your own studio experiments. The book is organized into 64 experiments, each one representing a unique way of using acrylic colors and the accessory mediums. Those experiments beginning on page 16 are concerned with composition; those from page 44 through page 95 offer suggestions for new concepts; and the experiments on pages 96 through 143 have to do with specific techniques. Keep in mind these are arbitrary divisions, and that some overlapping of these categories is inevitable. There is no real way of completely separating one category from the others, because all three—composition, concept, and technique—are elements in making a painting or, for that matter, any work of art. The groupings in this book have been made to show you only where the emphasis of the painting lies.

Begin by skimming the book, noting those techniques and approaches that are either familiar or new to you. Then select an experiment from any of the three categories. It doesn't matter which one you choose or in what order; try them in whatever order seems logical and accessible to you. The important thing is to get going and turn theory into practice!

As you proceed, you may find yourself trying out only those experiments that use ideas and techniques you are familiar with. Try to remember, however, to look for something new in each experiment, even if the technique is familiar. Next, you may want to go on to those experiments that offer an approach to the medium that you have not thought about before. In this way, you can expand your knowledge and skills to their fullest capacity.

Although these experiments are not formal lessons, as such, they are specific exercises to consider. They serve as starting places and as aids to innovation. As you complete some of the experiments, you may in the process create a satisfying finished painting, but don't let that be your goal. Instead, allow yourself to explore the ideas presented even though the results are less than successful every time. By doing so, you should find that some of these experiments will lead you to new directions and ultimately to your own personal approach to painting.

Above all, let your imagination and skills take you beyond the specifications set forth in each experiment. Remember, there isn't a single "correct" way to paint just as there isn't a single style of painting. What makes painting exciting is that there are no barriers or restraints to hold back the adventuresome. Your art can be as imaginative—as bold and as new—as you want it to be.

Introduction

Critics have described the art of the 1980s as a pluralistic phenomenon, identifiable by rich diversity of artistic styles, individual goals, and innovative studio practices. The introduction of acrylics radically expanded the artist's technical repertoire and has been an important contributing factor to this diversification.

Acrylic artist colors and emulsions, unheard of less than 30 years ago, are now commonplace and favored by a large percentage of contemporary artists and designers. The development of acrylics (and the accessory mediums) has been touted as one of the great achievements in art technology in the past 500 years. Not since the introduction of oil painting techniques in the fifteenth century by the Van Eycks has there been an event to equal its importance.

QUALITIES AND CHARACTERISTICS

Acrylics satisfy the demands of contemporary painters for many reasons: They are a water-based medium, fast drying, safe and easy to use, highly versatile, and permanent. The most unusual characteristic of acrylic artist colors is the vehicle itself —the *acrylic polymer emulsion*. This special plastic emulsion provides the medium with three very desirable characteristics: *transparency*, *body*, and *adhesiveness*.

It is common knowledge that oil, wax, or grease will not dissolve in water. However, it is possible to prepare stable mixtures of oily materials in water by the incorporation of a surface-active agent called an *emulsifier*, which keeps one liquid dispersed in the other. These two liquids, which under normal conditions are insoluble, can be made to combine with the action of an emulsifying agent. This intimate mixture is called an *emulsion*. For example, milk is an emulsion in which the emulsifying agent is present naturally; in most industrial emulsions, the emulsifying agent must be added.

When you examine an emulsion under a microscope, you see a liquid solution in which minute droplets of a second material are suspended. When the solution is water and the droplets are oil, the resulting emulsion is called the "oil-in-water" type and is readily diluted with water. Three essential ingredients compose an emulsion: the water-insoluble material, the water, and the emulsifying agent. The emulsifying agent provides a film that surrounds each particle and prevents it from coalescing with other particles. An acrylic emulsion, however, is not of the liquid-in-liquid type. Instead, it consists of fine, solid particles of methyl methacrylate resin suspended in droplets of water, emulsified by means of special agents such as ammonium oleate. The result is a water-soluble emulsion (such as Rhoplex AC234) that is used as the basic material for manufacturing acrylic paints.

The term *polymer* simply describes the molecular structure or chemical makeup of the emulsion. Chemically, acrylic polymers are composed of many small molecules that are united into a large molecule of greatly enhanced strength and stability. Thousands of weak monomers (chemical compounds that can undergo polymerization) are joined together in a union to form the tough, durable polymer. The monomer can be likened to a kind of molecular building block through which the scientist can build a chemical chain called a polymer.

When acrylic paint (or a polymer medium) is brushed over a painting surface, the water in the vehicle immediately starts to evaporate. This action allows the acrylic resin particles to coalesce and form a tough, durable paint film. The dried acrylic paint film, however, is much different from that produced by oil paints. Oils produce a film that is continuous and subject to cracking and blistering. Museum conservators pay special attention to the crackle (the cracking pattern) inherent in aging oil paintings. Acrylic paintings, on the other hand, do not have a continuous paint film and therefore do not crackle. Instead, their film is porous and flexible.

The built-in porosity of acrylic paint film can be likened to human skin; it allows the painting to "breathe," which prolongs its durability. Curiously, moisture passes through acrylic paint film without endangering it. Unlike the paint films produced by oils, acrylic films do not crack, blister or bloom with age. Although acrylic paints and emulsions have not withstood the actual test of time, chemists have subjected them to extensive laboratory testing, which has projected a long life expectancy.

Acrylic paints are thick in consistency. Tube colors contain a filler that provides a consistency similar to oil paints; the colors packaged in jars and tins, however, tend to be thinner and dry faster. Fluid acrylics—a new product line—have a consistency similar to ink and are ideal for spraying, staining, and calligraphy.

Although acrylics are a water-based medium and are thinned with water, it is important to remember that they are water insoluble when dry. This is a distinct advantage for overpainting prepainted areas without fear of color "pickup," but can be a problem if paint is

left to dry on expensive brushes! Only a small amount of water is required to thin the acrylic color as it is squeezed from the tube. Add just enough water to provide "brushability"—a condition in which opaque covering power is preserved, but which does not leave brushmarks or allow the brush "drag" on the painting surface. (Polymer medium is generally added to excessively thinned colors to maintain adhesiveness and body.)

To make acrylic artist colors, the paint manufacturer orders acrylic polymer emulsion from the plastics factory and then adds pigment, filler, plasticizer, stabilizer, and other special ingredients to the emulsion according to the requirements of the formula. Manufacturers of high-quality acrylic colors and mediums insist on the following characteristics:

1. *Durability.* Color and paint film must be permanent.

2. *Versatility of Covering Power.* Paint must be capable of producing opaque films, yet also be transparent with the addition of water or polymer emulsion.

3. *Versatility of Use.* Paint and mediums must lend themselves to a variety of studio techniques.

4. *Fast Drying.* Drying must be quick but controllable, as required by the artist.

5. *Stability.* Paint films should not decompose or change chemically; they should be capable of resisting degradation caused by ultraviolet light.

6. *Versatility of Brushing Characteristics.* Paint should have leveling or nonleveling characteristics, as demanded.

7. *Color Compatibility.* Colors should readily mix with others without adverse color reaction.

8. *Optically Clear Binder.* Although milky in appearance, the binder should dry to a clear, transparent state, permitting maximum visibility of the pigment.

9. *Flexibility in Application.* Paints and mediums should be easy to use; brushes and tools should clean easily.

10. *Studio Safety.* Paints should be nontoxic and nonflammable.

Most of the commercially available acrylic artist colors and mediums meet the demands outlined above. Check with your local art supply store for specific details and brand names. Acrylic paints are available in tubes as well as jars and tins where larger quantities of paint are required.

ACRYLIC MEDIUMS

Mediums are added to acrylic colors for several reasons: They improve the flow and brushability of the paint; and whenever the paints are thinned extensively, they help to maintain adhesiveness and increase transparency. Mediums are also designed to impart special surface characteristics, such as glossy or nonglossy qualitites to the normally flat-drying colors, and to protect the surface of the finished painting from dust and grime.

Gloss Medium (also called polymer medium). This medium is an acrylic emulsion that is milky in appearance but dries clear and shiny. It is packaged in jars and squeeze bottles and is mixed with acrylic paint in small quantities for several reasons: to impart fluidity, added adhesiveness, and strength to the colors; to act as an aid in creating transparent glazes; and to help maintain "body" in the thinned colors. Also, because it is an excellent "glue," polymer medium is ideal for collage. For thinning acrylic colors, artists generally mix polymer medium 1:1 with water.

Mat Medium. Although compounded from the same acrylic emulsion used to make the gloss medium, mat medium dries to a flat, nonshiny appearance. It is used in place of gloss medium whenever a flat, nonshiny surface is desired. Satinlike surface qualities can be achieved by mixing the gloss and mat mediums.

Gel Medium. This is an acrylic emulsion that has been thickened to a jellylike consistency. It, too, is milky and opaque in appearance as it comes from the tube, but dries completely clear. Gel medium can be added to acrylic paint to produce thick transparent impastos or textures that can be applied by brush or palette knife. To prevent cracking, thick impasto reliefs should be built up in successive layers (no thicker than 1/8″) rather than in one single layer.

Paste Extender (modeling paste). Even thicker than gel medium, acrylic paste extender is an acrylic medium that has a butterlike consistency. It contains acrylic polymer emulsion and fine marble dust, which serves as the thickener. This material is white in appearance and is easily mixed with acrylic colors to produce colored pastes and putties for impasto painting or textures. The acrylic paste extender can be applied with a palette knife, painting knife, trowel, squeegee, or a makeshift tool. It is useful for making *embedments*: loose objects such as pebbles, mosaic, clock parts, etc. can be pressed into the moist surface and will be held firmly in place when the modeling paste is dry.

Water Tension Breaker (WTB). This is a detergentlike fluid that is added to acrylic paint in minute quantities

to improve brushing characteristics. It discourages "pinholing," generally caused by excessive brushing, which tends to whip up tiny air pockets into the paint film. This annoying effect is eliminated by adding a few drops of WTB (or photo-flo solution, available from a camera store) to the paint before brushing.

Retarding Medium. Acrylic paint retarder is added to the acrylic colors and mediums to delay their drying time. Most of these products cointain a form of glycerine (or glycol). Only a small amount need be added to inhibit the evaporation of water from the acrylics. However, caution should be exercised in using this product because too much will prove counterproductive and produce a sticky, nondrying surface.

Rhoplex AC-234. This is the trade name for a milky, water-thinned methacrylate resin. It is a binding substance that is used in the manufacture of all acrylic paints. Rhoplex can also be used by the individual artist as a strong glue for various collage and studio applications. In this form it lacks the properties that have been added by the paint manufacturers to make it a desirable medium. (To make acrylic mediums and colors from this material, the manufacturer adds plasticizers and chemical stabilizers to the emulsion, as well as pigments and fillers to make the colors.)

PRIMING AND PROTECTING YOUR PAINTING

Acrylics withstand the ravages of time much more than oil paints, but even so many artists prefer to use these preliminary and final applications. Although not essential, acrylic gesso and varnish provide, respectively, an ideal underpainting surface and extra protection for the finished painting.

Gesso. Acrylic gesso is used to prepare raw canvas or Masonite for painting. It sizes and seals the painting ground and is normally thinned with water (up to 25 percent) to improve brushability. This synthetic gesso neatly fills the pores of the canvas, preparing it for either acrylic or oil painting. Generally two thinned coats of gesso are sufficient to prime raw canvas. To prime Masonite panels and produce a smooth surface, dilute acrylic gesso with water and brush three or four coats on the surface with a wide, fine-hair sable. Sand each dry coat lightly with fine abrasive paper before the next one is applied.

Varnish. Acrylic varnish is applied over finished paintings to protect the underlying paint film and to control surface shine. Like gloss medium, it is milky in appearance but clear when dry. Both mat and gloss varnishes are available. They can be applied by brush or spray.

ACRYLIC TECHNIQUES

The most striking feature of acrylic paint is its versatility—its remarkable adaptability to a great variety of painting techniques. When acrylic paint is diluted with water, it handles similarly to watercolor; when thinned with a smaller amount of water, acrylic can have a superb gouachelike consistency. If you add even less water—or thin it with acrylic medium—you have a paint quality like that of oil. And if you want a medium that has even more body than oil, you can use a wide variety of additives to create the very thickest impastos.

If you are interested in working with collage techniques, there is no more ideal medium than acrylic. It is an excellent adhesive and can be used to bind papers, fabrics, sand, and other materials to the painting surface. Or, if you want to incorporate larger objects in your composition, acrylic gel medium can be added to acrylic color to bind them securely to the support.

Although not every technique that is possible to achieve with acrylics can be included here, the following is a look at some of the ways that acrylics can be used in the studio.

Airbrush. The acrylic colors packaged in wide-mouthed jars are much thinner in consistency than tubed colors and are recommended for airbrushing. Before putting the colors in the airbrush gun, however, be sure to thin them with water and polymer medium and strain them through a nylon mesh to remove any small solid particles that may clog the airbrush. Fluid acrylics (available from Golden Artist Colors, Bell Road Box 91, New Berlin, NY 13411) are ideal for airbrushing since they are produced with an inklike consistency. These colors have a rich intensity and can be used straight out of the bottle. They can be made transparent by mixing with mat or gloss medium. Designs to be airbrushed can be masked with frisket paper, masking tape, stencils, or a liquid masking material (such as Grip-Mask). Care should be taken to provide adequate ventilation when spraying acrylics to guard against inhalation of spray mist.

Alla Prima. This technique is a spontaneous one-shot way of working wet-into-wet color. Here, colors are mixed, applied, and/or blended on the canvas while they are still moist, an operation that calls for quick action because of the fast-drying properties of the acrylics. Acrylics don't offer the lengthy time for blending that oils do. You must work quickly, accepting the limitations of the material or prolonging the drying time by adding a small amount of retarding medium to the colors. As noted above, excessive use of the retarding medium can prove counterproductive.

Collage. All the acrylic emulsions—the gloss medium, mat medium, gel medium, acrylic modeling pastes, and the straight Rhoplex—have excellent adhesive properties. These materials are excellent "glues" for making collages. With the exception of the acrylic modeling paste, all dry transparently. They can be used to bind tissues, papers, fabrics, and other materials to a painting surface.

When acrylic paint is applied to a slick surface such as glass or acetate it seems to stick to these surfaces, yet with a little coaxing, can be neatly removed. This paint "skin" is an excellent material for collage. You will notice that the underside of the film has the best surface, one that is very glossy and perfectly smooth. Here's how you can make the paint films: Brush a liberal amount of acrylic paint, mixed with gel medium, on the surface of a sheet of glass of acetate; when the paint is dry, immerse the glass or plastic in lukewarm water. The paint film, which is porous, will allow the water to penetrate and, in turn, will be loosened for easy removal. The films can be cut into desired shapes and configurations and then "glued" to any support with gel or polymer medium.

Printed images from magazines, posters, or newspapers can be readily transferred to canvas or other supports. Here are two ways to do it: (1) Apply a thick coat of acrylic gesso to the surface of canvas or Masonite. Press the magazine image (which has been previously moistened in water) face down on the wet gesso. Allow it to dry thoroughly and then gently rub with a sponge that has been moistened with warm water to remove the backing paper. The image will be revealed in reverse, neatly transferred to the painting surface. (2) Brush six coats of polymer medium (either gloss or mat) directly on the surface of the magazine image, allowing each coat to dry before the next one is applied. When the final coat is dry, immerse the image in lukewarm water to loosen and remove the backing paper. At this stage, the image is seen on a thin transparent plastic film that is made up of the successive layers of polymer medium. The transparent image can then be adhered to the painting surface with polymer or gel medium. Unusual collage effects can be achieved by superimposing several of these transparent decals.

Glazing. Glazing is the technique of applying thin, transparent passages of color over previously painted areas. To produce a glaze, acrylic paint is thinned with water and polymer medium (either mat or gloss) to a milklike consistency. Then, with the canvas placed horizontally, the glaze is applied with a soft-haired brush and allowed to dry. Surfaces are enriched in color and luminosity by superimposing many glazes; they are given a luminous "inner glow," similar to that in egg tempera painting. When using only water to

thin acrylic colors, the glow is considerably duller than when polymer medium is also added to the colors.

Gouache Technique. Acrylic gouache is the technique of producing an opaque, rather than a transparent, watercolor style. Unlike the watercolor technique, which calls for water to lighten color to produce tints, gouache tints are made by mixing the hues with white paint. An advantage over the traditional tempera medium is that previously painted areas can be overpainted without fear of color pickup.

Hard-Edge Painting. Hard-edged shapes with ultra-smooth surfaces are created by using the "dynamic duo" of polymer painting—masking tape and acrylic paint. Various kinds of plastic tape can also be used to mask off areas on canvas or Masonite prior to painting. Curved shapes are more easily masked with 1/4″ masking tape, which is more flexible than the wider tape. A precaution: After the tape is pressed to the canvas, use the wooden end of a paintbrush as a burnishing tool to further compress the tape, insuring that it makes perfect contact with the surface. The inside areas of the masked shapes can then be painted and the tape subsequently removed. A hair dryer is useful to hasten the drying time of the acrylics so that additional taping and painting over painted areas can proceed without undue delay. Normally, when an acrylic paint film is dry to the touch, it can be immediately remasked and overpainted without fear that underlying color will peel off. However, to avoid any possibility of residue surface pigment picking up from the previously applied color, areas to be overpainted are often isolated with a coat of mat or gloss medium, thinned slightly with water.

Impasto. Impasto is the technique of painting with colors that have been thickened with acrylic gel or modeling paste. The pasty colors can be applied with a brush, painting knife, putty knife, squeegee, or a small trowel. This medium offers great potential for creating textures or relief designs. Opaque impastos are made by mixing acrylic colors with acrylic modeling paste, while transparent ones are produced by mixing the colors with the gel medium.

Iridescents. These are a new line of brilliant acrylic colors. They are made with coated mica platelets; the coating is rutile titanium dioxide for the silver range and iron oxides for the gold range. The iridescents have a high refractive index and can be used singly, or combined with regular acrylic colors, to produce luminous surface qualitites. These colors have added a unique dimension to acrylic painting.

Mixed Media or Assemblage Painting. Acrylic artist colors and emulsions will stick to any nongreasy surface. "Found objects"—from flea markets, junkyards, or second-hand stores—made of plaster, wood, cement, metal, bisqueware, etc., can be successfully painted with acrylic colors. Make sure, however, that the surfaces are clean before painting them. If necessary, the objects can be primed with acrylic gesso prior to painting. Objects from the environment, such as twigs, branches, rocks, or pebbles are great for mixed media art and are easily painted with the acrylics.

Oils Over Acrylics. Oils can be successfully applied over acrylic underpaintings. In this style of painting, begin by using the fast-drying acrylics to block in general shapes, tones, and the composition of the work, then switch to oil paints for the final work. *Grisaille*, which means painting in shades of gray, is particularly effective. In this method, you start with the acrylic colors—but with a limited palette of only black, white, and gray. Then, in the final stages, you apply oil paint and a full range of colors.

Staining. In this technique, stain unprimed canvas with acrylic colors thinned with water and polymer medium to a creamy consistency. Lay the canvas, stretched or not, flat on a table or floor and brush or pour the color on its surface. While they are wet manipulate the colors to produce the required shapes by tilting the canvas and/or using sponges, squeegees, brushes, etc. Because unprimed canvas is porous, the thinned color will penetrate to the back as in batik. The use of polymer medium insures that excessively thinned acrylic colors will maintain adhesiveness. Fluid acrylics, manufactured with an inklike consistency, are particularly useful for staining techniques. Note that unprimed canvas is particularly vulnerable to dirt and dust. Ideally, stained canvases should be protected with a coat of acrylic varnish.

Stratified Color. Here's a technique that calls for a bit of physical effort, but one that yields unique effects: On a Masonite panel, used as the support, apply 10 to 20 coats of acrylic paint, each of a different color. Wait for each layer to dry before applying the next, and finish up with the top layer painted either black or white. Next, begin the process of abrading—grinding down through the various levels—to reveal various shapes of underlying color. Use sandpaper, grinding tools, and/or solvents to remove selected areas of the "chromatic sandwich." (Note: Use solvents such as acetone with caution. Follow the manufacturers' recommendations carefully.)

Tempera Technique. The acrylic tempera technique is like the classic egg tempera method—but without the egg. In acrylic tempera, luminosity is created by the plastic emulsion that has a built-in light refractivity. This technique calls for great patience because it involves a laborious process of "building up" literally thousands of tiny, hairlike strokes of color with a fine brush to create pictorial images. The best painting surface for acrylic tempera is untempered Masonite, which is Masonite that is free of any wax or oil content. The panel is primed with several coats of acrylic gesso, thinned with water (about 1:1). Allow each coat to dry and sand smooth before the next coat is applied.

In the acrylic tempera, you start by blocking in the basic shapes of the composition with a large brush, scumbling the color over the surface to establish a rough underpainting. Then, turning to fine sable brushes, overpaint the areas with a laborious stippling or cross-hatching technique. It's important to note that the tiny brushstrokes are not blended, but remain intact. "Blending" is perceived optically, as in pointillistic art.

Watercolor Technique. Watercolor paintings created with acrylics tend to be brighter than those produced with the standard watercolor medium. The method of using acrylics as a watercolor medium is practically the same as that in traditional watercolor painting techniques. An important difference, however, is that acrylic washes are insoluble when dry, allowing you to work over prepainted areas without picking up the underlying colors.

Use Geometrical Abstraction

In the realm of art, the word "abstraction" has two different meanings. On the one hand, it is used to describe highly stylized or simplified representational images; while on the other it denotes a nonobjective artform that is completely independent of visual reality.

Geometrical abstraction deals with nonobjective design—an approach that is entirely devoid of representation and relies instead upon patterns derived from simple geometric shapes (such as straight lines, circles, and squares) for its artistic values.

Although geometrical abstraction had its origins with the schools of suprematism, constructivism, and purism in the 1920s, the concern for beauty in abstraction can be traced back much farther in the history of man. Two thousand years ago, Plato recognized beauty in geometrical design when he explained to his disciples: "By beauty of shape I want you to understand not what the multitude generally means by this expression, like the beauty of living beings or of paintings representing them, but something alternatively rectilinear and circular which one can produce with a compass and ruler. Because these things are not, like others conditionally beautiful, but are beautiful in themselves." And later during the Bauhaus era, artist Wassily Kandinsky had this to say about the power of geometry: "When a line is freed from delineating a 'thing' and functions as a 'thing' itself, its inner sound is not weakened by minor functions, and it receives its full inner power."

For this experiment, compose a nonobjective design—a geometrical abstraction—using only circles, squares, and triangles. For the moment, abandon figuration, free-hand drawing, or any type of representational imagery. Instead, draw only geometric shapes with the aid of a compass and a ruler.

Compose the preliminary design on paper. The idea is to create a painting based solely on the division of space and the manipulation of the formal elements and principles of design.

Exploit the interaction of positive-negative shapes, the dynamics of form and color, figure-ground relationships, proportion, counterpoint, dominance and subdominance, repetition and progression, and optical transition. Above all, try to achieve in your composition a state of *dynamic equilibrium.* Piet Mondrian used this term to describe compositions that display dynamic movement yet are pictorially stabilized: "When dynamic movement is established through contrasts or oppositions of the expressive means, *relationship* becomes the chief preoccupation of the artist who is seeking to create equilibrium."

Maintain a shallow, two-dimensional picture plane in your design by avoiding overlapping shapes, perspective, and other techniques that are normally used to achieve pictorial depth. In short, go for a geometric composition that features a flat picture plane. Then transfer your design or drawing to a prepared canvas in preparation for painting.

To paint shapes with razor-sharp edges, first mask each of the shapes with either masking or plastic tape. Rub the inside edge of the tape with the handle of the paint brush (or a burnishing tool), so that the tape makes perfect contact with the canvas. For extra insurance against paint seepage, brush a coat of polymer medium over the inside edge of the tape and allow it to dry before commencing to paint the masked-off area. A few drops of WTB (water tension breaker) added to the acrylic colors will improve brushability and serve to prevent "pinholing." As soon as the paint is dry, tape over the painted area and continue the process until the painting is complete. If desired, use a hair dryer to speed up the drying time of the acrylics.

THE PORTUGUESE NAVIGATOR, OR TWINKLE, TWINKLE, ETC.
by Hassel Smith, 1978, acrylic on canvas, 68" × 68" (172.7 × 172.7 cm).
Courtesy Hansen-Fuller-Goldeen Gallery, San Francisco, California.

Hard-edged geometric shapes, used in concert with bright color contrast, earmark the work of Hassel Smith, a San Francisco Bay area painter. The fundamental geometric shapes—circle, square, and triangle—serve as the design base and are effectively interrelated to create a dynamic balance. Notice that the artist allows one element—the rectilinear—to dominate. The horizontal-vertical motif provides a grid for positioning the other contrasting shapes. Bright colors are used in rendering both foreground and background shapes, and the discretionary use of overlapping contributes to the production of a shallow picture plane. Note, too, how the artist carefully provides optical transition by carefully positioning the constituent shapes. For example, some shapes "touch" in a kind of counterchange pattern, a pink shape overlaps, while other disconnected shapes are aligned in such a way as to provide "visual closure." This type of optical transition leads the eye to perceive "virtual configurations," like the "big dipper" in the sky, for example. The "invisible linear network" between points in this painting is well calculated. Although the painting is nonobjective, the shapes (and title) allude to ocean passage and navigation; to celestial bodies, lines of position, the sails and mast of an ocean-going vessel, and the open sea.

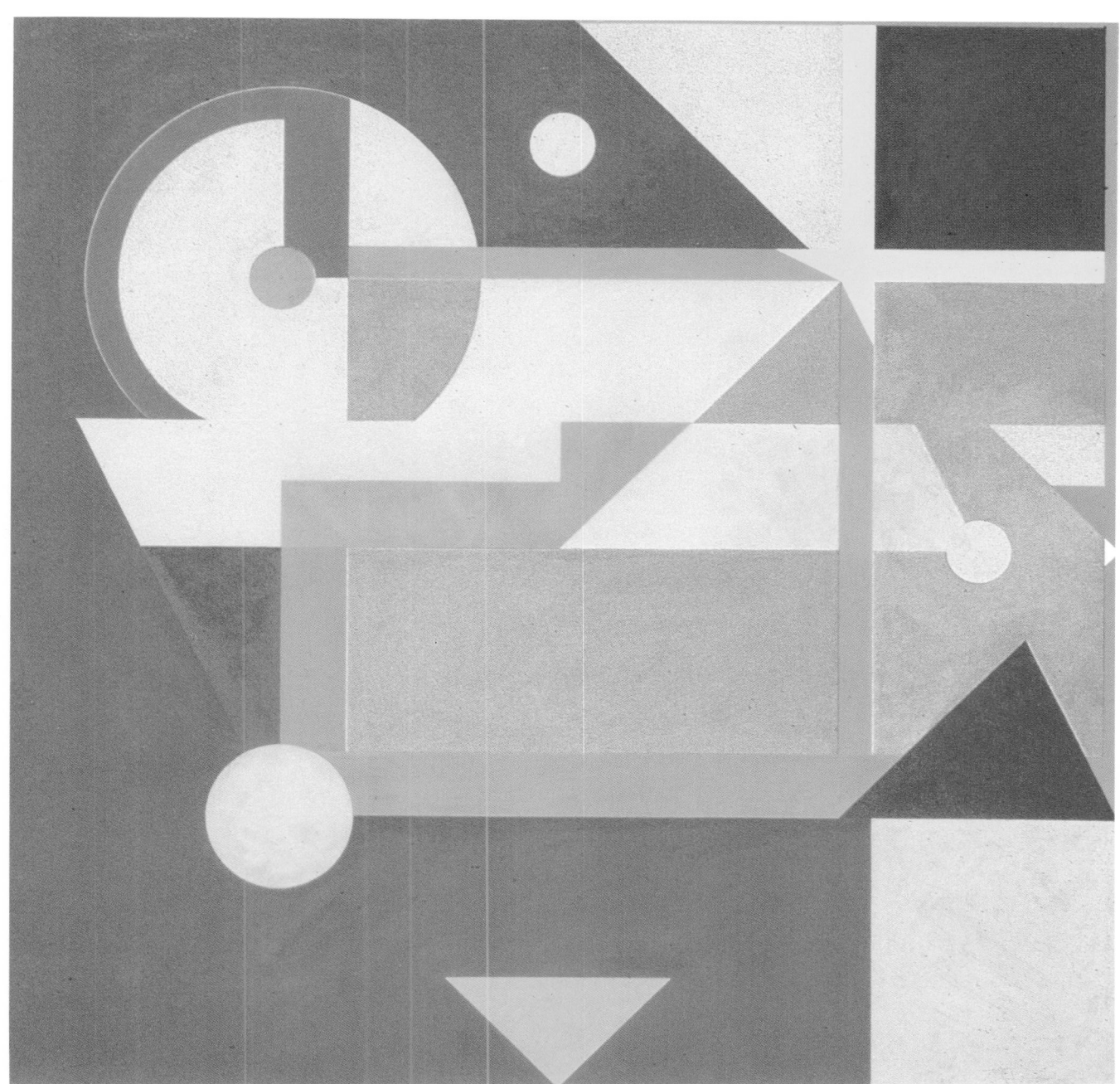

Compose with a Grid

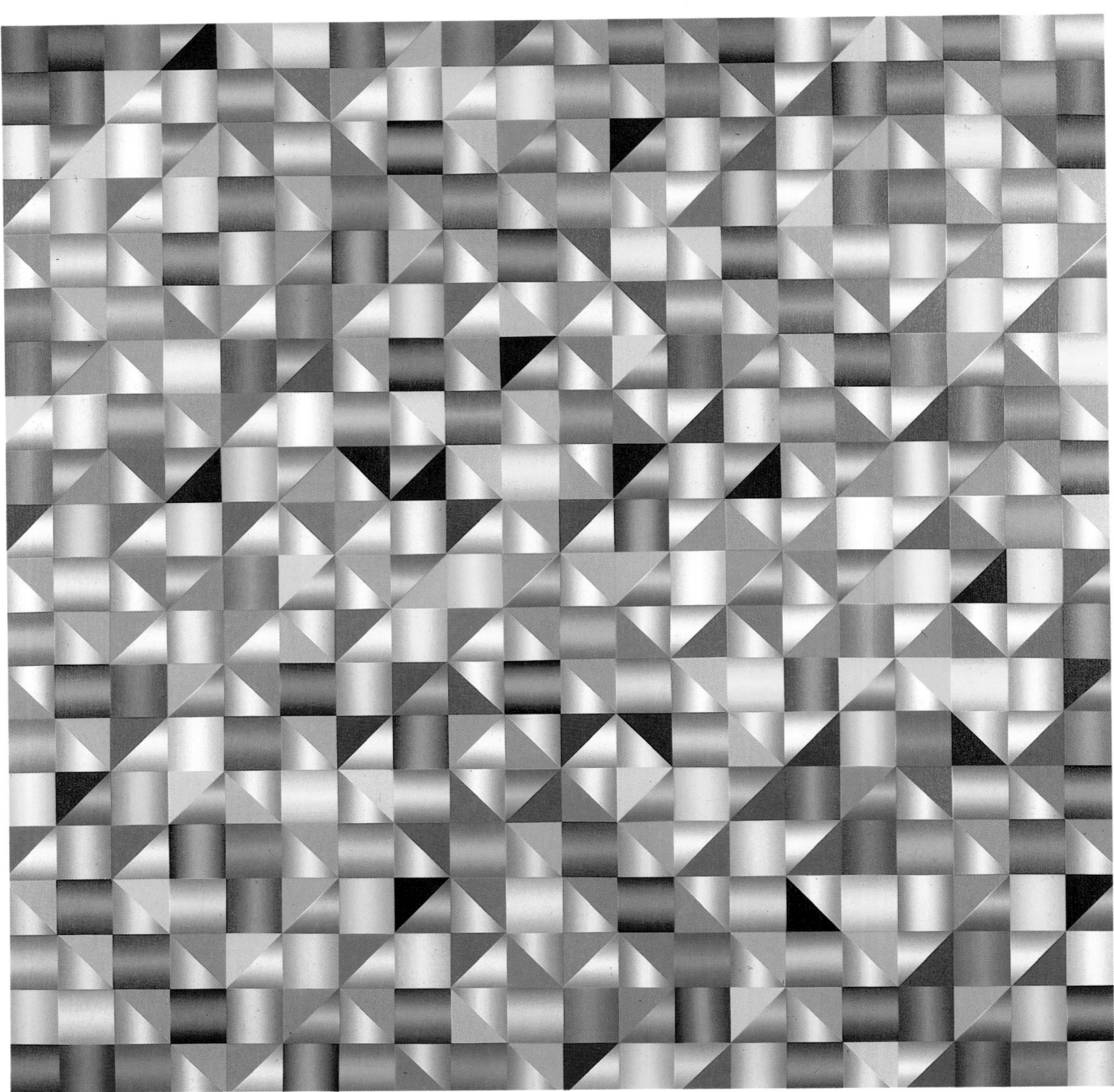

Grids, used as a matrix for organizing shapes and forms, are based on the harmonics of regularity and symmetry. Using the grid as a substructure or as a concept, the artist focuses attention on ways and means of applying the principles of repetition, serialization, counterchange, transition, and permutation in his or her work. Critic Lawrence Alloway suggests that what interests "system artists" more than anything else is the multiplicity of things, especially the multiplicity of things that can be generated by a simple idea, or simple modular method.

The type of grid most often used is the X–Y grid (made up of horizontal-vertical axes such as those seen in checkerboards or graph paper). Grids, however, can have diagonal, curvilinear, radial, concentric, or freeform subdivisions. In a completed work of art, the lines of a grid can be visible, or remain latent (used in the early stages of a design but later erased or absorbed into the imagery). Although most designs that emerge from systematized art are symmetrical, nonsymmetrical grid patterns are also used (see, for example, Mondrian's painting or the works of many constructivists.) Dynamic symmetry (The Golden Section) is a form of gridding based on the laws of geometric procedure.

In many of his paintings, Victor Vasarély uses a flexible grid, which is basically an X–Y type of axes, but modified with curvilinear lines to make the picture plane appear to "swell" or "contract." Op artists such as Vasarely and Bridget Riley often use grids to create patterns that produce perceptual stress, resulting in unstable and oftentimes oscillating visual patterns.

For this experiment, create a painting based on an X–Y grid pattern. As a preliminary activity, work out the design with colored pencils on graph paper or on an X–Y grid drawing that you have penciled on drawing paper. Start by developing a simple counterchange pattern—a glorified checkerboard design—and then modify it as you see fit. This kind of design is seemingly simple in structure, yet can yield complex patterns. Arrange the elements in your composition to form either a symmetrical or an asymmetrical motif. Keep in mind that the entire surface area of the composition need not be filled. Interesting designs can be produced by using only 50 percent of the gridded area, leaving the rest unpainted or colored in a single hue.

There are literally hundreds of different ways of using grid systems in art. For inspiration, examine the designs of African or native art, Islamic patterns, fabric design in folk and contemporary craft, tile patterns, tartans, and architectural patterns as well as the work of contemporary artists who work in this idiom.

Think about different ways that a simple X–Y grid can be developed and made more complex. Experiment with checkerboard and counterchange patterns, as well as designs involving interlacing, interlocking, and permutating patterns. Try placing one grid inside of another, distorting lines, weaving together two contrasting grid patterns (say, a square and circular pattern). Experiment by superimposing grid designs drawn on acetate and make a tracing of the composite result. Also, try cutting and rearranging grid designs to form new patterns.

When you have a satisfactory working drawing, stretch a canvas and prime it with gesso in preparation for painting. Lightly pencil in the grid lines on the canvas and transfer the configurations to the canvas. Mask each shape with tape as you paint to achieve a precisely rendered, hard-edged design. Add just enough water to acrylic paint to achieve optimum brush handling so that the colors will produce a perfectly flat, nontextural surface.

TWENTY SQUARED

by George Snyder, 1980, acrylic on canvas, 60" by 60" (152.4 × 152.4 cm). Courtesy Art Focus, Inc., Charleston, West Virginia. Photograph by Joe Neil.

The underlying structure of this painting is an X–Y grid, composed of horizontal and vertical subdivisions. The use of diagonal lines further divides the space and provides the artist the opportunity to create an equivocal visual field. The complex labyrinth of brightly colored shapes plays a "cat-and-mouse game" with your perception. Notice, for example, that as you stare at this painting for a few minutes the ambiguous visual field abruptly changes; the diamond shapes seen in the composition suddenly "flip" and become part of a larger, interpenetrating constellation, then flip again into other configurations. Given the complex, undifferentiated matrix as a stimulus, the eye is free to take many "paths" and finds many ways of organizing the visual elements. The artist effectively uses bright color contrast within the counterpoint harmony between the square and triangular modules, as well as skillful brushwork to heighten the effect of optical flicker.

Use Selective Cropping

The term *cropping* is generally associated with photography and refers to the process of trimming a print to improve its composition. In other words, it's something that's done *after* the photograph is made. Here, however, I use the term to describe a form of composing that is done *before* a picture is painted.

Why crop? In order to create any form of pictorial composition, you must of necessity establish boundaries. *Selective cropping* merely refers to the process of isolating a specific part of a visual field and earmarking it as the "picture frame," while simultaneously excluding the area outside its frame of reference.

Selective cropping magically transforms commonplace objects; they become uncommon and exciting because the artist forces us to see them in new and unexpected ways. Although photographic realism is preserved, the emphasis is shifted from the representational to the aesthetic and abstract.

For this experiment, take your camera on an urban safari in search of compositions that can be used for a painting. Select only inorganic subjects to photograph: a part of a building, a fabricated object, a vehicle, an airplane, an appliance, a tool, etc. Look for subject matter in your home, or school, or places where you might find interesting objects, such as a used car lot or a junkyard. The idea behind this experiment is to analyze the subject through the lens of the camera. Make a variety of exposures: Try different angles and distances; zoom in on your subject; lop off part of its structure in making close-ups. Look for the abstract qualities of line, shape, and form. Keep in mind, however, that the camera is only a means of collecting data for subsequent use.

When you're sure you have a number of interesting photographs, select one of your best shots and make a pencil drawing in preparation for an acrylic painting. Crop the photograph even more if necessary and simplify the image by omitting distracting details. Simplify and exaggerate the local color and use bright color contrasts.

Another useful device for selective cropping is the cardboard viewfinder, especially if you are painting directly from a still life subject. To make an adjustable viewfinder, cut two pieces of cardboard into L shapes, then fasten them together with paper clips. The size of the window can be adjusted according to the proportion of the desired composition and field of reference. By moving the window, you can view your subject through a square, rectangular, or long and narrow format. As a novelty, make the viewfinder in a circular, triangular, or any other shape or configuration.

As you study your subject through the viewfinder—whether through the lens of a camera or the cardboard "window"—pay particular attention to the following: (1) Figure/ground relationships (the interaction of background-foreground shapes). (2) Proportional relationships (of size, shape, color, and texture). (3) Truncation (what happens to your subject when it is "pruned" in different ways). (4) Light/dark contrast. (5) Color contrast. (6) Rhythmic transition (the way the eye moves through the composition).

Study classical and contemporary paintings and examine closely the way artists have cropped their subjects. Degas, for example, shocked his contemporaries with a unique form of selective cropping wherein figures were placed close to the edge of the picture frame, alluding to events that occur outside the frame of reference. Andrew Wyeth, Philip Pearlstein, Richard Estes, and Robert Cottingham are but a few contemporary painters who use this pictorial device very effectively.

PROP JET
by George Snyder, 1975, acrylic on canvas, 70" × *88" (177.8* × *223.5 cm). Courtesy Art Focus, Inc., Charleston, West Virginia. Photograph by Joe Neil.*

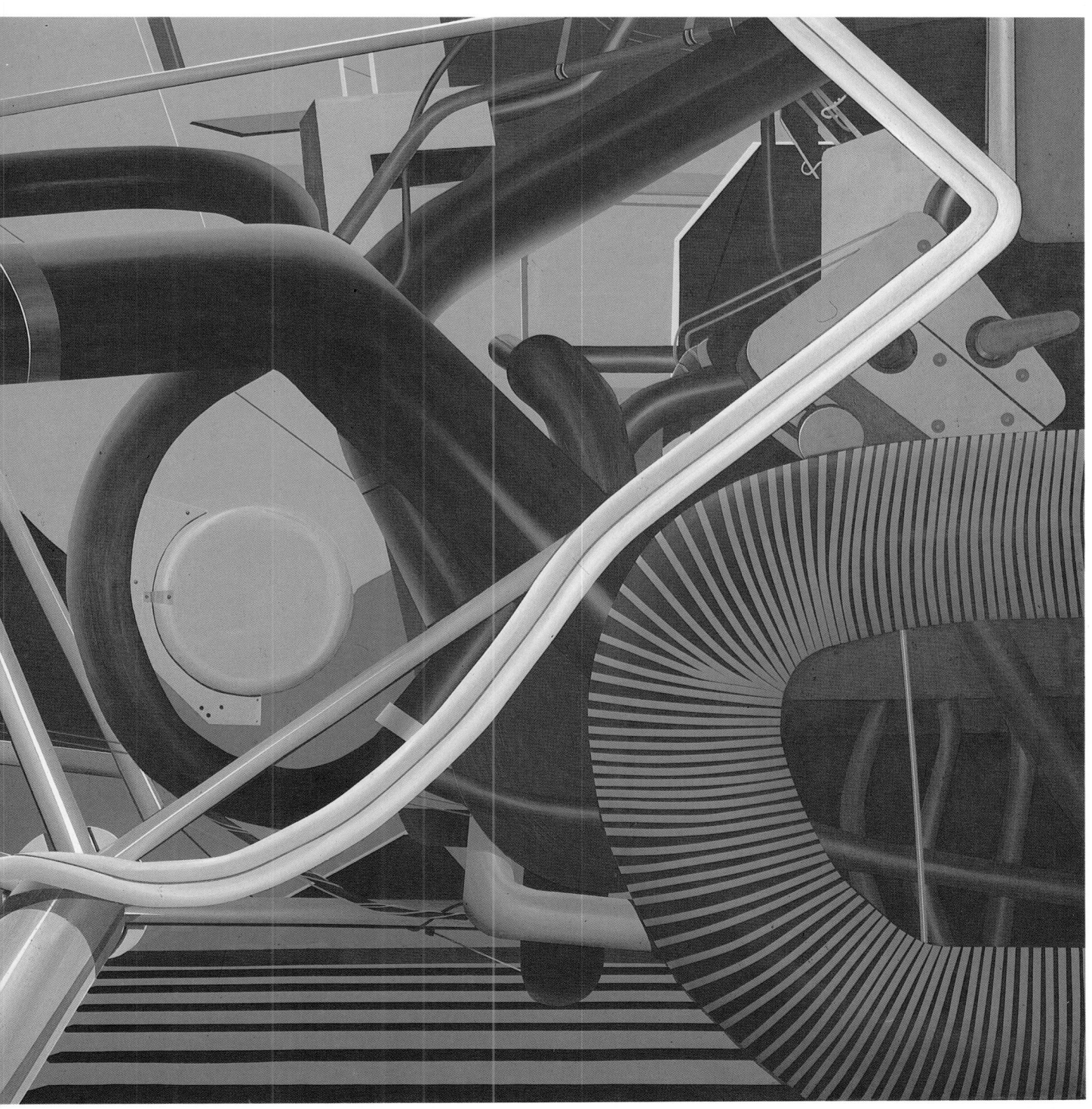

This painting is an exciting design, largely because the field of vision was severely cropped. The artist used a 35mm camera to frame the picture, in this case an extreme close-up of a helicopter. By making many exposures from different angles and distances, he obtained the required "visual data" in the form of photographic prints, which he used later in his studio to paint the picture. Although the painting is rendered in a meticulous style, the details and colors have been simplified and stylized; an emphasis is placed not on pictorial representation, but on the appealing abstract qualities found in the image and on the interrelationships of form, shape, and color. Notice, for example, how the artist effectively used design counterpoint: figure/ground, light/dark, thin/heavy, warm/cold, and texture/nontexture contrast. Although the pictorial components seem at first glance to be at odds with each other, a harmony of dynamic equilibrium is achieved.

Employ "Designed Realism"

Every successful painting, whether representational, abstract, or nonobjective, is based on an underlying foundation of abstract design called composition. In essence, pictorial composition is simply the way things are put together in a painting to insure that, in one way or another, otherwise disparate components will be related to each other and to the whole.

Before figurative images are set in place, the artist must lay a proper foundation for the work—an underlying structure or framework on which to "hang" the images. This abstract pattern—comprised of the initial lines and shapes that divide pictorial space and establish the gesture of the painting—becomes an integral part of the painting and is perceived only as a latent image in the completed work. If, for example, we stop to analyze the abstract qualities of the paintings by Pieter Brueghel and for the moment ignore the powerful imagery and symbolism in his work, we are immediately struck by the skillful network of interacting lines, shapes, patterns, and rhythmic flows that make up his compositions, as well as by the clever use of spatial tensions. His exemplary work is a symphony of controlled visual tensions and forces and pays special attention to focal points, fulcrums, and the thoughtful balance of pictorial weights.

The term *designed realism* simply denotes a concern for simplifying and rearranging visual elements to suit the demands of design and composition and emphasizing the underlying abstract qualities of the image. Think of the components in your picture as "pieces of furniture" that can be moved around to provide a smooth optical transition.

Use a camera as a starting point for this experiment. Photograph action shots of an event, for example, a football game, marathon race, dance, etc., or a special event that involves several figures in action. As you make your exposures, look beyond the figurative images; pay particular attention to the abstract qualities and substructure of the images framed in the viewfinder of your camera. Avoid static images. Use a high-speed film and an appropriate setting to "freeze" the action. Be on the lookout for events that will provide dynamic lines and movement. Compose with your camera; take lots of pictures and photograph your subject from many angles.

Next, examine the prints and select those you think provide appropriate visual information to do a painting. Then, make a composite pencil sketch from the photograph. Remember, use "poetic license" to rearrange the elements in the composition—for example, the position of arms, legs, or objects—so that you can improve the transition between the components.

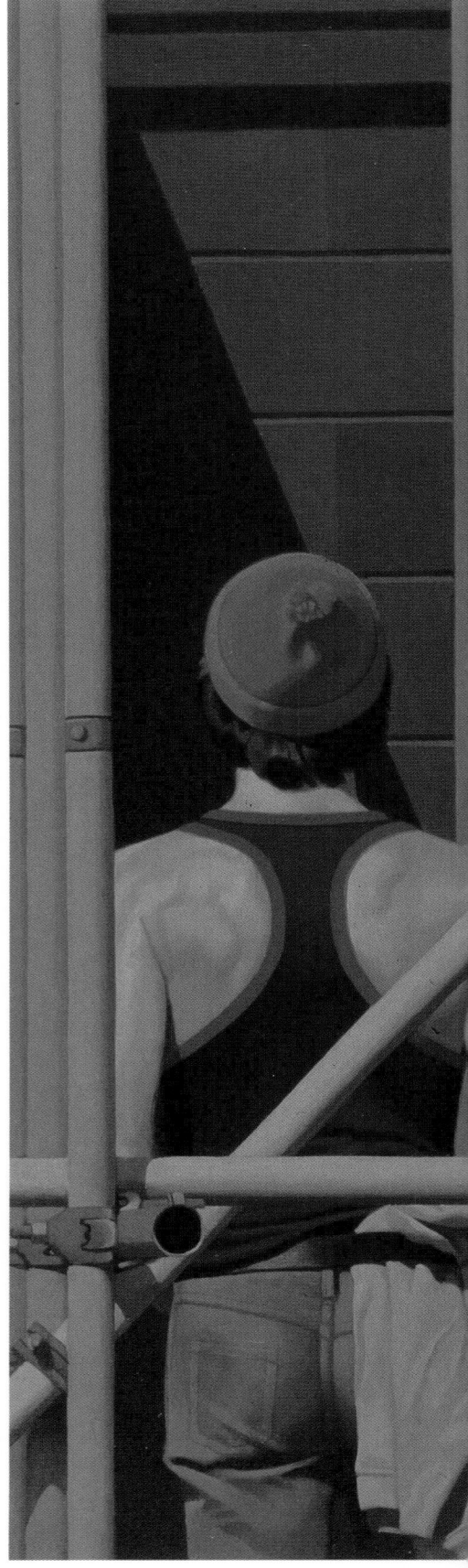

PASSAGE OF ARMS
by Michael Leonard, 1979, acrylic on cotton duck, 34" × 31½" (86.4 × 80 cm). Courtesy Fine Art Ltd., London.

Diagonal lines produce a dynamic effect in this painting, both in configuration of the scaffolding and in the sympathetic poses of the figures. The "frozen action" of this scenario provides an interesting setting for a seemingly casual yet calculated representation. Notice how the pipes "frame" several different pictures within the larger format, each a unique composition in its own right. As the title of this painting explains, the artist emphasizes "optical passage" and rhythmic transition through the positions of the workmen's arms. The composition depicts a totally spontaneous, unposed situation—a moment of human activity frozen by the camera. Although the artist used photography as an aid, the visual information provided by the photograph was modified to some extent as he made his preliminary sketches in preparation for the painting. Among those modifications were a change in the tonality of the setting, selective cropping, and a simplification and modification of form to provide visual transition. Notice, too, the dramatic interplay between the positive and negative shapes.

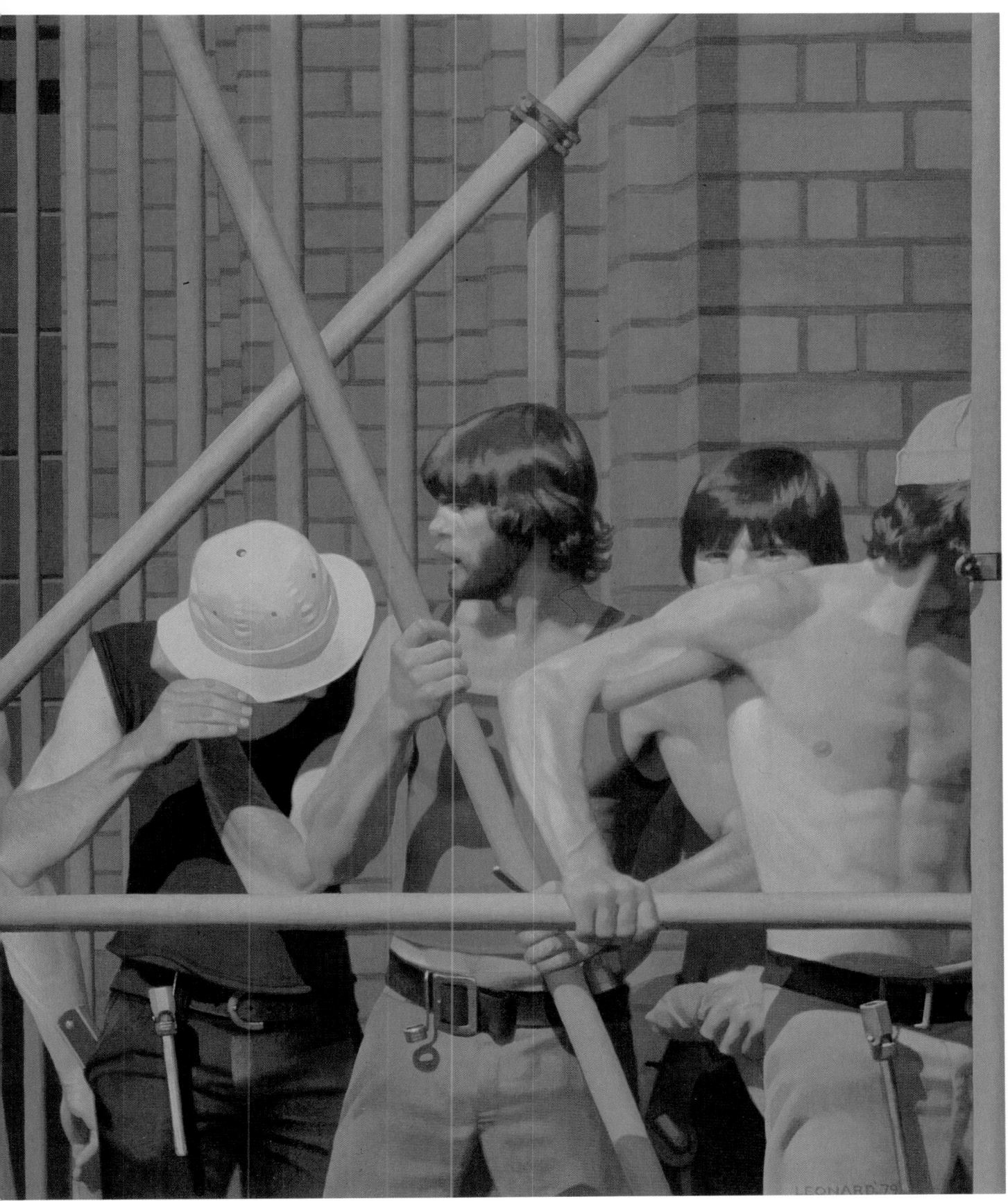

Overlap to Create Depth

Overlapping as a device for creating pictorial depth is evident in even the earliest art forms. It can be seen, for example, in the designs of the cave paintings at Lascaux, Egyptian tomb painting, early Greek art and pottery design, Byzantine mosaics, as well as Gothic art.

The implied "space" between shapes in a composition of overlapped shapes determines whether a picture is to have a shallow, medium, or deep picture plane. Overlapped shapes that "touch" (like shingles on a roof or cards in a deck) present a shallow depth of field. Through the use of color and tone, however, overlapped planes can be made to convey great distance. For example, the interrelationship of a plane that establishes the pictorial position of a distant mountain range (in reference to foothills in midground, trees in the foreground, and a figure set even closer to the picture plane) works together to establish the spatiality of a composition.

If you examine early cave art or aboriginal painting, you will notice another early graphic technique: relative size. By simply drawing some images large (the ones that are perceived as being close to the viewer) and the distant ones small, you can capture the illusion of spatiality. Also, drawing the smaller shapes near the top of the picture further intensifies the illusion of depth.

Color, of course, also affects spatiality. Distant shapes, for example, are affected by atmospheric interference and tend to lose their color intensity; therefore, they often appear duller than figures in the foreground.

The following is a suggested way to begin an experiment that deals with spatiality. (For the purposes of this experiment, don't concern yourself with perspective techniques. Instead, concentrate on the use of overlapping as a means of representing spatial relationships.) Imagine that you're holding a deck of cards—not playing cards, but a deck of cards made up of solid colors. The cards may be modules of a similar shape (all rectangular, or circular, or triangular, etc.) or made up of combined geometric shapes (rectangular plus circular and/or triangular). They could even be made up of a combination of geometric and freeform shapes. Next, in your mind's eye imagine spreading out the cards as you would fan out a deck of playing cards, arranging them in any way to create an un- usual composition, but still preserving their unity through overlapping. Imagine the cards touching or having great distances between them. When you have the image of your deck of shapes visualized in your mind, render it in pencil on paper, making necessary design adjustments, and then transfer the composition to a canvas or panelboard.

As you are composing, think about the ways in which you can use color in concert with the drawing of the overlapped forms. You could, for example, select a color scheme that features analogous color progression (see composition experiment 11) or a color combination that employs a monochromatic color sequence (one that features a single color, plus tints and shades of that hue). For extra sparkle, slip in a "surprise" color within a monochromatic sequence. Stick a hot color, for example, amid a sequence of greens. Decide on how the colors will be assigned and progress in the various shapes. For example, are they to progress from top to bottom, or from bottom to top, or from the center outwards? Above all, emphasize the feeling of spatiality; imagine that each shape is "floating" over the others.

LIMBO NOCHES

By Richard Carter, 1981, acrylic on canvas, 66" × 60" (167.6 × 152.4 cm).
Courtesy Carson/Sapiro Gallery, Denver, Colorado.

In this pristine composition, the artist effectively contrasts hard-edged shapes with delicate tonal gradations. A critic once said of Carter's work: "It's as if he mixes color to look like atmosphere." Notice how the color that's used in this painting varies in "temperature" from hot to cool hues, yet how their values are kept close together, a technique that produces a subdued overall effect. Like many geometric painters, Carter relies on masking tape for sharply defined edges and clean lines. Unlike minimalist painters, however, he uses quick, wet-in-wet brushstrokes to produce a chiaroscuro effect within each of the geometric shapes. The effect of spatiality is achieved principally by overlapping, a pictorial device that in this case provides a shallow depth of field. The artist's imagery works on two levels: The painting can be seen as an abstraction of nature (a reductivist landscape), or as a formal, nonobjective design created in the style of constructivist art. Motivated by the vastness of the open spaces and mountain terrains of his Rocky Mountain environment, the artist effectively portrays the feeling of spaciousness through an economy of design and color.

Paint Stripes

To most people, line is an element associated with figuration. Obviously, it serves an important function in that role, but line—as well as the other elements of art—can also be used as a visual language in its fundamental form.

In an abstract mode, line can be used to divide space and create interval, rhythm, and mood. For example, a design that is made up of repetitive lines can suggest a "beat" or rhythmic pattern, and in this respect is analogous to musical notation. Through the process of serialization—the controlled use of repetition and progression—line can be used to establish a "visual cadence," as well as suggest variation in intensity and harmonic transition.

Lines of identical size, spaced equidistantly, create a simple cadence, a kind of "one-beat rhythm," while the same lines spread out at irregular intervals can generate an entirely different "beat," one with a freer and more complicated rhythmic pattern. In music, rhythm is defined as "the regular rise and fall in intensity of sounds." Translated to art, it can be said that rhythm is created by the regular rise and fall of intensity of color and value, as well as the orchestration of optical tensions that are felt to exist between the visual elements. The abstract expressionist Hans Hofmann called the latter "push-pull."

Repetition—whether in the form of line, shape, or color—provides "optical stepping stones" that lead the eye from one point to another in any pictorial arrangement. The repetition of line also serves to create texture, pattern, and visual gradients. Used in this way, repetitive lines can produce chiaroscuro effects, sparkling color fields, and spatiality.

For this experiment, use repetitive lines to make an abstract "stripe painting," which is composed only of either horizontal or vertical lines. Divide the pictorial space in an interesting way, while simultaneously exploring the potential of acrylic color in producing lines of various types and sensitivities. Produce a cadence or "visual beat" by the way you repeat the lines. Interpret a musical composition, if you like, say a Beethoven sonata or a Gregorian chant, to create a visual analog. Remember that by controlling the quality of color, value, intensity, and texture, you can produce "visual sounds" that can range from pianissimos to crescendos and fortissimos.

Use the acrylics on a heavy watercolor paper to produce different types of lines. Make some opaque, others thin and transparent; superimpose some; apply the color with different tools. Use the brush, palette knife, squeegee, or even unorthodox tools to apply the color. Try glazing or scumbling the color, or scraping painted areas before they are dry to produce textured effects.

Since it is virtually impossible to isolate human emotion from visual perception, nonrepresentational forms spontaneously elicit feelings and emotions. Exploit this characteristic in your composition.

APOLLO SERIES
by Robert Natkin, 1980, acrylic on paper, 18¾"
× 26¾" (47.6 × 67.9 cm). Courtesy Gimpel
Fils Gallery, New York.

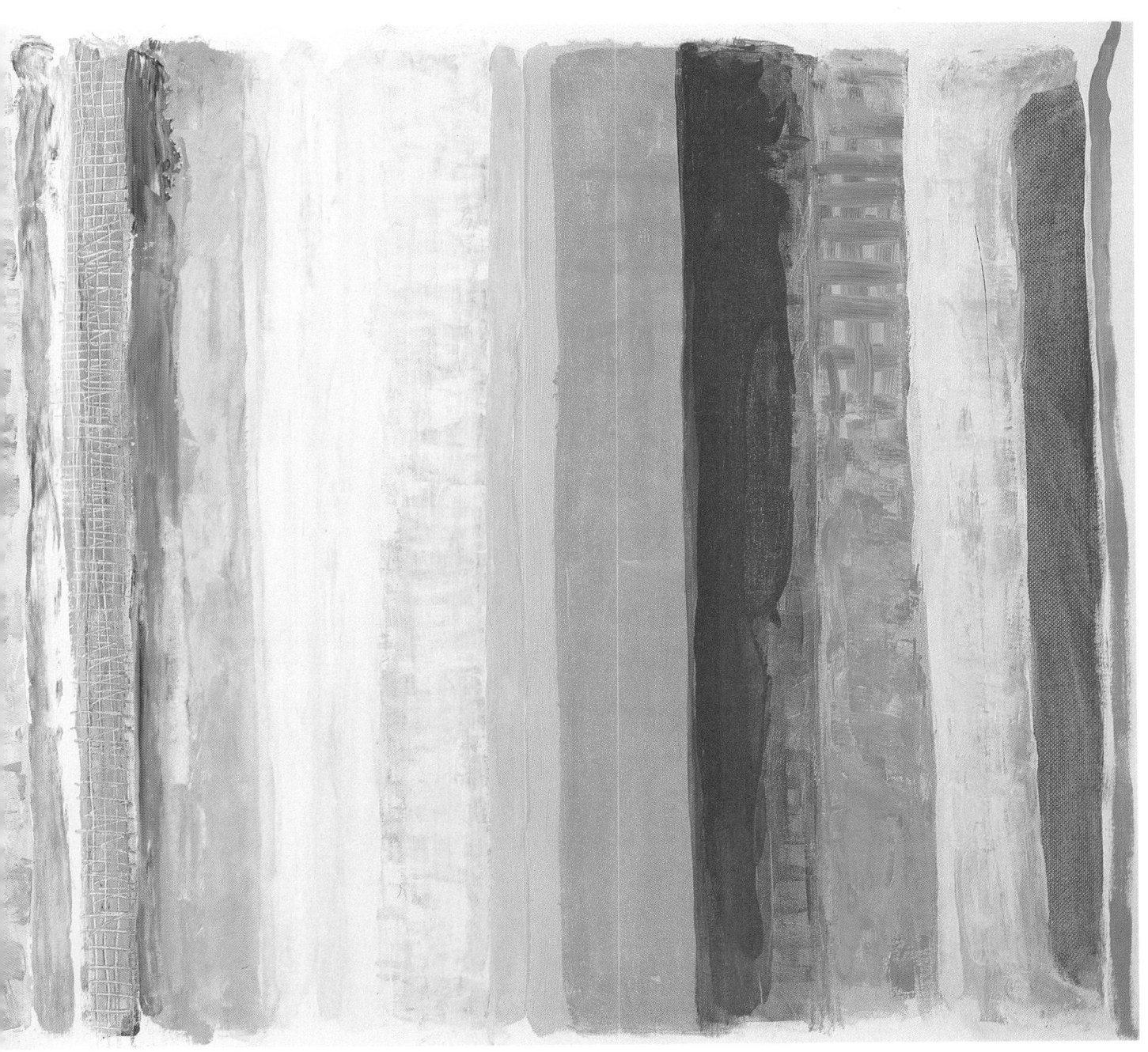

This composition is different from hard-edged "stripe paintings" because the bands of color are applied freehand, without the aid of masking tape. Here, soft-edged lines are juxtaposed with hard-edged stripes; paint is applied in both a flat and textural manner. The overall effect evokes a feeling of directness and spontaneity, and what one critic has labeled "a sunny painting, filled with energy and variety." Although a full spectrum of primary and secondary colors is used, the majority of acrylic hues are mixed with titanium white to produce delicate tints and nuances. Notice how some of the high-key tones that are barely discernible work in harmonious contrast with the bright, fully saturated, primary and secondary hues. In Natkin's work you can perceive an analogy between art and musical notation. The quality of color and texture, as well as the carefully spaced intervals between the bands of color, emphasize the allusion to "color-sound." Although abstract, the painting reflects influences that range from impressionism to the work of Willem de Kooning and Mark Rothko.

Use Transparency to Flatten Space

In pictorial art, the *picture plane* is considered to be an "imaginary window" through which the eye can be led into the recessions of illusionistic space. The "planes of recession" take the form of overlapped compositional elements that are rendered in such a way as to emphasize spatiality.

There are circumstances, however, where the artist will want to do exactly the opposite, for the sake of either design or concept: that is, to create a shallow picture plane or to flatten pictorial space altogether. Examples of flat pictorial space are seen in the work of Braque and Picasso. These artists, along with other cubist painters, were concerned not with portraying a subject as it appears visually—but as it is known conceptually. In order to describe a subject more completely than a single view could offer, it became their practice to *superimpose* images, for example, a front and side view of a face or figure overlapped to produce a single, unified image.

To the cubists, this operational technique was simply a device to represent reality in a different way—one that ignored overlapping, linear perspective, and other traditional means of portraying depth. Instead, they used transparent overlapping shapes as a principal means of flattening space. Overlapping transparent and skeletal shapes tend to produce flat pictorial space and a pictorial ambiguity; it presents an optical paradox because it is impossible to determine which of the superimposed elements are in front or in back of the other.

Can two or more objects occupy the same space? In reality, no, but in art, yes! Superimposed drawings are, in effect, simultaneous presentations; they interpenetrate each other's space and, by this token, literally occupy the same pictorial space. Notice what happens, for example, when you superimpose two different colored shapes cut from cellophane or translucent paper. The result is that you get a *third* color and a third shape—along with a flattened spatiality.

Let's put this idea to work. As an experiment, create a design that involves the superimposition of several elements. Maintain a flat picture plane by rendering the elements so that none of them appears to be in front or in back of each other. Remember, the technique of overlapping solid elements "hides" portions of some shapes and produces depth. Transparency, however, allows all shapes to appear whole.

As the subject for your composition, select letters, numerals, geometric or free-form shapes, simple outline drawings of figurative shapes—or a combination of these elements. An interesting way to produce a composition is to draw many individual shapes on separate pieces of tracing paper, overlap them to form a unified design, and then make a tracing of the combined effect. Transfer the design to a gessoed canvas or panel and use the acrylic colors to produce a painting that has a flat, nonspatial pattern. Emphasize *counterchange*—the alternation of light and dark shapes such as those found in a checkerboard pattern—as well as *transparency*. Transparency is implied visually when two forms overlap and are both seen in their entirety. Because it is not clear which form superimposes the other, the spatial pattern is perceived not only as a flat but also as an equivocal pattern, as a kind of "flip-flop" optical illusion. Remember that new intermediate shapes are created through the overlapping of transparent shapes, and with the thoughtful assignment of light and dark color and tone to those shapes, an exciting visual pattern can be created.

FACET
by George Snyder, 1980, acrylic on canvas, 55" × 55" (139.7 × 139.7 cm). Courtesy Art Focus, Inc., Charleston, West Virginia.

George Snyder negates pictorial depth in favor of a flat and ambiguous picture plane. He does this by ignoring linear perspective, overlapping "solid" shapes, atmospheric color, and other pictorial devices normally used to create depth. Instead, he uses transparency *and* counterchange—*two techniques that produce a simultaneous effect. Although several different geometric shapes are superimposed here, each shape is shown in its entirety; the total effect is bound together by the counterchanges and the network of intermediate shapes that are produced. Bright primary and secondary color contrasts are used without regard to their "advancing or receding properties," a technique that further denies the effects of illusionist space. Notice that the composition presents an interesting phenomenon: Because of simultaneous presentation, the painting is literally transformed into an optical illusion and tends to produce a visual "flip-flop" effect. The use of transparent planes effectively foils the viewer's attempts to determine the spatial position of the composite shapes. Notice, too, the curious use of shading in this composition. Under normal circumstances, the technique of highlighting and shading (chiaroscuro) tends to suggest volumetric form. In this case, however, the elements of the composition are fragmented. "Modeled" shapes are combined with shapes that are rendered in flat colors—further adding to ambiguous spatiality.*

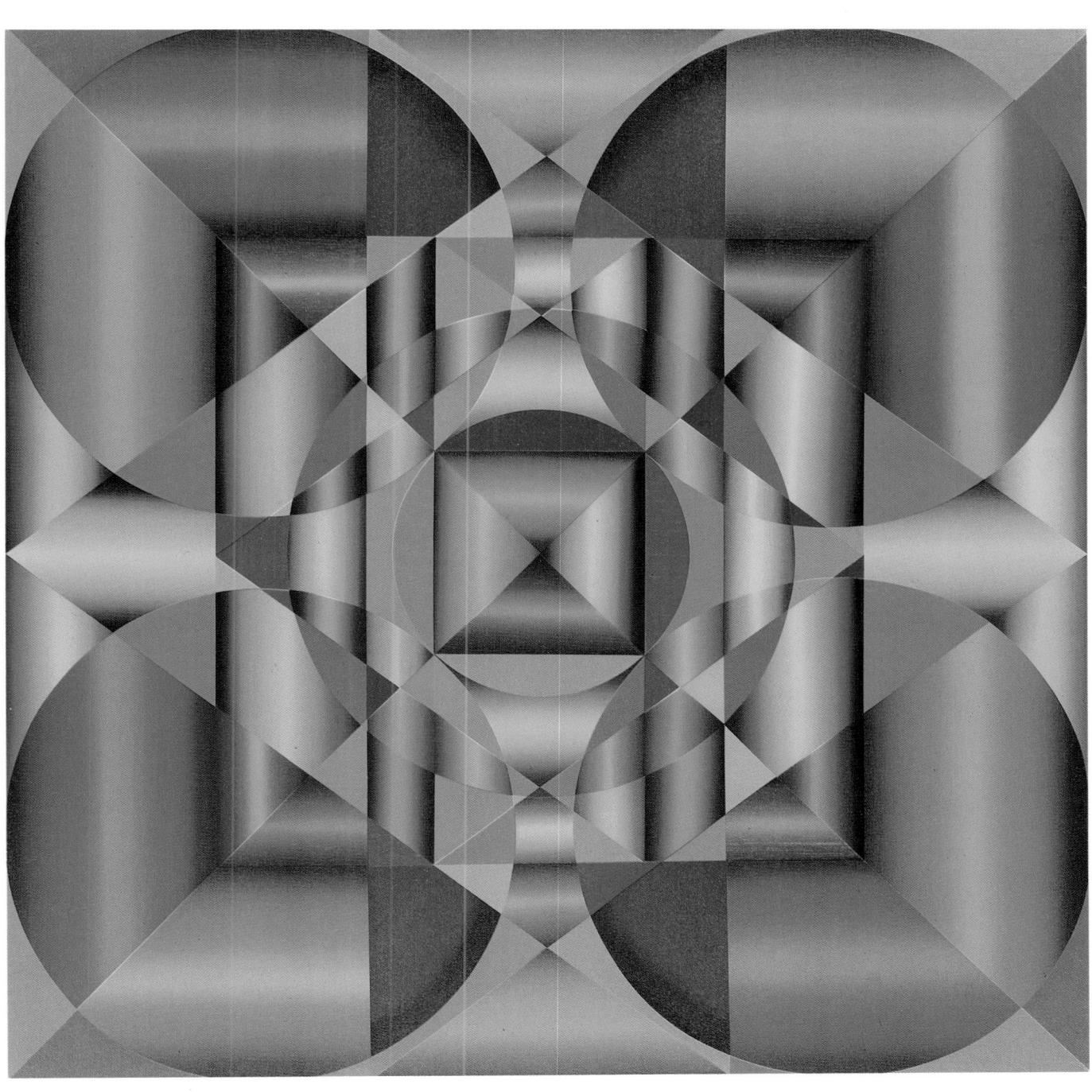

Compose a Symmetrical Motif

Radial and bilateral symmetry are the two types of symmetrical patterns most often observed in nature. Patterns of *radial* symmetry are those with explosivelike designs; their constituent parts spread out from a center like spokes from the hub of a wheel. *Bilateral* symmetry is most often perceived in vertebrates and larger plant forms. Both halves of a design are mirrorlike images of each other, divided by a central median. Examples can be found in the cross-sectional configuration of fruits and vegetables, as well as in the form of trees, animals, sea life, and the human figure.

Exact symmetry is never found in nature. Although many bilateral patterns *appear* to be equally balanced, closer inspection usually reveals slight differences and imperfections between the parts. Only in art is perfect symmetry possible. Throughout history, this mode of design has been highly valued by artists and architects. In Renaissance architecture, in particular, we see a brilliant use of symmetrical order. Other examples include Islamic artforms, Roman floor mosaics, English heraldic devices, and various forms of Iconic art from the early Christian churches.

Begin your experiment in symmetrical design by contriving a motif for a painting based on either radial or bilateral symmetry. As a preliminary venture, experiment in producing symmetrical patterns with mirrors.

To make the mirror device, tape two mirrors together (12″ × 12″ is a good size) so that they open like a book. Next, place the mirrors perpendicularly over various designs you have drawn and study the symmetrical variations that are created by manipulating the mirrors, changing the angle between them. You will notice that by varying the angle of the adjoining mirrors, up to ten reflective images may be created.

Once you find a desired composition, trace the portion of the design between the mirrors on acetate with a felt marker. Make additional tracings of the pie-shaped design on acetate to complete the kaleidoscopic pattern. (Note: every other design will have to be reversed to duplicate the mirror reflection.) Enlarge the design with the aid of an overhead projector and project it onto the surface of a gessoed canvas. Then trace the enlarged image.

A photocopy machine is also a handy device for making symmetrical patterns. Isolate a pie-shaped section of a drawing or photograph and make a number of prints that can be combined to make a kaleidoscopic design.

Another quick method of producing bilateral patterns is to simply draw a line through the center of a sheet of paper and make a pencil drawing on one side of the line. Fold the paper over itself and rub the back of the drawing. The design will be transferred to complete the bilateral composition.

PRAIRIE HARVEST

by Brian Fischer, 1966, acrylic on canvas, 72″ × 60″ (183 × 152 cm). Courtesy Nickle Gallery, University of Calgary, Alberta, Canada.

Although the artist abolished figuration in favor of abstraction, this painting nonetheless presents a potent visual metaphor. As its title suggests, it is symbolic of the living quality found in every cell. It intimates fertility, the seed embryo, the radiance of sunshine and of golden wheat fields. In effect, it is a celebration of nature's splendor and of the promise of the abundant harvest. Although composed of many parts, the conception is unified through its symmetrical motif. The painting was meticulously painted in acrylics with flat, hard-edged color. Each area was carefully isolated prior to painting with masking tape to produce the mechanically sharp configuration. The fine lines were painted with a striping tool, a device commonly used by automobile paint shops.

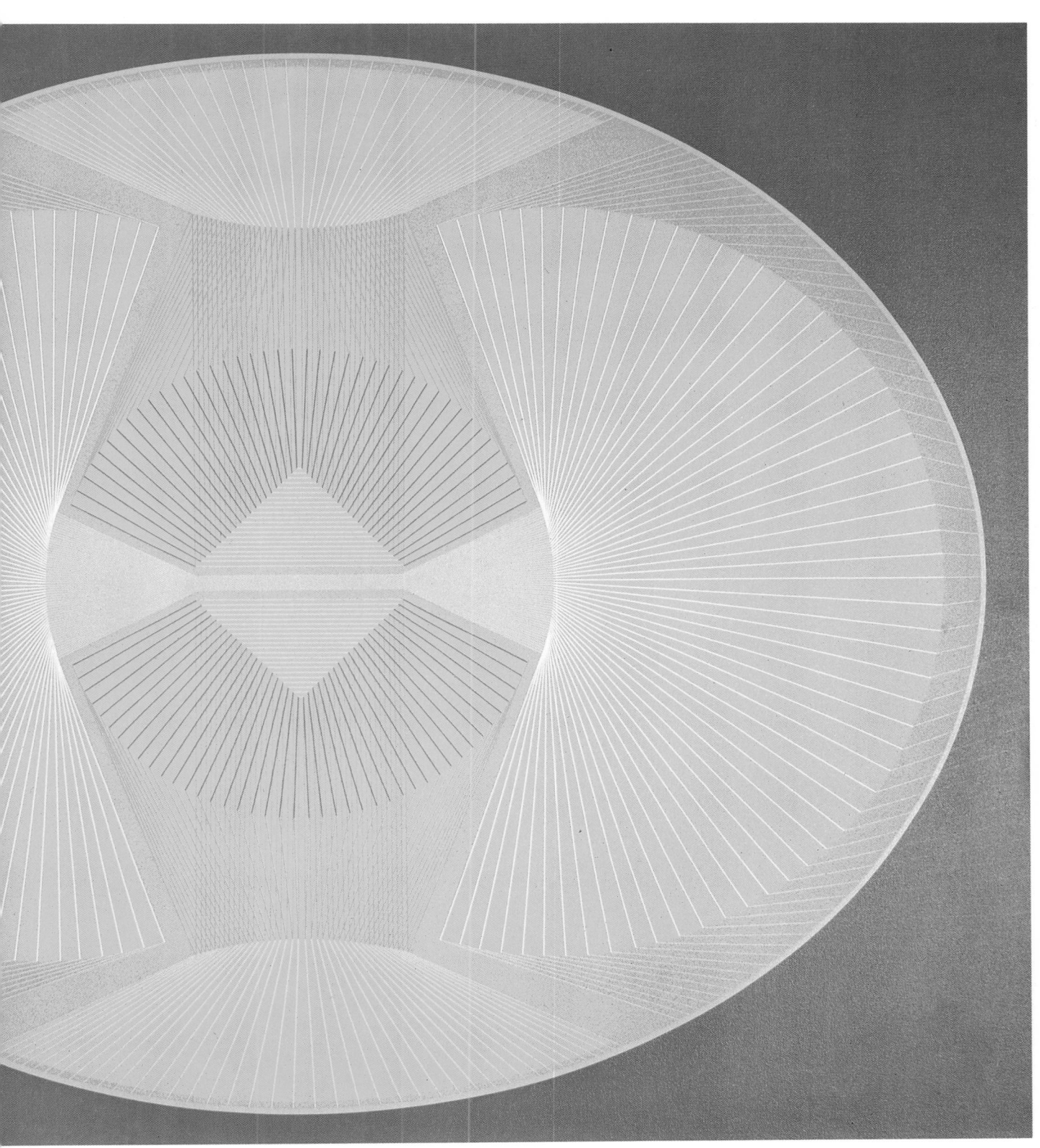

Use Isometric Drawing to Delineate Solid Shapes

Like perspective rendering, axonometric drawings present a graphic illusion of the third dimension. In this type of orthographic projection, three faces of a rectangular object are shown in one view. Unlike linear perspective (in which one-point, two-point, or three-point perspective is employed), axonometric drawing involves parallel rather than converging lines and is far simpler to use.

Isometric drawings belong to the family of axonometrics and are characterized by equality of measure. In an isometric drawing of a cube, for example, the cube is turned so that an edge faces the picture plane and is represented by a vertical line. The diagonal lines that delineate the side planes of the cube are all parallel and drawn at either 30 or 45 degrees. The view of the cube is centered, and the two sides are shown of equal size.

In this experiment, use isometrics to draw "a constellation (or a cluster) of cubes," which in turn, will serve as a painting motif. You'll need the following materials to get started: (1) Isometric graph paper, a translucent paper with a printed grid, available in sheets or rolls (printed with lines angled at either 30 or 45 degrees); (2) drafting vellum, a translucent paper that is placed over the grid to make the drawing; (3) a 30 or 45 degree triangle; and (4) a drawing board. A T-square and drafting table, or a drafting machine, are great if you have them, but are not necessary if you simply use the graph paper to make the isometric projections.

Start by taping a sheet of drafting vellum (sandwiched over the isometric paper) on a drawing board. The gridded lines will show through and serve as a guide to help you make the drawing. To make an architectural constellation that is symmetrical and composed of interlocking cubes, draw the middle cube first, and then work your way outwards, adding similar cubes or architectural units to each side of the cluster as you go along. The very first line you'll draw is the vertical line, which represents the *leading edge* of the middle cube. (Remember, you're viewing the cube from kitty-corner, and see two side planes, plus either a top or a bottom plane.) Draw the diagonals to suggest the side planes by tracing the underlying lines on the isometric grid. Remember, all lines are drawn congruent to the underlying grid. Complete the cube, then add additional blocks to produce a complex, geometric constellation. Stack, overlap, and interlock the architectural units to produce a symmetrical composition. Transfer the design in light pencil to a gessoed support (either canvas or Masonite) and isolate it with fixative.

Next, decide on the color scheme. Monochromatic hues are particularly effective with this type of design. Select a color and mix it with white and black (or gray) to obtain three distinct values of the hue. Each hue can be assigned to one of the isometric planes to emphasize the effect of solidity. Be consistent in the assignment of light values. If you imagine a light source in your composition to be coming from the top left, for example, then assign *all* the corresponding planes in each cube the same color and value. (In this way, all of the right front planes will share the second value; and all of the remaining planes will share the third value.) Imagine how different your design would look if the light source were to come from another direction.

To paint hard-edged shapes, use masking or plastic tape to mask off each shape as you go along, and use a fine-grain support such as linen canvas. Stretch the canvas and prime it with about three coats of diluted acrylic gesso (add about 25 percent water). (Sand the surface lightly with fine garnet paper between coats.) Burnish the tape with the brush handle so that it adheres firmly to the canvas. As a further aid in producing sharply defined edges, brush a coat of polymer medium over the inside edge of the tape and allow it to dry before applying the color.

Think ahead. Prepare your colors in advance. As soon as the color scheme is determined, mix up the appropriate hues and tones and store them in labeled air-tight containers until ready for use. To obtain a good paint film on your canvas, apply two coats of acrylic color rather than just one over each taped area.

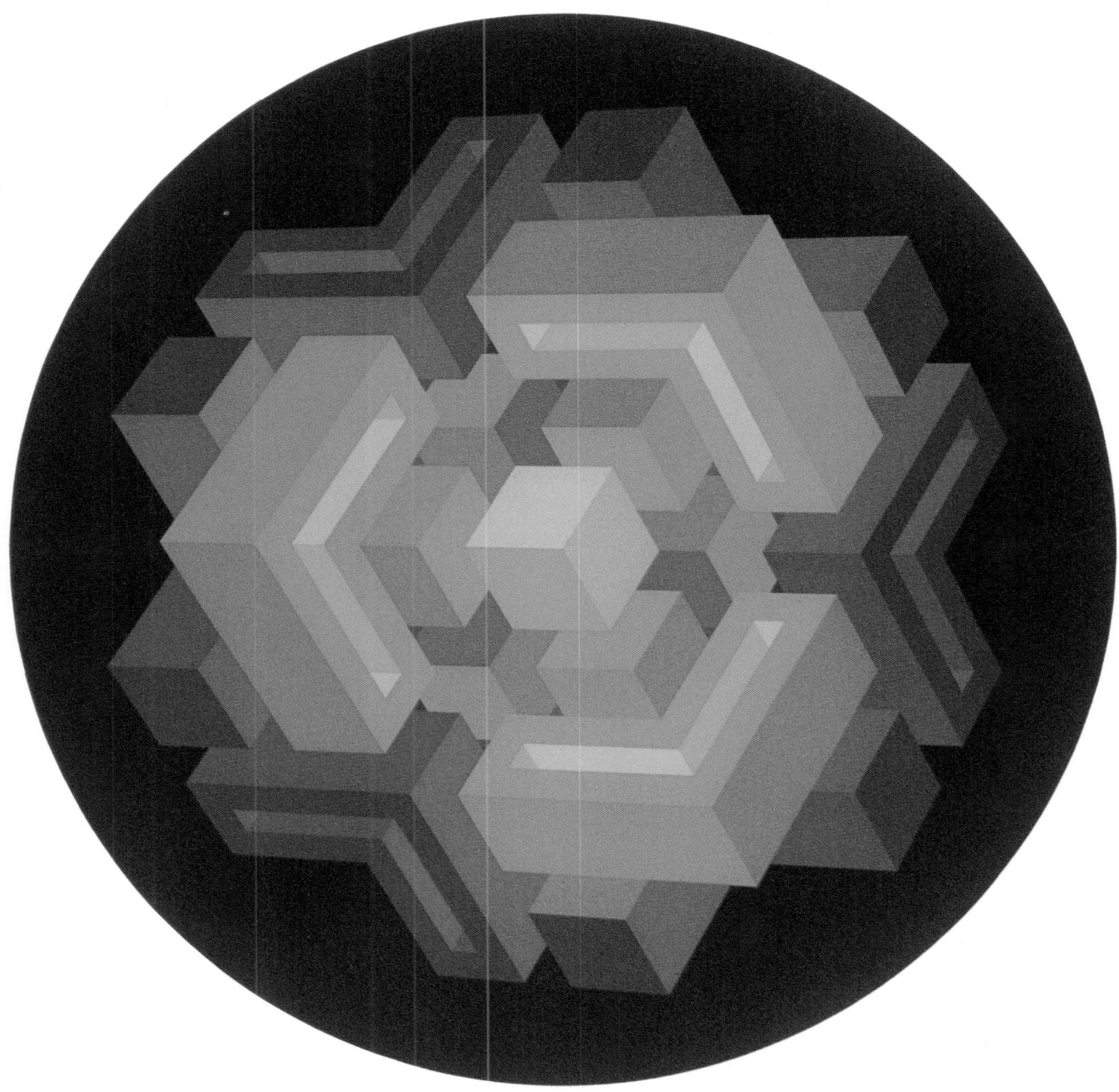

PARAGON

by Brian Halsey, 1983, acrylic on canvas. 48" diameter (121.9 cm). Photograph Theisen Fine Arts, Ann Arbor, Michigan.

This isometric painting is a skillful amalgamation of architectural drafting and fine art. Aesthetically, the geometric abstraction is pleasing because of its forceful spatial qualities and precise craftsmanship. The assignment of values—light, medium, and dark—emphasizes the volumetric illusion. There is dynamic interaction between positive and negative spaces; some architectural forms "touch" or interlock, while others float and interpenetrate. The use of monochromatic color contributes to the striking effect. The canvas—a finely woven linen—was stretched over a plywood panel to assure a uniformly rigid painting ground. Over this firm surface, the artist laid out the design with a straight edge, triangle, and mechanical drawing tools. A light pencil drawing was made directly on the support in preparation for painting. To achieve the razor-sharp edges, the artist used ¾" plastic automotive tape to mask off the areas to be painted. Well in advance, the artist mixed the required tints and shades and stored them in air-tight containers. He used a very soft brush, and thinned the acrylic colors just enough to insure that the brush marks were not visible when the paint dried.

Maintain the Outline

Georges Rouault's *The Old King*, painted in 1916, is an example of the effective use of bold outline and compartmentalized color. Well-intentioned art teachers have trained us to avoid the black outline, considering it, perhaps, an evil allied to the infamous paint-by-the-numbers kits. Yet, this method of composing pictures is particularly interesting because it is so *unlike* nature. Line does not exist in nature; line is man's creation.

As a compositional technique, the black outline does several things; its most important function is that it creates a shallow picture plane. Designs that are outlined in heavy black collapse spatially and tend to become flat decorative patterns. The black contour also emphasizes the richness of color. Because each color-shape is framed in black, it takes on a special brightness not unlike that in a stained glass panel.

Patrick Caulfield, a contemporary British painter, has personalized his work through the use of the black contour. The "boxed" color in his paintings is unique because texture is used as a counterpoint to soften the effect of the black lines and bright passages of flat color. Rouault worked as a craftsman in a stained glass studio early in his career and later derived inspiration from that source. Caulfield's stimulus—as well as that of other contemporary "outliners" such as Roy Lichtenstein—comes from the images in advertising art and commercial illustration.

To try your hand at "outlining," set up a still life with about six or seven objects on a table. Place the objects on a patterned tablecloth and arrange the table close to a wall that shows part of a window or curtain detail as well as an object such as a mirror, painting, or clock. Analyze and transform the motif; make a contour drawing with pencil and paper. Use economy of line; reduce the objects in the still life to simple silhouettelike shapes. Simplify the color, too; exaggerate it, or change it to suit your design purposes. Finish the drawing by coloring in the shapes with marking pens (some good brands are Pantone, Schwan-Stabilo, and Eberhard Faber design markers). Use the black marker to draw in the contour lines.

Next, transfer the design to a prepared canvas, penciling the images lightly on the support. In preparing to use acrylic paint, thin the color from the tube with just enough water to provide good brushability. The brushstrokes should be applied evenly on the support so that a flat, unmodulated color surface is achieved.

Overpaint some of the areas with a pattern or texture, again remembering to keep the effect simple. A good way to add texture is by stippling acrylic color with an old toothbrush or bristle brush. (Mask each of the shapes to be treated with a paper stencil.) Finally, use a small, flat red sable brush to paint the black outlines.

Because this painting style has a reference to stained glass and cloisonné enamel design, you should make an effort to investigate these artforms. Also research the art of Gothic design, art nouveau, art deco, and the decorative patterns in medieval and Islamic art. Examine, too, the works of artists who favored the use of a bold outline. Among these are Fernand Léger, Wassily Kandinsky, Piet Mondrian, Theo van Doesburg, and Juan Gris.

SPRING FASHION

by Patrick Caulfield, 1978, acrylic on canvas, 24" × 30" (61 × 76.2 cm). Private collection. Photograph courtesy Waddington Galleries, London.

Characterized by simplified shapes, bright color, and black contour lines, this painting is reminiscent of stained glass and cloisonné. Although the artist uses the traditional still life as a motif, his technique is contemporary, inspired by commercial art and media design. Notice that the black outlines are used to delineate the shape of the objects, yet in certain areas (such as the tablecloth, curtain, and wall clock) it is used to create the interior patterns of these objects. The fish design in the platter also offers an interesting counterpoint because it is rendered in a contrasting chiaroscuro style.

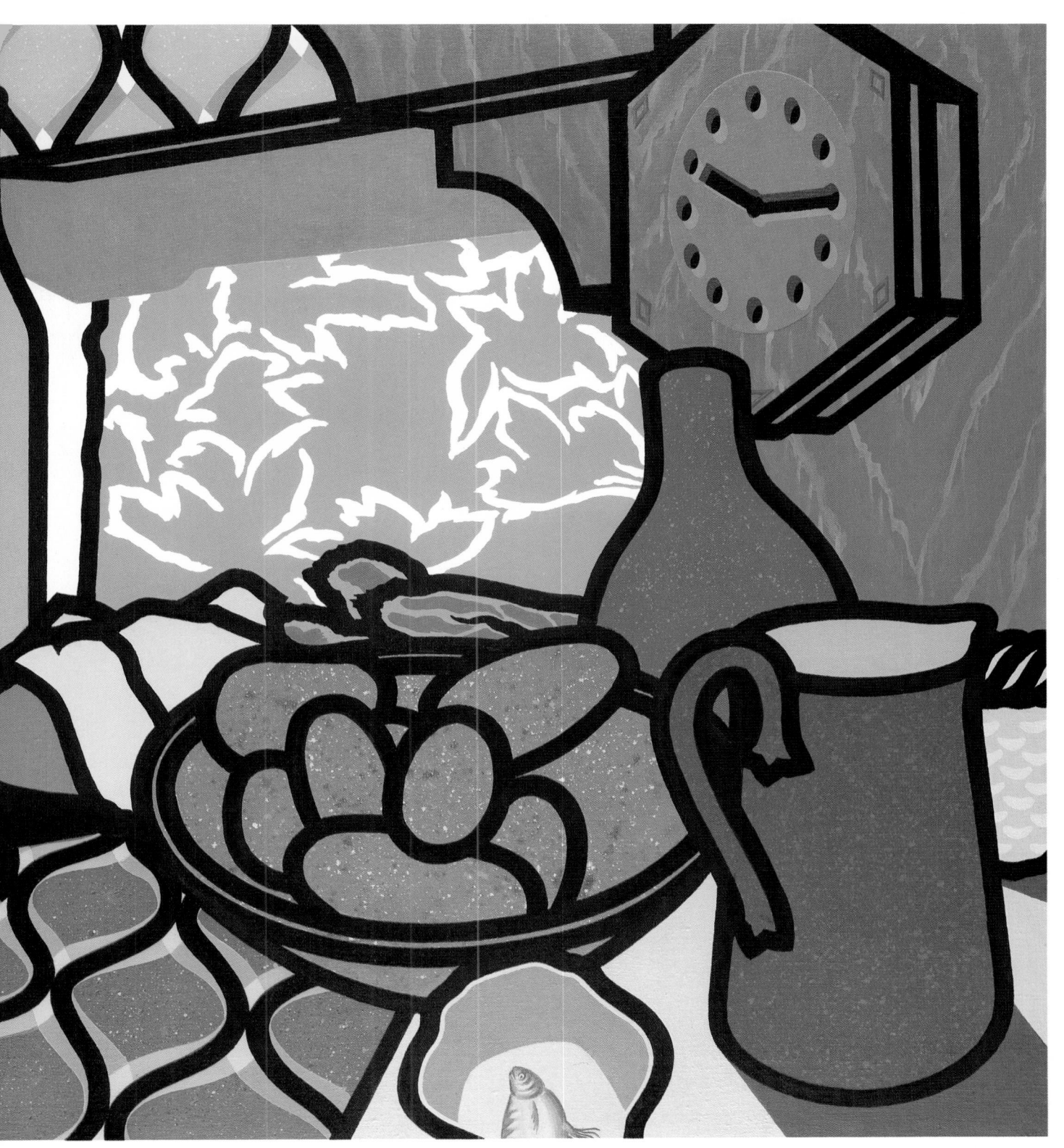

Use Analogous Color Progression

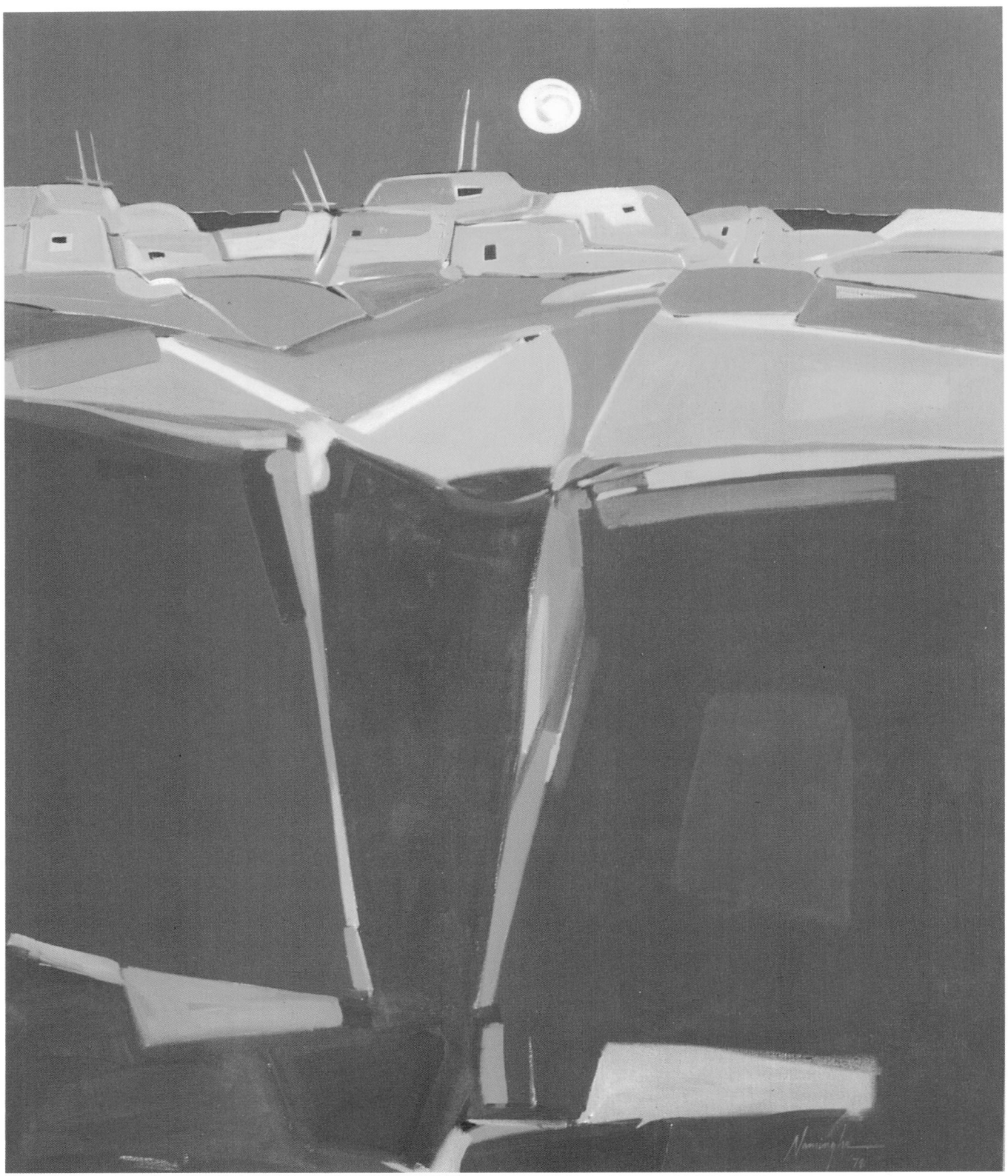

Analogous color progressions yield harmonious effects because, like their counterparts in music, they involve a natural order of repetition, continuity, and "growth." In application, colors are combined in a consecutive order (according to their position on the color wheel) to produce chords, and these chords combine with others in further progression. Karl Gerstner, a well-known contemporary authority on color, follows the line of Johannes Itten and Josef Albers when he describes color as part of "chromatic evolution." "All colors occur in series," he says. "There is no color that cannot be transformed into another through progressive sequence."

Color compositions that are made up of highly contrasting hues but no in-between passages to lead the eye from one color to the next tend to produce "jumpy," discontinuous effects. However, this should not discourage you from using such combinations in certain instances (the controlled use of discontinuous color is another form of harmony) but should simply bring attention to the fact that continuity of color movement requires some form of analogous color chording—or, in other words, the presence of optical "stepping stones" to get you from one

color to the next. Analogous colors are related because they lie adjacent to each other on the color wheel; by using kindred hues, it's practically impossible *not* to achieve color harmony.

In this experiment, use analogous colors in a composition that is divided into many component shapes—either of a lineal or concentric nature. Assign colors to each shape in a progressive manner to produce a natural transition.

There are several ways to choose an analogous color harmony. One is to use a combination of adjacent colors that features *only* the chromatic (or undiluted colors). Such a color combination would include, for example, yellow, yellow-orange, orange, and red-orange. Another way is to use one chromatic, such as yellow, along with analogous progressions of the same color in either a high or low key range. In other words, use a bright color, along with progressive sequences of that same color, but in various tints or shades. You may opt to use only high key colors (light tints), which will produce quiet and subdued tonalities, or only shades to obtain darker and more somber effects.

A particularly effective way of using analogous colors is to combine them with their complements (those colors

directly opposite them on the color wheel), allowing one color to dominate and using the complement as an accent. For example, you could start with red, progress through the consecutive hues of red-violet, and violet—then jump across the color wheel to yellow and continue the analogous progression with yellow, yellow-orange, orange, etc.

Aside from complementary combinations, think about the possibilities of using analogous color progressions in other color combinations, such as *triadic* (a three-color combination, each color equidistant from each other on the color wheel); *split complementary* (three-color combination featuring a color plus the two hues adjacent to its complement); or a *double complementary* (a four-color combination featuring two complementary combinations).

For further research, examine the works of the great colorists. If you look, for example, at Constable's paintings, the rich, vibrant greens are, in fact, made up of many strokes of several different "greens." The pleasing effects in Cézanne's paintings—as in Monet's —are due largely to the use of analogous color applied in mosaiclike patches.

WINTER NIGHT
by Dan Namingha, acrylic on canvas, 1980, 72" × 60" (183 × 152.4 cm). Courtesy the Gallery Wall, Inc., Scottsdale, Arizona.

Although Dan Namingha lives at a San Juan pueblo, just 15 miles north of Santa Fe, New Mexico, his favorite motifs are those inspired by his Tewa-Hopi heritage and of First Mesa, his early childhood home. In this painting, the artist captures the spirit of the pueblo village—its sky and land, and flat-roofed adobes—by stylizing, abstracting, and exploiting the inherent analogous color sequences that he observed in the pueblo. Nuances—of flatly painted color patches—progress through hues of yellow-orange, orange, red-orange, red, red-violet and violet. These analogous sequences crossover from the warm to the cool

side of the spectrum, reinforcing the visual metaphor of the pueblo in winter.

Notice how the artist uses small touches of the complementary color, blue, to make the warm colors appear brighter and more luminous. Namingha works with quick, spontaneous brushstrokes to capture the qualities of "earth and spirit." "I work fast so I don't lose the idea in my mind. Then I sit back and study the painting. I have the freedom to paint over something if it doesn't satisfy me, and do it again in a different way. What matters to me is the color and the way it sweeps across the land."

Use Value Contrast to Emphasize Form

Although artists rely heavily on it to delineate shape and form, *line* is not found in nature. It is an abstraction, a graphic "tool" invented by man, and by itself, has shortcomings, especially when used to portray mass or volume. Only when line is coupled with value can the illusion of mass or monumentality be fully established.

For this experiment, use value to emphasize form. Select an architectural subject such as a building, or other three-dimensional structure as a motif. Begin by using a cardboard viewfinder (see composition experiment 3) to isolate your subject and establish the composition; pay particular attention to the relationship of positive and negative shapes, and, of equal importance, reduce all forms to simple, geometric shapes.

Use pencil and paper in your preliminary sketches to make a contour drawing of your subject, but add contrasts of value to transform the linear shapes into form. With tone, lines become edges and shapes become planes, developing and heightening the illusion of sculptural form. Start with line, but get rid of it through chiaroscuro rendering and the controlled use of color-value contrast. Line automatically "disappears" when you paint the inside or outside of a linear shape.

The direction of light also plays an important role in establishing form, and should be carefully studied. Is the subject illuminated from above, below, or from the side? Is it backlighted or illuminated by indirect or reflected light? Carefully study the effect of sunlight and shadow on your subject; look for the interplay of highlight, halftone, shadow, and cast shadow areas. Although you'll be painting in color, consider how your subject would look if it were photographed in black and white to better understand the tonal relationships. Remember, the idea is to use value contrasts to emphasize monumentality.

If you have a camera, photograph your subject in black and white and use the pictures as reference material, along with sketches made directly from the subject. The camera is a useful tool because it objectively records and "freezes" the fleeting qualities of light and shadow.

Rather than paint this picture at the site, gather the information you'll need through photos and sketches and do the actual painting later in your studio.

Paint with a limited palette. Use only a few colors, but mix them with black, white, or gray to obtain a variety of tones and color intensities. Carefully assign the values to the appropriate planes. Allow sufficient contrast between highlight, halftone, and shadow areas to emphasize form.

Remember that it's not necessary to attempt to duplicate the *exact* values of your subject. Because you are interested primarily in the expressive and design potential of the subject, it is natural to revise and exaggerate the qualities that are perceived in nature through the process of abstraction and simplification.

ROUTE 5, #2
by John Manning, 1972–77, acrylic on canvas, 72″ × 54¼″ (182.9 × 137.8 cm). Photograph courtesy the artist and Peter Rose Gallery, New York.

In this painting, John Manning imbues the barn—a classic American farm motif—with bold and monumental properties. He achieves a convincing illusion of three-dimensional solidity by reducing the components of the subject to simple, geometric shapes and by controlling the interplay of light and shadow on their surfaces.

Trees, shrubs, animals, and people are intentionally excluded from this composition to produce a solitary effect—a quality reminiscent of the paintings by Georgia O'Keeffe, Charles Sheeler, and Edward Hopper. By the noticeable absence of humanity, the painting also presents an eerie silence and feeling of immutability—a reference to René Magritte. Manning pre-fers to complete his paintings in his studio rather than outdoors. This one was produced from photographs and sketches made on the site; these provided visual data for subsequent interpretation. The artist notes that he takes "poetic license" to change or abstract the colors and values observed in nature: "My paintings are neither literal translations nor copies of the real thing. They are transpositions with a healthy blend of objective reality, subjective interpretation—and technique." The painting was executed with a limited palette—primarily grays and low-key hues—controlled by contrasts of tonality that produced dynamic intersections of planes and masses.

Omit Detail

Like his contemporary Cézanne, Monet was a keen observer of nature and an artist who recognized the importance of translating—simplifying, reducing to essentials—the reality of nature to produce an "aesthetic reality," a vision expressed through the properties of canvas and paint. Monet's vision was a perfect integration of style, medium, and subject. And, by subject I mean not only the visual stimulus observed in nature but the image in the mind's eye that is used to control that visual input. Monet's vision was concerned with capturing the effects of light and the sensations of color, rather than with a slavish reproduction of nature.

Simplify. *Compress* the visual information observed in nature—that is the concept to employ in this experiment. Work directly from nature, or from a detailed color photograph. To help reduce the complexities of your subject, squint your eyes as you view it; this tends to obliterate detail and helps you focus on the larger masses and shapes rather than on the myriad of bewildering details. Also notice how sunlight illuminates the shapes and interlocking patterns in your subject.

It might also help to think of your subject as a "topographical map," and break up your subject into interlocking and concentric shapes, as the map-maker does when charting the contours of terrain. Try to maintain that initial split-second perception of your subject, that first glance impression which registers in the mind *before* an image comes into complete focus. The camera can be a useful tool in this respect. It presents a one-eyed, rather than a stereoscopic, view of the subject. In a photographed image the spatiality, colors, and values of nature are compressed, more so with telephoto lenses and wide-aperture settings.

"Map" the patterns observed in your subject by making a careful contour drawing in pencil on paper. Aside from drawing the obvious patterns—such as the outline of a tree trunk, for example—be sure to observe and record the shapes-within-the-shapes, the light and dark passages of value and color that are produced by the effects of sunlight on form. Divide all the details of your subject into a topographic pattern like the composition of a "paint-by-numbers" design. The constituent shapes can then be assigned appropriate color values in preparation for painting.

Rather than mixing small amounts of

color on your palette as your painting progresses, take the time to mix the required quantities of color ahead of time. Carefully mix the tints, shades, and intensities and store them in small lidded containers. In painting, try holding the brush parallel to the canvas rather than at an angle or perpendicular to it. Hold it like you would a tennis racquet, rather than a pencil. With the brush held in this manner you can scrub the acrylic color to the support with freer, bolder gestures. Apply the paint liberally and try to "push" the paint over the surface and against the adjacent colors. Don't blend or shade; instead, apply the color in flat, mosaiclike shapes to the canvas. Let your brushwork replace drawing; strive for an overall pattern of interlocking shapes.

ALONG THE RIDGE
by William Kortlander, 1984, acrylic on canvas, 48" × 144" (122 × 366 cm). Courtesy the artist and Haber Theodore Gallery, New York.

In this robust landscape painting of the Appalachians, the effects of sunlight and shadow are massed into simplified shapes. Ignoring detail, Kortlander delineated only the prominent abstract patterns observed in his subject, yet maintains a representational effect through the careful handling of color and value. Notice that no outlines are used in this painting; the artist substituted brushwork for drawing. Color is not "modeled" as in the traditional chiaroscuro style but applied in flat, irregular shapes, resembling a mosaic pattern. White was mixed with most of the hues to achieve a pastel-like luminosity, reminiscent of Monet's paintings. The consecutively smaller shapes are painted over larger and intermediate ones, maintaining a fresh spontaneous quality in the brushwork. The painting fairly bursts with energy—an effect created through the use of simplified form and exaggerated color. Notice, too, how the small passages of warm color on the left side of the painting contrast dramatically and offer a relief to the overall cool effect. The painting may also at first glance appear to be flat, yet the artist has carefully included many planes of recession, which provides a spatial dimension.

Use Serialized Images

A painting executed in the form of serialized images will bombard the viewer with an image-haze like that of a wall of illuminated TVs. This compositional style calls for the use of multiple images—in the form of miniature paintings—to be attached to the surface of a larger background image. Depending on your idea, the images may be unique, yet interconnected, or completely discontinuous.

A pictorial format of serialized images is like a book with many pages; yet, unlike a book, a painting assaults the eye with a single view. Since we have an inherent tendency to "read" all visual input in a way conditioned by reading habits, serialized images are normally comprehended sequentially, as in reading a comic strip, for example. However, since the eye is free to roam the pictorial surface of a painting, random connections are also made.

Why multiple images? In this century, simultaneity is a fact of life. Marshall McLuhan aptly portrayed "pre-media" man as lineal; one who lived in a tiny village shut off from the world and who communicated orally, without benefit of the printed word or electronic boxes. In today's crazy-quilt mass-media culture, however, information is transmitted instantly; man has become synaesthetic, capable of handling and (for the most part) flourishing in the plethora of multiplicity.

Experiment with the format of serialized images. Arrange them either in a tight format (as in a comic strip grid) or a more casual asymmetric manner. Consider using this pictorial model for putting forth images in a symbolic, metaphoric, fantastic, or surrealistic mode. As a motif, create a "visual diary"—a pictorial déjà vu of an event, either imagined or real. Notice, for example, how Jan Sawka uses serialized images in his painting entitled "Nepalese Diary," a presentation of recollected events from a special time-space and journey in his life.

Start by cutting a piece of Masonite to use as the background support, along with a series of smaller pieces—also cut out of Masonite—to use for painting the "miniature images." Prime the Masonite components with acrylic gesso. Glue ½″ × 2″ wood strips on the back of the large panel to prevent warping. The small shapes of Masonite can vary in size, or be of uniform proportion. Depending on your design, make the boxed shapes as small as 3″ × 3″ or larger, depending on the number of components you want to include in your painting.

Paint an appropriate background on the large panel, then compose and eventually glue the "miniatures" onto the surface. Adhere the small images directly on the background, or for a sculptural effect, elevate them slightly with small wood blocks glued behind them. Use this format for the pictorialization of subjective impressions, as a vehicle to produce metaphoric structures, political statements, or Magritte-like portrayals of fantasy or paradox. René Magritte deliberately employed "the cloak of obscurity" in his painting, presenting ambivalent images that seem to defy logical symbolic resolution, but hit hard on the subconscious level. The viewer is presented the task of subjectively completing the work through intuitive responses.

Likewise, it has been said that a distinguishing characteristic of many contemporary artforms is that content is presented in the form of unprocessed data rather than resolutions. Whether this "data" is perceived as chaotic or symbolically cohesive depends entirely on the personal interpretation of each viewer.

NEPALESE DIARY
by Jan Sawka, 1982, acrylic on Masonite, 72″ × 52″ (182.8 × 130 cm). Courtesy Andre Zarre Gallery, New York.

In this "chromatic smorgasbord," over 150 separate "miniatures" are painted on Masonite and attached to the surface of the larger background panel. The background, which portrays a mountainous terrain, establishes the locale and motif, as well as the setting for the smaller panels. Executed in simplified color and form reminiscent of poster art, the images are bright and colorful, almost cartoonlike in character. The miniature images are enclosed within various-sized boxes. Each image, like an individual tesserae in a mosaic, contributes a "fragment of memory," aiding in the synergistic effect of the overall motif. The painting is a visual diary of happenings and impressions of a particular journey, a pictographic chronicle of sights and sensations that have been captured with a sense of childlike wonder. Although the artist has simplified the images to the form of symbols that comprise a personal vision, the images nonetheless communicate universally on both objective and subjective levels.

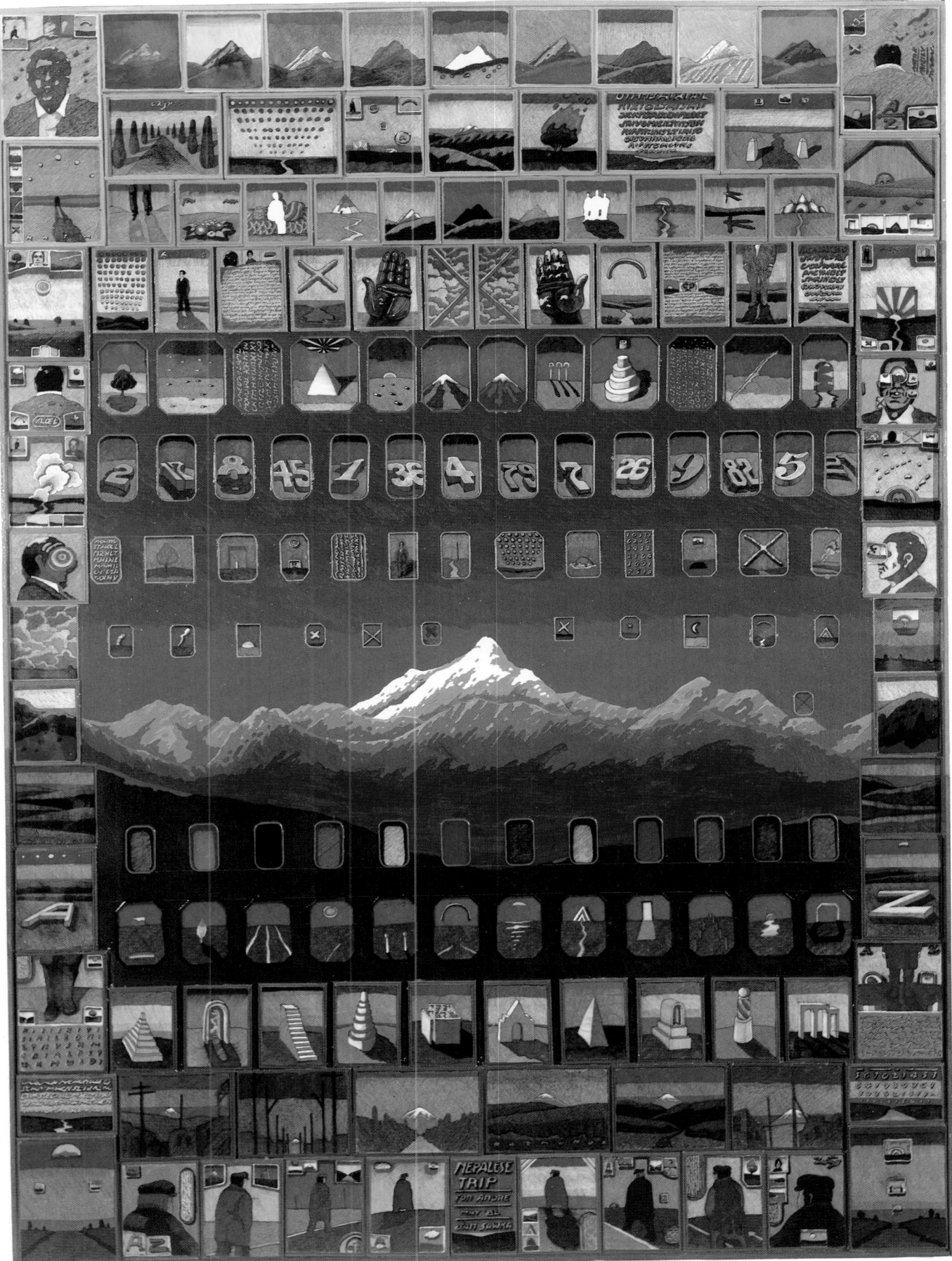

Shape the Canvas

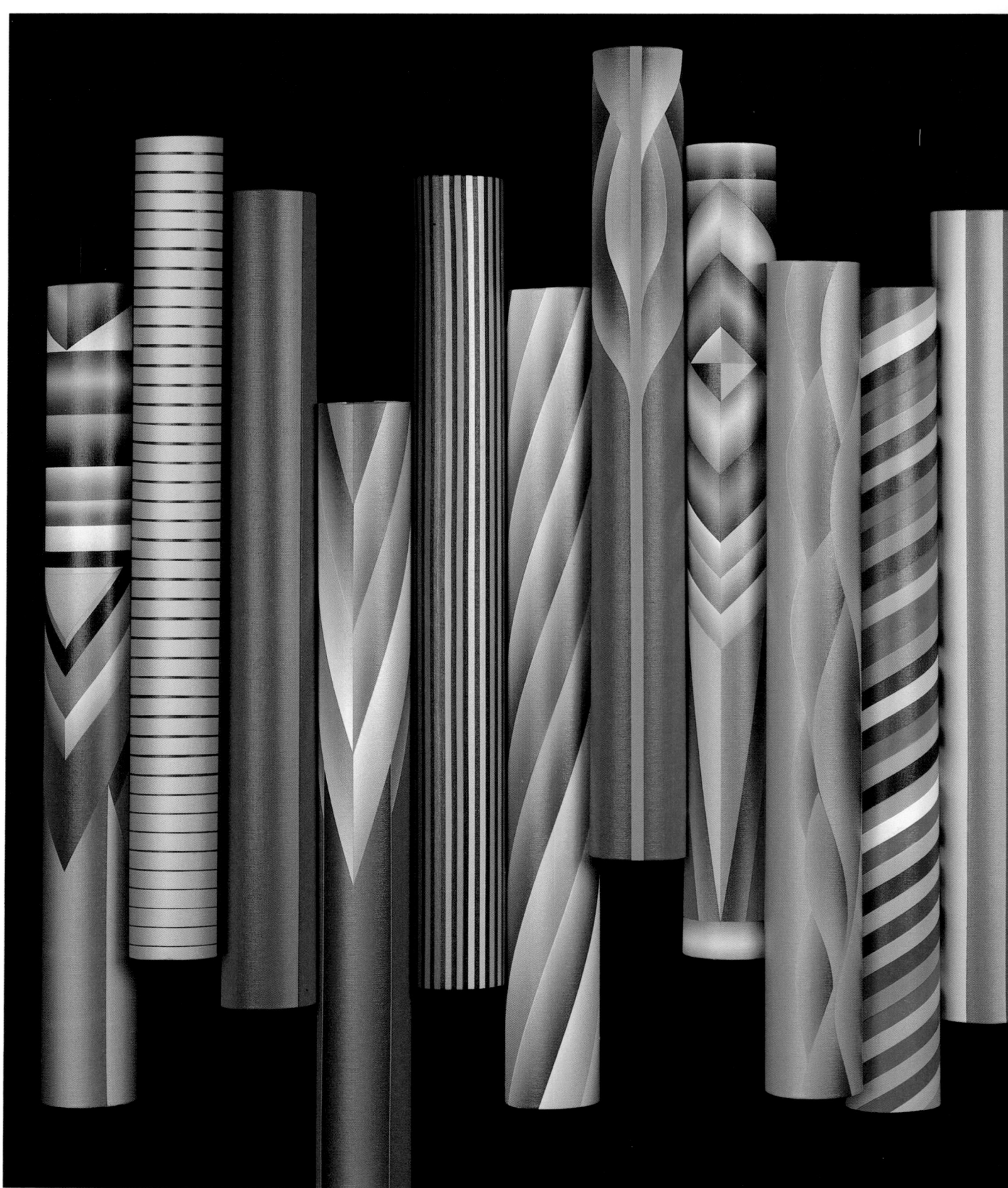

One of the main reasons that the rectangular canvas dominates all others, says critic Ed Feldman, is because of the Renaissance convention "that a picture is a window opened on the world and then painted by an artist." The contemporary artist, having a more liberal attitude, realizes that the rectangular format is just one of many possible shapes for the stretched canvas.

Frank Stella, for example, shuns the "window of the world" theory in favor of painting abstract, nonreferential works. "My painting," he says, "is based on the fact that only what can be seen there is there. It really is an object." On the other hand, contemporary realist painter Howard Kanovitz uses the shaped canvas in an entirely different way by painting images that are "freed from the background"; presented as clustered, yet separate images in the gallery space, his paintings are like pictures in a giant "pop up" book.

There are many ways to shape a canvas. Here are a few options to consider:

1. Shape the contour. Get away from the rectangle or square format. Compose a circle, half circle, triangle, diamond-shape, or a composite made up of various geometric shapes.
2. Shape a curvilinear canvas. Design a composition with a freeform or organic configuration.
3. Shape the contour, plane, and surface. Cut out an irregular shape from plywood, then attach wood cutouts to its surface. When canvas is stretched over these forms, it will have an irregular configuration and a three-dimensional plane.
4. Shape over volumetric forms. Attach painted canvas onto boxes, tubes, geometric constructions.
5. Shape individual components for a relief structure. Glue canvas to separate wood cutouts, then attach the components on a common ground plane. Use tilting planes, overlapping shapes or spacing bars to produce either a high or a low sculptural relief.
6. Create a pop-up composition composed of an image (or images) without a background. Some shapes can be hung on the wall, while other free-standing units can be placed on the floor directly in front of them or into the gallery space.

An important consideration in planning a shaped canvas is the integration of shape and pattern. In many of Frank Stella's canvases, for example, you will notice that the painted designs echo the structural shape of the canvas.

You can plan your stretched canvas as a single monolithic shape, or as several interlocking parts that fit together like pieces of a jigsaw puzzle. The canvas support can be stretched across wooden stretcher bars, reinforced plywood, presswood, or Masonite. Because the irregular-shaped stretcher frames have a tendency to warp, you may prefer to stretch the canvas over a reinforced plywood cutout.

Plan your preliminary drawing on graph paper, particularly if you are working on an abstract design. It is also advisable to construct and paint a small cardboard or balsa wood model before embarking on the final project.

COCKTAIL PARTY
by George Snyder, 1984, acrylic, canvas, PVC tubing, 55" × 60" × 7" (139.7 × 152.4 × 17.8 cm). Courtesy Arts Focus, Inc., Charleston, West Virginia. Photograph by Jim Osborn.

Each of the 15 sections in this festive work was first painted on stretched canvas, then removed from the stretchers and assembled onto plastic tubes. The tubes, made of 4" and 6" PVC pipe, are fastened together with wing nuts and bolts through pre-drilled holes. Rivets were used on the rear seams of each canvas panel to hold it securely in place. Both the top and the bottom of each tube were capped. The tubes are connected to form an irregular line; some jut higher than others, providing an irregular surface plane. Although the painted designs in this assemblage have the smooth look of airbrushed paint, they are actually handpainted with a brush and sectioned off with masking tape.

Portray Motion

"All we know about motion," said Aldous Huxley, "is that it's a name for certain changes in the relations of our visual, tactile, and muscular sensations." Motion, the active (or functioning) state of things as they pass from one position in space to another, is depicted in art by several means: repetition and sequencing of shape, form, and color; partial delineation of form; blurring of images; integration of "motion lines" (or lines of force); and the use of overlapped, interpenetrated, or fused shapes, as can be seen in the work of futurist artists.

In her book *Orphism*, Virginia Spate describes Francis Picabia's technique for portraying the movement of a dancer: "He first drew a linear structure—perhaps while thinking about the dancer—then improvised from this by filling in the areas bounded by line, or breaking it down by continuing a color over a boundary, by overpainting earlier shapes, or by fading one plane into the next, but always taking care that the abstract linear substructure remained visible."

For this studio experiment, paint a composition that somehow expresses the vitality of motion or dynamic movement. As a motif, select an event, or a physical subject in movement. For example, it can be a recollection or a photographed image from a track and field event, a dance performance, a football game, a circus event, a sportscar rally, a machine in motion, etc. The subject, in fact, can be human, animal, or mechanical.

In planning your composition, consider the spectator's point of view: Is he or she active or passive? The futurists, for example, were the first to advocate the concept of a pictorial space wherein the viewer would be "situated in the center of the picture." For example, if a viewer is placed in the driver's seat of a fast-moving vehicle, although his own image is not seen, the elements of the landscape—what he sees—in front of him may be painted in sharp focus, while details in his peripheral vision may be blurred or treated with "motion lines." Placed outside the picture plane, the viewer is passive because the action is happening to someone outside his own physical frame of reference.

Use the acrylics liberally and boldly; rather than draw every single detail and end up with a static picture, suggest rather than explain the shapes and forms. Consider leaving part of the painting unfinished, or partially blurred to exaggerate the effect of movement. Another way to emphasize the quality of transition is by using color that changes in progressive steps from light to dark, warm to cold, chromatic to achromatic, or through analogous sequence, in concert, of course, with the abstraction of the image.

Apply the futurists' idea: "Bring the spectator into the center of the picture; make him participate in the action; the lines of force must envelop and draw him in." Francis Picabia's *Danses à la Source I* (painted in 1912) admirably applies this "lines of force" idea, as does the famous *Nude Descending the Staircase* by Marcel Duchamp.

As a preliminary warm up activity, make some motion studies with a camera. For example, try multiple exposure, shooting at slow speeds while "panning" with a telephoto lens, sandwiching negatives in printing, strobe photography, manipulating the soft emulsion of a Polaroid print while it is setting, etc. Also consider making preliminary studies in colored chalk or oil-pastel to visualize your concept. Then, with the idea fixed in your mind, approach your canvas with a bold brush to capture the feeling of dynamic movement.

EAGLE DANCER
by Dan Namingha, 1981, acrylic on canvas, 52" × 68" (132 × 172.7 cm). Courtesy Gallery Wall, Inc., Scottsdale, Arizona.

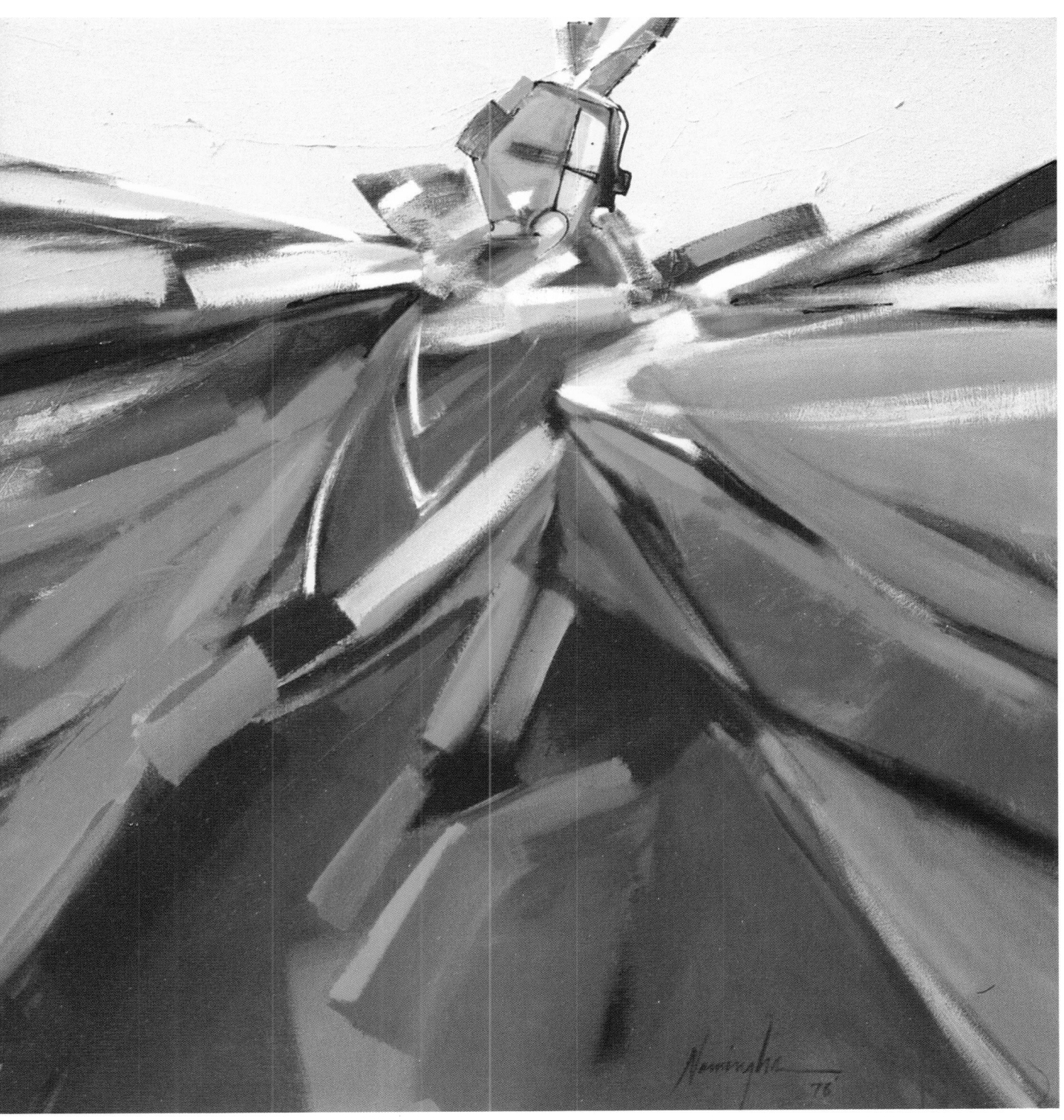

The explosive power and movement of a tribal dancer is beautifully captured in this abstract painting. The artist has employed bold and spontaneous brushwork coupled with the pictorial energy of dynamic diagonal thrusting shapes to capture the quality of kinetic movement. Notice how the facial details of the dancer are simplified in deference to the motion lines that give this painting its vitality. Namingha's imagery stems from keen observation of tribal customs and rituals: "My big inspiration has always been based on my tribes, the Hopi and the Tewa. . . . All my ideas evolve from that heritage, and from the things I have seen and experienced. . . . As for the abstract nature of my paintings, that comes from observation, too. Like many young artists, I am impressed by the work of early twentieth-century artists, particularly Picasso, Matisse, and Klee.

Create an Allover Energy Field

Allover painting is a term for an art style that developed as an offshoot of the early 1950s "drip" paintings by Jackson Pollock. In this method of abstract painting, the figurative image is abolished in favor of a fairly uniform textural field that is established by juxtaposing and overlapping patches of color, color dots, or squiggly lines. As critic Lawrence Alloways puts it, "The whole picture becomes the unit."

In *New Art Around the World*, Sam Hunter describes Jackson Pollock's allover painting style in these terms: "Pollock's open drip paintings cancel pictorial incidence in a field of uniform accents. As disrupting image fragments were submerged, the overall effect of the painting gained importance. The entire evenly accented painting achieved a single effect, or totality, and arranged itself in the eye of the beholder as one palpitant, shimmering whole."

Although Georges Seurat's pointillistic paintings are figurative and not considered allover patterns, their surface textures nonetheless are synergistic and of much interest to the field painter. These color-dot patterns are made to throb with energy as disparate hues "mix" optically in the eye of the viewer. Van Gogh was aware of this quality, too, when he spoke of "the mysterious vibrations of kindred tones." As well, many of Paul Klee's compositions are dynamic energy fields.

The idea of using "broken color" (as opposed to continuous tone) to produce optical mixes was dubbed *divisionism* by Paul Signac and is an effective compositional device used by impressionist and neo-impressionist painters. A close examination of the surface textures of such paintings, as well as those of contemporary "field" painters, is helpful in preparing for this experiment.

To start your experiment in allover painting, select a motif or an idea you think is suitable to this style. Subjects from nature, for example, such as a field of wild flowers, herbage or vegetation, seed patterns, galactic swirls, atmospheric patterns, micro- or macrocosmic views, or nebula patterns would make ideal motifs, as would energy-event themes such as "Cosmic Event," "Radiance," "Fusion," "Fission," "Life Force," "Transcendance," "Luminous Particles," "Molecules in Motion," "Energy Flux," etc. The idea here is to apply a systematic process of juxtaposing dots, flecks, or squiggly lines that will produce a pulsating energy field—one that will "snap, crackle, and pop." The forms and colors should be spread more or less evenly over the entire picture frame, filling it up to the edges, with little special focus.

On a stretched and primed canvas, dab the acrylic colors with a bold brush; apply the paint directly over freshly primed surfaces in areas that have been previously underpainted to create a rich textural field. Control the pictorial quality of your energy field by using passages of brilliant and saturated color on an otherwise monochromatic underpainting, by suggesting a flow pattern of several disparate energies in counterpoint, or by suggesting an underlying invisible grid. You may also consider implanting a cryptic, or latent, image within the overall camouflage.

CELEBRATION, BIRTH
by Richard Pousette-Dart, 1975–76, acrylic on canvas, 72" × 120" (182.9 × 304.8 cm) Courtesy Marisa del Re Gallery, New York.

This minutely textured allover painting is a dynamic energy field. Its mosaiclike surface works as a total unit, yet there are small special areas of focus and differences in textural rendering to lend variation. Depending on the viewer, the subject matter or "meaning" of this painting may be interpreted in many different ways. Is it simply a decorative surface texture or something more—an artist's interpretation of a rich, colorful field of wild flowers? A symbolization of cosmic or spiritual energy? A metaphoric allusion to a mysterious liturgy or manifestation? Does it hide a cryptic presence? A latent image? In speaking about his work, Pousette-Dart further challenges our perception: "Art lies behind the cloth of surface things; it is always deeper than appearance and must be delved for. . . . We must learn to look past titles. Real painting is untitled and unsigned, it is a flower of its own self."

Emphasize Texture

Perhaps the reason texture holds such a special fascination for the artist is because it offers a direct sensory contact with the environment. We touch things in order to fully understand the nature of their shape and surface. The tactile sense—more than any other—is the one that informs us of the physical nature of objects in our environment. This information, of course, can be translated emotionally and intellectually to produce a painting or a graphic artform. In this way, perceptual knowledge, gained firsthand through physical encounter, is paraphrased by the production of visual textures.

Visual texture is often only an illusion—a trompe l'oeil effect produced by careful observation and precise drawing. Such textures have little or no surface "feel" or tactile property. They are produced by controlling the form/interval relationship between marks and spaces that establish visual density.

Through careful use of texture, the artist portrays shape and surface qualities, establishes spatiality, and embellishes a composition with an enriched surface. Texture can also be used to heighten emotional response to a work of art. This is accomplished by emphasizing or changing the textures observed in nature—or inventing new ones from pure fantasy.

The painter—particularly one who works from photographs—is interested primarily in the accurate perception and rendering of the specific shapes which make up textural fields. He or she employs mainly optical, rather than tactile textures—an approach that we'll use in this experiment. (This approach is not to deny you

the pleasure of working with impasto textures, but to arbitrarily separate tactile texture and visual texture into two separate classifications in order to deal with them in separate experiments.) So, for the time being, ignore heavy impasto and concentrate solely on the creation of optical texture.

For this experiment, work directly or indirectly from nature. Either take your art materials outdoors and work directly from a selected subject, or work from an original photograph that you have taken. As you develop your painting, carefully analyze your subject to determine the small differences in the figure-ground relationships that make up its texture, as well as the differences of tonality and color.

Strive to create a composition that exploits surface and texture. Emphasize, simplify, stylize, and paraphrase the observed textures in nature to suit your pictorial needs. Invent new ones from your imagination.

Depending on how closely packed you make the components of a texture, they can appear either as coarse patterns or pulsating energy fields. Op artists, for example, produce paintings which are, in fact, highly unstable visual fields. Such textures bombard the optic nerves to produce vibrating, disturbing, and even hypnotic effects. Proximity also affects your perception of texture. A texture that is coarse up close can appear smooth when seen from a short distance. Also, tightly woven textures do not "flicker," from a short distance they appear as continuous tones. Using crosshatched tiny brushstrokes produces this tightly woven look as well as the effect of continuous tone.

THUNDERHILL
*by Ivan Eyre, 1979, acrylic on canvas, 56" × 64" (142.3 × 162.7 cm).
Photograph courtesy the artist.*

With the exception of the sky, all of the areas in this landscape are textured, producing a rich, visceral effect. Eyre's emphasis is on the interplay of textural fields, which he uses effectively to paraphrase the proliferate vegetation found in nature. The view from the artist's studio, set in rural Winnipeg, Canada, provides him with ample inspiration, yet this painting is a composite of many observations and *memories of the Canadian prairies. Notice how the composition appears both spatial and flat; although the artist employed overlapping planes and diminishing size—two standard pictorial devices to create spatiality— he effectively compresses pictorial depth by the generous use of pronounced color and texture shapes that are both near and far from the picture plane.*

Use Only Black and White

Because we live in a chromatic world and are constantly saturated with color, the confrontation with anything black and white is immediately arresting. Pablo Picasso realized this in painting *Guernica*, as did cinematographer Alfred Hitchcock—the master of mystery and suspense—whose most memorable films were often black and white. Both men were ingenious explorers of black and white as a vehicle for creating dramatic moods and arousing passions and emotions.

Black and white is the strongest of value contrasts. Black possesses in the highest degree the property of light absorption, while white—its polar opposite—transmits all the rays of the spectrum without absorption. Together, they make a powerful duo.

Chiaroscuro, the art of light and dark, was masterfully used by Albrecht Dürer, Michelangelo, Rembrandt van Rijn, Giovanni Piranesi, Andrea Mantegna, Pablo Picasso, and the Chinese and Japanese brush artists. There are many contemporary artists, too, who have produced exemplary achromatic works. Among them are Franz Kline, Maurits Escher, Gordon Onslow Ford, and Richard Pousette-Dart.

Why paint in black and white? Pousette-Dart, who has recently returned to the use of achromatic color in his paintings, answers: "I've gone to black and white because of my need for an intensity, the most intense light and the most intense darkness—and the instantaneous balance between opposites." The master colorist, Johannes Itten, told his students, "The painter's strongest expression of light and dark are the colors white and black. . . . Their effect should be thoroughly studied, for they yield valuable guides to our work." Removed from the seductions of color, the artist who works solely with black and white turns his or her full attention to elemental issues: the control of chiaroscuro and a fuller understanding of white-gray-black gradations, achromatic patterns, textures, and figure-ground relationships, as well as the psychological use of light-dark contrasts for stimulating emotional response.

Try an experiment using only black and white. Paint *all* the shapes in your composition with either black or white paint—don't intermix the colors to produce gray. The illusion of gray can be produced, however, by juxtaposing black and white dots as in pointillistic art. In this approach, emphasize pattern, alternating shapes, and strong contrast. A second approach is to use black and white, plus a range of intermediate grays by mixing the two colors. In preparation for painting, to save time, mix the grays ahead of time and store them in lidded containers until ready for use.

Paint your motif in the style of your choice. Apply the acrylic colors on the canvas with any technique presented in this book. Some options are free brush, brush and masking tape, painting knife, roller, squeegee, sponge, or airbrush. Thick achromatic impastos can be made by mixing the black, white, and gray colors with acrylic modeling paste or other fillers (such as Rhoplex and fine sand) and troweled on the canvas with a painting knife. Another way to apply the acrylic color is to extrude it from a plastic squeeze bottle (see technique experiment 10), a technique that produces a raised line or dot pattern. A preliminary sketch made on paper will help you visualize your work in preparation for painting on canvas. For this purpose, try sketching with a combination of pencil and acrylic washes.

MIRROR OF DARKNESS AND LIGHT
by Richard Pousette-Dart, 1978–80, acrylic on linen, 80" × 40½" (203.2 × 102.9 cm). Courtesy Marisa del Re Gallery, New York.

Heavily impastoed contrasts of black and white acrylic are used to create this contemplative painting, which at once seems to radiate explosive energy and yet, paradoxically, quiet tranquility. Pousette-Dart is a painter of "mystic abstractions." Critics have described his work as enigmatic and—like those of Rothko—having stimulating hypnotic effect. Critic Donald Kuspit describes the works as "shapes that seem at once embryonic and geometrical, organic and abstract." According to Jungian psychologists, the circle and the square are the original symbols of man and, essentially, the basic symbols of the world. Accordingly, such shapes have been symbolic of man's quest for spirituality and inner vision. Pousette-Dart's painting is beautifully crafted technically. Shimmering paint surfaces are created with many applications of heavy, Braille-like impastos of thick acrylic pigment—a technique that effectively transforms the painting into the realm of bas-relief sculpture. The artist meticulously worked the surface—black carefully textured over white, and vice versa—until the form and texture "worked."

Let One Color Dominate

Dominant color—like other forms of pictorial emphasis—plays an important role in art and design. Fundamentally, it is used as a form of visual punctuation, as well as a unifying factor to establish a pattern of prevailing hues and sequences. The "temperature" of a painting—its hot/cold polarity—is also established by color dominance, as is the painting's subjective timbre and mood. An important determination that an artist must make in working with color is the establishment of a hierarchy—or "pecking order"—of color relationships. In this regard, the use of dominant hue tends to establish pictorial concord and harmony.

Rembrandt's famous painting, *Man in the Golden Helmet*, is an example of the effective use of dominant hue. By emphasizing tones of golden-brown, which are varied by sharp value contrasts, Rembrandt achieved a dramatic, yet unifying effect. Also seen in this painting are small patches of bright yellow paint, which serve as accents of sharp contrast to the overall brownish tones.

Picasso's "blue period" paintings are also excellent examples of the use of dominant color. In that series, Picasso imbued his paintings with an overall bluish tone to achieve dramatic effects, as well as a subjective quality, which, for the most part, emphasized a melancholy mood. El Greco, too, used color dominance to stir up passions. Rather than employ local color—the actual color of a subject—he abstracted color to heighten the subjective character of his work. By emphasizing and exaggerating color to meet the *psychological* demands of his theme, his paintings are able to elicit profound emotions. El Greco's palette of cold hues—grays, grayish-blues, and blues—was often modified with strong value contrasts to bring forth the feeling of "tormented spirituality," further emphasized by his drawing style.

Remember, that colors—like sounds—are "orchestrated" in terms of proportion, movement, contrast, and intensity. In this regard color is synaesthetic—having properties that stimulate other senses. As Karl Gerstner, the contemporary Swiss color theorist puts it, "Visual harmony is obtained through the process of organizing 'color-sounds.'"

For this experiment, select an appropriate motif and then make a comprehensive line drawing. Transfer the drawing to a prepared canvas and select a palette of colors composed of only cool or only warm hues—*plus* the value variations that are achieved by mixing white, black, and/or gray with them. Emphasize a single color to create a dominating effect, such as blue, for example, and allow the contrasting color—in this case, orange, to act in a minor role as accent and counterpoint.

The idea here is to employ variations of the dominant hue, along with permutations of analogous hues (colors adjacent to each other on the color wheel). Remember, if your design begins to get overly cluttered, one way to rectify the situation is to simply apply a glaze of a single color over the entire composition. For example, by applying a thin glaze—such as a transparent blue—over discordant colors, an integrated effect is instantly achieved. (You can preview the effect by viewing the painting through blue cellophane.)

Keep in mind that there is no single, "correct" way of using color; any way that "works" for you—and satisfies the representational and emotional demands of your subject—is a correct way.

WINTER MIST
by Edward Betts, acrylic on canvas, 1969, 40″ × 50″ (101.6 × 127 cm). Courtesy Midtown Galleries, New York. Photograph by O. E. Nelson.

This canvas demonstrates an effective use of dominant color. The large area of blues dominate yet are crisply accented by smaller contrasting patches of red and yellow. Using a limited palette of primary hues, the artist effectively captures the phenomenon of energy in nature, while maintaining a freshness and spontaneity in his brushwork and color handling. The predominating cool tones progress from deep to light ultramarine with touches of blue-green.

"The list of specific colors in any color scheme is not really as important as the proportion of those colors to each other," comments the artist. "If all colors were used in equal amounts, I cannot imagine that the color relationships would be at all interesting—nothing more than a checkerboard of colors in which each tends to cancel the others. It is necessary, therefore, to decide which one or two will be the dominant color or colors, which two or three will be subordinate, and which one or two will serve as minor color accents."

Emphasize Achromatic Hues

Achromatic hues—colors possessing very little, or no, chroma—give the artist a special way of controlling the spatial dimensions, atmospheric effects, and mood set in a painting.

Since color is derived from light, and the quality of light is constantly changing during the passing hours of the day, a landscape setting is kinetic insofar as it constantly presents different views. The painter interested in capturing the atmospheric qualities of landscape must be an early riser and be prepared to capture the special effects and poetic qualities in nature in adverse weather or in misty or dim light.

In this exercise, choose a landscape motif that you think will be a good subject for an achromatic painting. Work either in "plein air" (directly from an outdoor subject) or from a good black-and-white or colored photograph. Start by making a few exploratory sketches in pastel to establish the image, general composition, and color.

Do the painting in two stages: grisaille and glaze. First, paint the underpainting in grisaille (an achromatic rendering done only with black, white, and gray acrylics). Use this limited palette to establish the fundamental shapes and forms of the composition as well as its basic value and spatial relationships. In the second stage—glazing—the gray grisaille is literally "brought to life" by overlays of thin acrylic glazes. Make the glazes by mixing acrylic colors with water and polymer medium and brush them over the surface as many times as deemed necessary. To give the painting only a hint of color, apply just a few glazes, but vary the effect of color by making a few smaller areas brighter by applying more and brighter glazes. Apply them with smooth sable brushes, with the canvas flat on a table.

Another way of creating an achromatic painting is with an alla prima technique: Mix very small amounts of color with titanium white or gray acrylic color to obtain a muted color and paint directly on the canvas with thicker paint in a "wet-into-wet" style. (Premix different tones of gray and store them in lidded containers for this activity.)

To achieve natural color progressions as seen in the overlapping atmospheric planes in nature, paint with muted analogous colors. Make soft, achromatic hues move in sequential progression, such as the consecutive growth of yellow-green, green, blue-green, blue, blue-violet.

For a moody or surreal effect, glaze the grisaille painting with any color that is not normally associated with the motif in real life. Exercise your "poetic license" to transform an ordinary setting—and make it extraordinary—by "subjectifying" its normal color.

MENDOCINO COAST
*by Martha Borge, 1977, acrylic on canvas,
36" × 48" (91.4 × 121.9 cm). Courtesy the artist.*

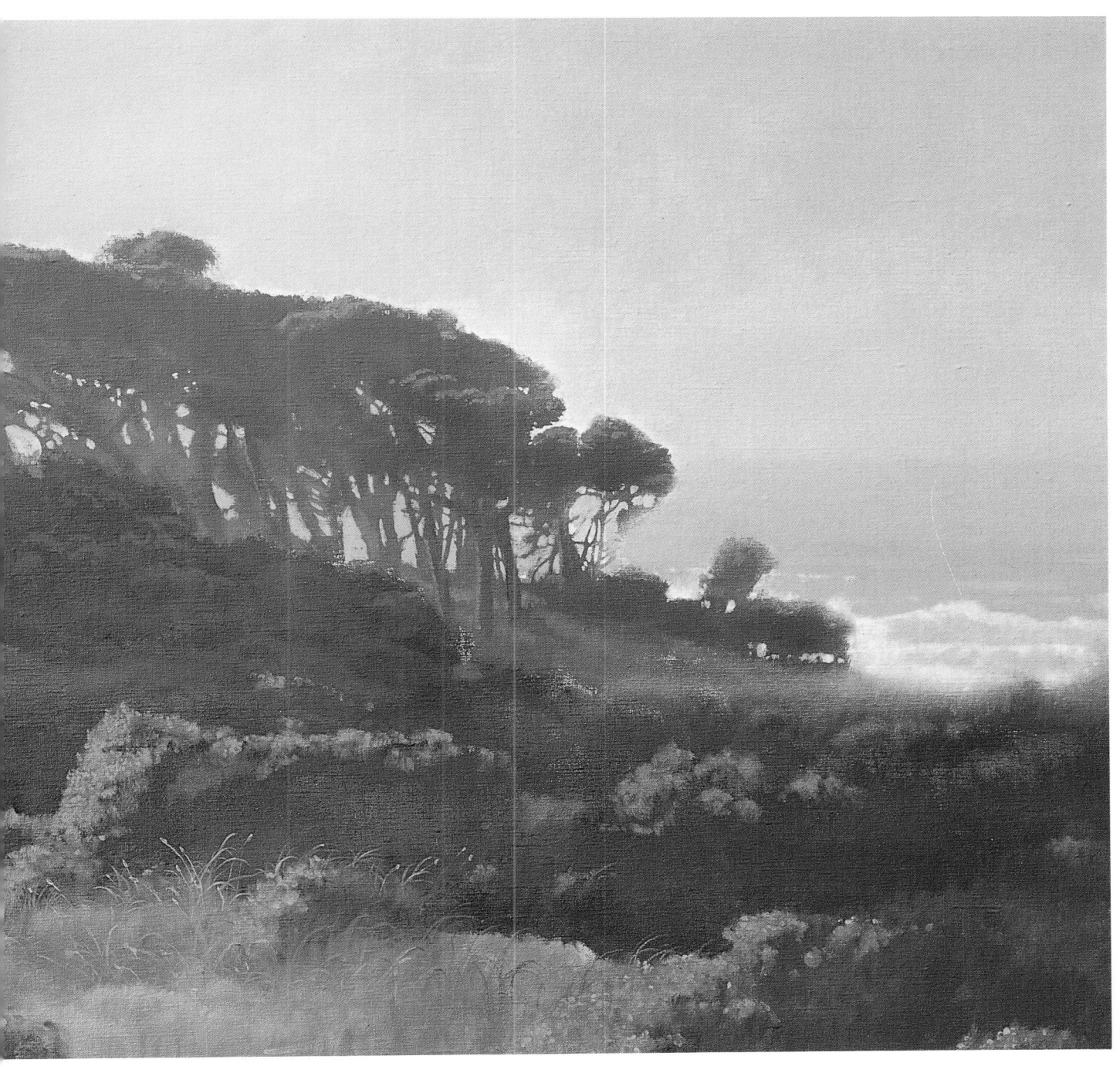

The subject matter of this painting is taken from a location along the rugged northern California coast. Soft, achromatic color is seen in sharp counterpoint to the rugged cliffs and pounding surf typical of this area. To best capture a dramatic quality of this beautiful landscape, the artist patiently waited for "just the right moment," when atmospheric conditions, light, and color suited her poetic vision. Says the artist: "This would be a time when the trees and hills can be viewed so as to get a haloed look, unusual color, long shadows, depth of form—or when the fog drifts in for an ethereal, achromatic effect. When I'm captivated by a particular scene I have to act fast because 'magic light' is fleeting. A beautiful light on some rocks—or raking over the tops of trees or a tree trunk—might disappear as fast as it appeared. So I begin immediately taking photographs, hike over the land if possible, and drink in the atmosphere. I take mental notes, do a few line drawings, and, in some cases, a small quick acrylic sketch. Back in my studio, I begin the real work of blending a beautiful scene into an abstract pattern, hopefully without losing the feeling that drew me to it in the first place. Some days I go out just to take pictures of clouds only or rocks or cows, or foreground flowers and grasses. My paintings are composites of many elements—the clouds of one day, the hills of another, together with the hemlock in the foreground of yet another location. My main goal is to have the essence of the general area dominate, but I use to the fullest the artist's liberty to make changes."

Let Color Flow

In my formative years, I remember a painting instructor once saying, "After the first brushstroke, the canvas assumes a life of its own; at this point, you become both governor and spectator to your own event." It is important for an action painter to establish a dialogue with the canvas, pausing regularly to contemplate what has happened, and what is possible. In this style of painting, major changes can be made at any time, and both rational and gut-level intelligence put to work.

Why is the phenomenon of free-flowing color so fascinating to us? Whether observed in a spectacular natural event such as the aurora borealis, patterns in oil slicks, kinetic light shows, or in the work of artists and designers, the effect is indeed captivating. Some writers explain that free-flowing color is the antithesis of life experience: Whereas life is jagged and bumpy, color-flow is continuous and, therefore, its effect is healing and nourishing.

Make a "flow painting" that exploits the fluidity of the acrylic colors. Explore a style of expression that features intuitive and spontaneous action, rather than calculated and cerebral effort. Make use of fortuitous events—happy accidents—yet govern them by aesthetic restraint. Start by making some preliminary sketches on paper in pastel to suggest compositions and general movements. Some of these sketches might be based on phenomena of nature: the ebb, flow, flux, sedimentation, evaporation, and capillary action that is constantly at work in the universe. Next, decide on the rules that will govern your physical action. In what order are the pours to be made? Which one is to be poured first? From which direction? Should the color be poured from only one side of the canvas, or from several? Should there be diagonal or radial pours? How about

the possibility of making pours only on the periphery of the pictorial area, leaving the central part of the canvas unpainted, or with a solid color? Also, think about the color scheme and its effect on the mood of the painting, as well as transparent/opaque relationships, dominant/subdominant themes, and sharp-edged versus soft-edged or mingled effects.

With some of these ideas in mind, start the action. Lay a stretched and gessoed canvas flat on the table or floor and begin the color-flow by pouring a color from a tin directly to the support. Then, tilt the canvas to maneuver the flow and direction of the color. Incidentally, much time can be saved by preparing the acrylic colors in advance. Thin them with water and polymer medium to a milklike consistency and store them in air-tight containers until ready for use.

While the paint is still fluid on the surface of the canvas, coax the rivulets and swirls of color into special configurations by using tools such as cardboard "squeegees," brushes, sponges, knives, or feathers. Continue the operation, alternately pouring colors adjacent or into each other. Try wet-into-wet, as well as wet over dry, or partially dry color. Timing, of course, is important. The elapsed time between pours determines to a large extent the quality of the edges and of the mingled effects. Remember, this is an "action event" that involves the larger body muscles, not just a wrist action. Get into it. Enjoy the phenomenon of flowing color!

Acrylic paints are water-based, fast-drying, and permanent—perfect for a spontaneous and impulsive painting style. Unlike oils, you can overpaint quickly, without the annoyance of long waits for the paint to dry. (You can make the paint dry even faster with the aid of a hair dryer.)

PHENOMENA:
SHADOWS OF THE EVENT
by Paul Jenkins, 1971, acrylic on canvas. 64" × 81" (162.5 × 205.7 cm). Courtesy Martha Jackson Gallery, New York.

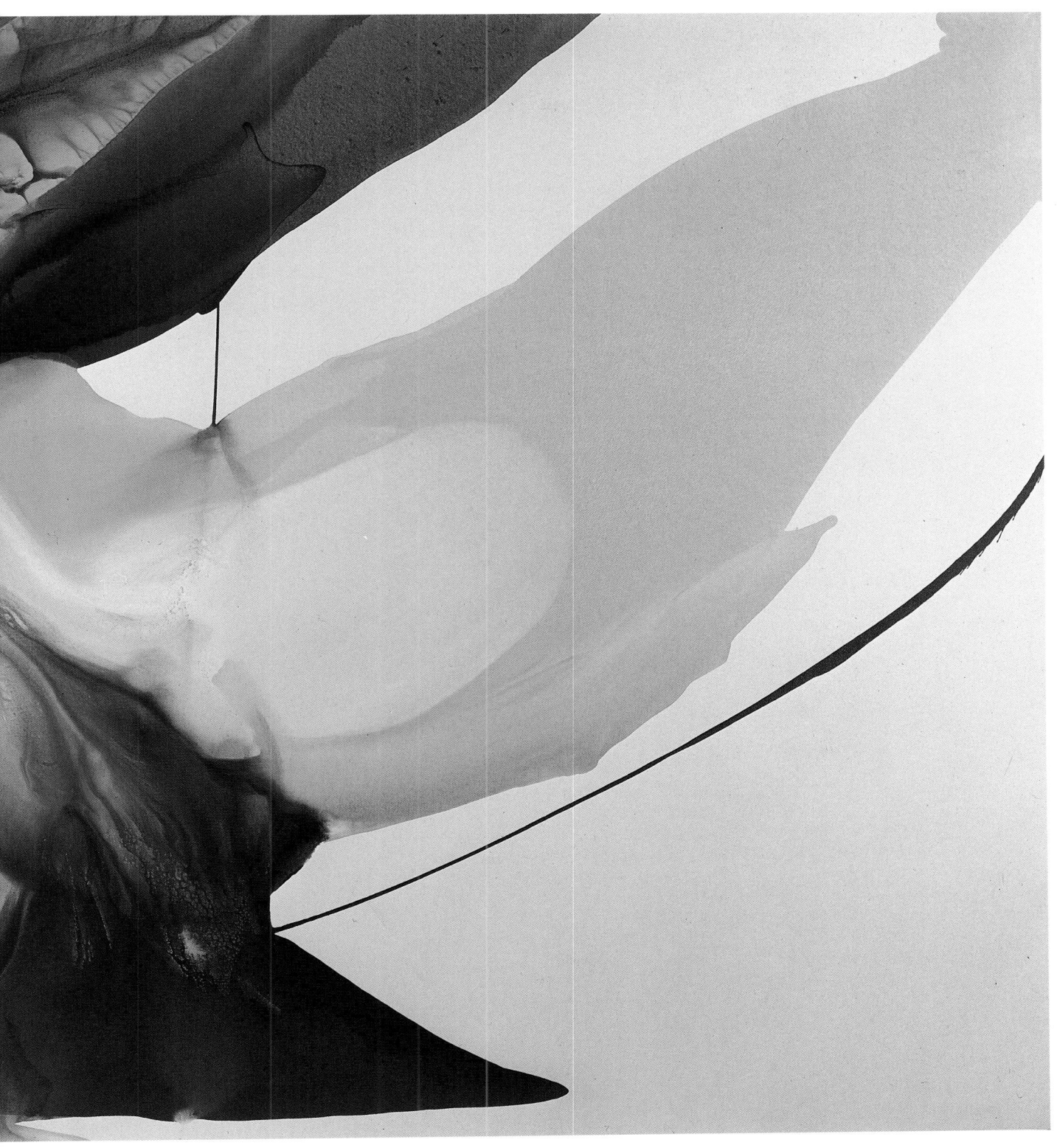

With precision and dexterity—and the canvas laid flat on the studio floor—the artist poured colors wet-into-wet, allowing the oozing hues to intermingle and create diaphanous forms. Transparent glazes were poured over dried surfaces to establish intermediate tones and surface lumi- nosity. In this action painting, the integrity of the medium—its fluidity and chromatic brilliance—is pre- served, as is the record of the painter's movements. After each pour, the artist lifted the edges of the canvas and directed the path of fluid color. With deft movements, he coaxed the wet paint to change direction, to form into swirls, rivulets, and billowy shapes. Without forcing the medium, Jenkins created delicate and sophisti- cated configurations by using an ivory knife, which he drew in front of the pools of color, leading them into specific directions.

Emphasize High-Key Color

Metaphorically, a painting can be said to have a "voice" or a phonetic quality. No artist understood this better than Francis Picabia when he said, "A line should have the vibration of a musical sound." Depending on the way in which line and color are used, a visual composition can be made to "scream," "speak" softly—or "whisper" quietly.

The diaphonics of music—the composition of aural vibrations—is similar to those in visual composition, but appeal to a different sense. In a cross-sensory representation, however, we can say that a painting is a composition of visual sounds." The use of contrasting, fully saturated hues (such as the juxtaposition of primary and secondary colors) tends to evoke lively and agitated effects, while tints (colors mixed with white) or shades (colors mixed with black) convey softer and more subdued qualities.

Remember that, as an artist, you have the power to control the "phonetic quality" and timbre of your painting. By controlling color, you govern not only these properties, but also the emotional effects induced by color.

For this experiment, work primarily with high-key colors, that is, colors that "whisper" and provide soft, quiet harmonies. These hues are the ones that have been elevated in value by the addition of white. Light colors can be further desaturated by the addition of gray. Of course, you can also use some dark tones and a few bright colors in your composition—but use them sparingly, and only as accents. Work in any style, from photorealism to nonobjectivism, but emphasize a soft, delicate—rather than a harsh and blatant—approach in the use of color. Have some of your colors "whisper" just below the level of pure white.

There are many ways to approach this experiment. One is to search for subjects that are naturally high key in color, such as sandy beaches, snowy landscapes, or a white-washed building on a Greek island. Or, you can take *any* subject and *reinterpret* its color qualities, "pushing" the normal (or local hues) into the high-key range. Another approach is to *subjectify* color, that is, to alter the "local color" (the

color we know objects to be) in order to imbue them with emotional sentiment. Examine the paintings by Marc Chagall—a master of subjective color.

Remember, acrylic paints have strong tinting properties, so only a very small amount of color should be added to white to produce tints. For a color that "whispers"—only a speck of a selected hue need be added to white. If you elect to work on paper, rather than canvas, and wish to use acrylics as a watercolor medium, dilute the colors with water rather than with white paint to produce the tints.

Capturing atmospheric effects was of major concern to the impressionist painters. As an example, Monet's sun-drenched landscapes, as well as the misty, atmospheric seascapes by Turner, and the sensual nudes by Renoir, rely heavily on high-key color for their poetic imagery. Monet perceived his subjects as "dissolving in form and substance" through the effects of light, while other painters simply used high-key color for conveying soft and delicate effects.

SPRING LATTICE
by George Woodman, 1982, acrylic on canvas, 60" × 50" (152.4 × 127 cm). Courtesy Haber Theodore Gallery, New York.

By combining interweaving patterns—both abstract and representational—with high-key color, the artist has produced a painting that effectively symbolizes sunshine, new growth, and the regenerative qualities of spring. The color scheme is made up principally of tints—colors mixed with large amounts of white. Notice that the busy movement in the composition is not violent, but soft and subdued, an effect produced by the

sensitive use of color. Warm tints are contrasted against cool ones, and the hues are kept close to each other in value—a technique that also contributes to the achievement of the subdued effect. Notice, too, how the artist has used gray, as well as white, to desaturate the color in selected areas. The overall use of high-key achromatic shapes is punctuated by small patches of bright reds and yellows.

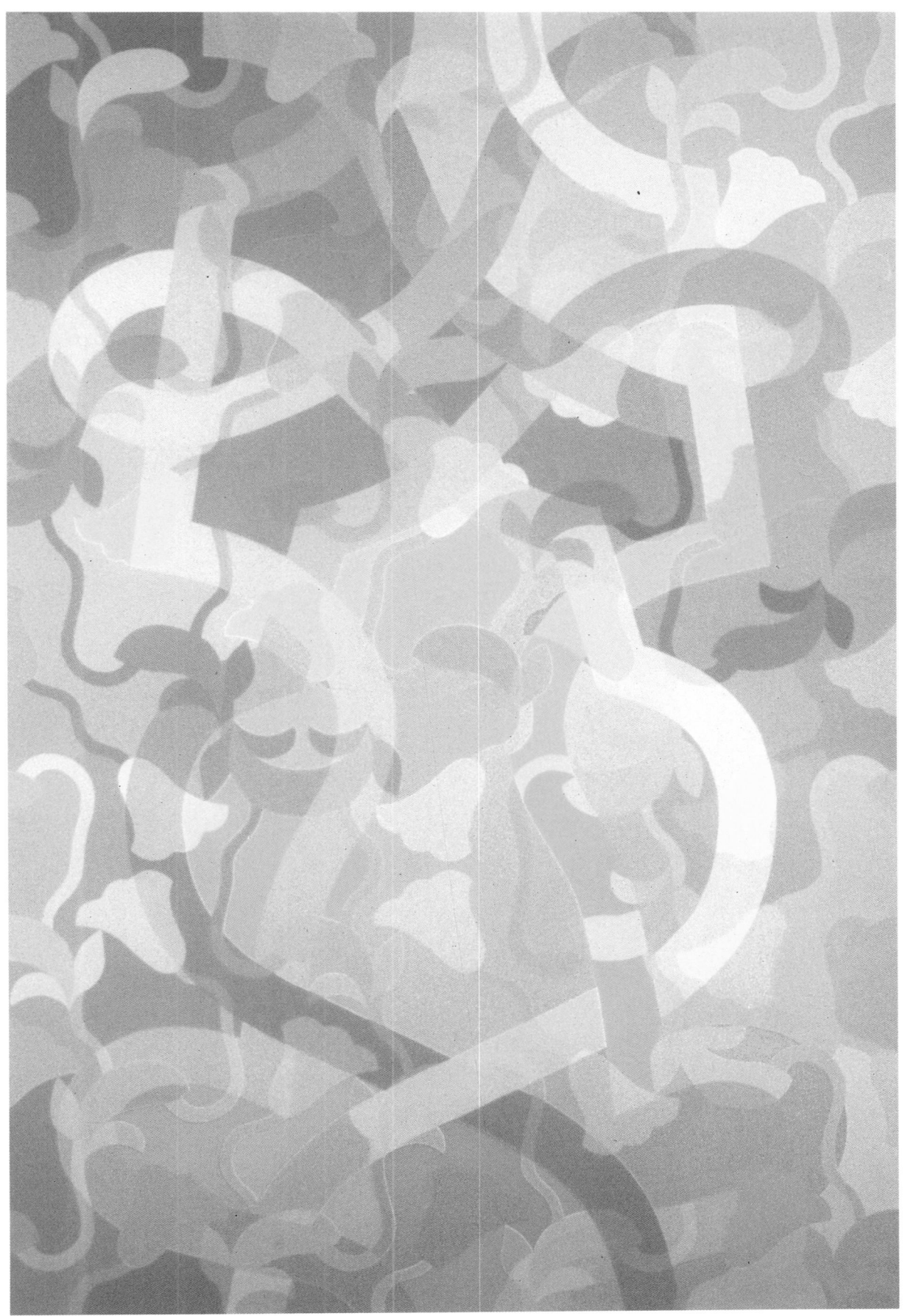

Reduce the Subject to a Simple Pattern

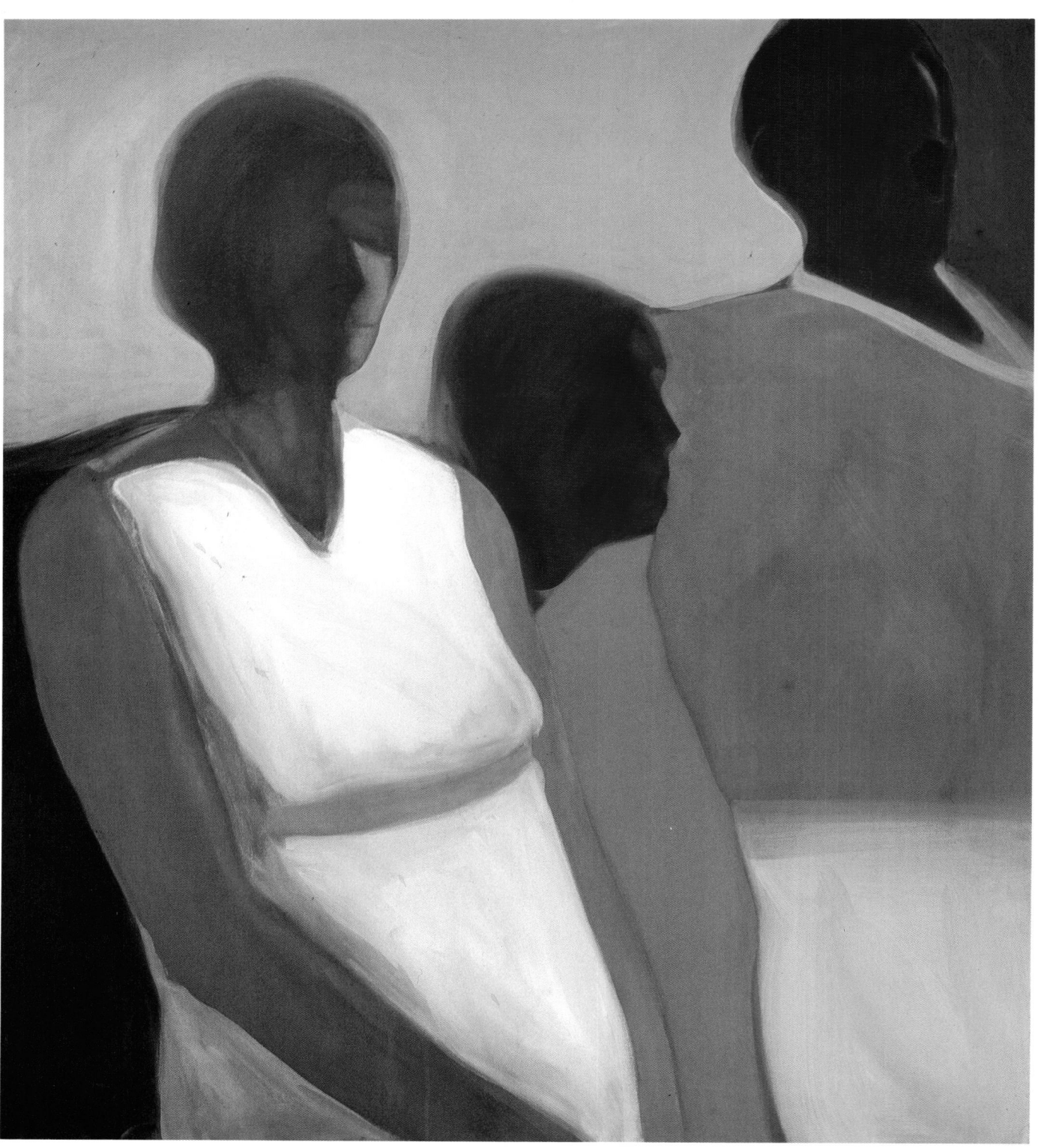

Oftentimes, it is more advantageous to "suggest," rather than "explain." Some of the most poetic and emotionally charged paintings have been created by using the greatest economy of means. The Scandinavians have an adage, "less is more," which is the key to their effective use of design. Remember, the camera records every detail. The artist, however, selects only the detail that is pertinent to his poetic vision. Thus, *reduction* is the essence of abstraction—as well as an important tool for creating aesthetic imagery.

Begin this experiment by making a figurative charcoal drawing on a stretched canvas that is lightly primed with acrylic gesso. As a motif, use an image derived from an original photograph or one acquired by drawing directly from life models. Another option is to draw from memory and then pose the life models as required to strengthen the drawing or to make corrections.

As you develop your drawing, break the images down to simple, uncomplicated shapes. At this early stage, it is important to provide a solid foundation for your painting by clearly establishing contours and values. Smudge vine charcoal over the canvas with a small piece of cloth to develop the chiaroscuro pattern. Endeavor to work out an interesting arrangement and variation of shapes as well as a good figure-ground relationship. Erase errors by wiping the charcoal with a clean cloth.

When you have a satisfactory drawing, isolate it with a spray fixative or mist acrylic mat medium (thinned with water) using an atomizer. You can also fix the drawing by dabbing it with a cloth saturated with the mat medium.

Get some good brushes to do the painting. Because this painting style calls for an aggressive approach, you'll need brushes that will take the punishment of the vigorous scrubbing and scumbling techniques. The brushes should be responsive to techniques ranging from transparent, semitransparent, semiopaque, and opaque application of color. The best brushes for this approach are bristle brights (short, square-ended), rounds (completely round with pointed shapes), and filberts (oval-shaped tips).

The first stages of your painting should be concerned with the application of color in thin, ephemeral washes. As you work, stop occasionally to contemplate the progress of your painting. A good way to get an objective look is to view the reflection of your painting in a mirror. The reversed image provides a fresh look and invariably allows you to immediately spot errors in composition. You can also assess the composition by turning the canvas upside down or on its side.

As you paint, remember to reduce the forms to essences and patterns and to emphasize color and value contrast, but to avoid detail. Stick with large brushes and use swift, free brushstrokes. Let the traces of the brushwork remain as an integral part of the surface. Maintain spontaneity by avoiding overworking the canvas.

To protect the surface of your painting, apply two coats of thinned acrylic picture varnish over the painting. This will also produce a uniform surface and brighten the color.

As research, examine the paintings by Edvard Munch and Pierre Bonnard along with works by contemporary artists Seymour Pearlstein, Larry Rivers, and Richard Diebenkorn.

NEW CANAAN
by William Kortlander, 1966, acrylic on canvas, 49" × 43¾" (124.5 × 111 cm). Photograph courtesy the artist.

By simplifying image, form, and pattern, the artist has created a painting with strong sculptural qualities as well as an arresting composition. The use of strong contrasts of color and value also contribute to the dramatic pictorial effect. Notice how each shape in the composition is treated uniquely, yet all are unified in the overall effect. "I work rapidly," the artist says, "and the abstract elements are important to me. As I paint, I make changes all along the way, painting out areas and drawing again over the painted surface until I have something. I do not paint from photographs, but increasingly, I work from a model, if only to have someone assume the pose of a figure that I have already established on the canvas. In this painting, I used simple contours and fairly abstract facial forms. The washes that model the faces worked well on the ungessoed canvas, which was primed only with a thin coating of acrylic mat medium."

Make Disparities Work Together

Max Ernst once said, "Creativity is that marvelous capacity to grasp mutually distinct realities and draw a spark from their juxtaposition." Naturally, a fertile imagination is the prime ingredient necessary for creative thinking. Yet, imaging—the power of the mind to form mental pictures—is really not constructive in itself. Only when the mind senses a relationship between diverse elements are ideas and metaphors conceived.

Mondrian said, "Everything is expressed through relationships." Long before Mondrian, however, the ancient Greeks had a special term for creative thinking: *Synectics*. Synectics means "the synthesis of disparities," or, in simpler terms, "making dissimilar things function together." Why is synectic thinking so important to the artist? First of all, it's a way of stretching the imagination. Second, it encourages parallel information-processing functions— the stuff that metaphoric thinking is made of. More importantly, however, it stimulates transformational thinking. Through synectics, for example, a painting composed of commonplace objects combined in a special way produces "a spark"—a synergistic reaction—in the mind of the viewer.

Synectics is a form of creative thinking; it's a way of symbolizing, subjectifying, and of transferring feelings and emotions to inanimate objects. According to psychologist Herbert Silberer, "the mind loves a puzzle," and when presented with seemingly contradictory input, immediately pops into "a subconscious search mode" to seek a resolution. In short, the mind, like a computer, mixes and matches new data with information already stored in the memory to produce unities. Buckminster Fuller said, "Everything can be linked together in some fashion, either a physical, psychological, or symbolic manner." Synectics provides the ways of finding "the links."

Let's apply synectics in this experiment. In a composition, combine four or five dissimilar elements that "spark an idea" or generate a visual metaphor. A good way to start is through collage. Make a preliminary collage, using disparate images and elements from magazine cut-outs, and/or original drawings and photos. Arrange and paste the images on a background paper. Next, transfer the design to a prepared canvas with the aid of a grid. In using the grid transfer method, first tape the grid (which has horizontal and vertical lines drawn on acetate) on the collage. The size of the squares may be 1″ square, but this depends on the size of the artwork. In pencil, draw the lines of the grid on the canvas, but enlarge the squares proportionately to the desired scale. Finally, carefully transfer the "visual data" observed in each square of the collage to the corresponding square on the canvas. (Another, faster method is to use an opaque projector. Again, tape a transparent grid on top of the collage and trace the projected images of both the subject matter and the grid lines.) In tracing the lines to the canvas, draw lightly in pencil, then spray the canvas with fixative in preparation for painting.

Set out a palette of acrylic paint according to the color scheme, and, again, scan the squares in the collage, one at a time, then transfer properties of tone, color, and texture from the collage to the canvas.

A NIGHT IN THE 40's
by Fred Danziger, 1984, acrylic on canvas, 48″ × 54″ (121.9 × 137.2 cm). Courtesy Rodger LaPelle Galleries, Philadelphia, Pennsylvania.

A vintage Wurlitzer, an old Victor 78 in a velvet-lined leather case, a trumpet and lace handkerchief laid out on a table, an all-night diner glowing in neon, an empty bench— these are fragments of memory brought together in the space of Danziger's canvas. Although the elements are disparate, in the mind of the viewer they fuse to produce a poetic metaphor of sentiment and nostalgia. Each image works synergistically with the others to produce an integrated overall design.

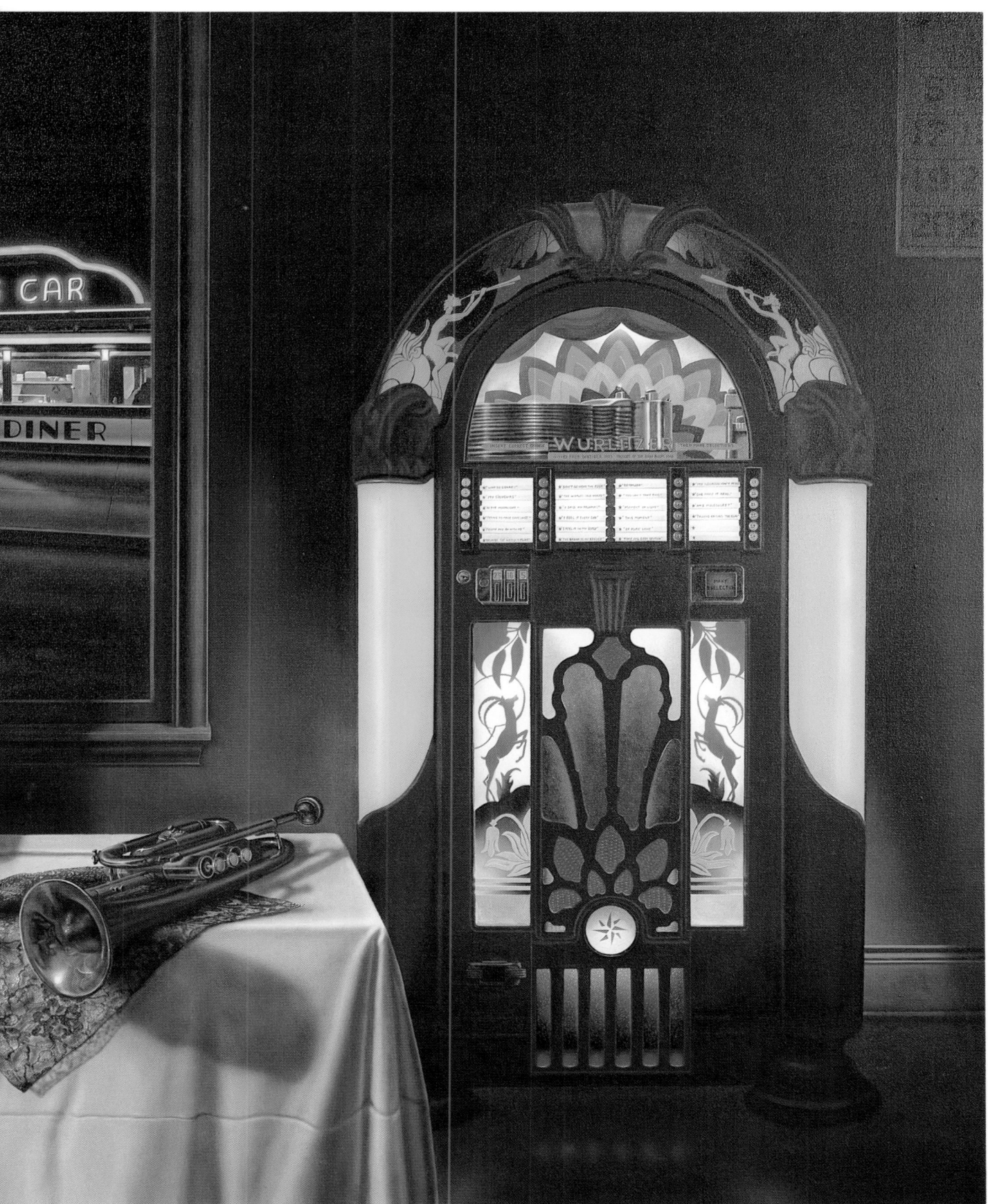

Abstract a Living Form

Throughout history, nature has been the artist's most dependable teacher, as well as a perennial source of inspiration. Tom Chetwynd writes in *A Dictionary of Symbols* that the transformations in nature—the way everything changes into everything else—reflects the inner processes of growth and transformation within our own psyche. It follows, therefore, that the artist who uses organic forms as a motif for artistic expression can aspire to aims beyond that of decoration, since such forms can act as powerful metaphors.

Begin this experiment by selecting an image of an invertebrate (a creature without a spinal column). Here, you'll find incredible living compositions of design and color in the configuration of beetles, butterflies, moths, bugs, spiders, mollusks, etc. Obtain a good photograph (preferably one in color) or a mounted specimen if you can get one.

Start by sketching some preliminary ideas in colored chalks or oil pastels on scratch paper to work out a three-part idea. Use free-association of drawing, thinking, and feeling in responding to the images and data that you have collected. Think of the image of the invertebrate as a springboard for a design adventure.

What kind of support should you use? Try working with acrylics on watercolor paper. Select a heavy-duty paper such as Arches no. 10 with a rough or a moderately toothy surface. Prepare it by first soaking it in the tub, then tape it down onto a drawing board or a

piece of plywood with butcher's tape. When it dries, the paper should be drum-tight and ready for painting. Draw light lines in pencil to divide the paper into three parts.

Acrylic colors are instantly transformed into a watercolor medium by simply thinning them with water and polymer medium. (A small amount of medium is mixed with the colors to maintain their adhesiveness. Mix the paints with enough water and emulsion to obtain a milk-thin consistency.)

Apply the fluid colors with soft-hair brushes, using standard watercolor techniques. Exploit the fluidity and brilliance of the colors and emulsion by experimenting with techniques such as staining, scumbling, and glazing. Incidentally, by adding white paint to your acrylic colors, you automatically convert them to an *acrylic gouache* medium.

Don't be afraid to scrub or scumble the color onto the paper with a bristle brush; the tough Arches paper will take quite a bit of abuse. For special effects, use a clean sponge or a cloth to wipe damp color from the support.

Remember, a real advantage in painting with acrylics is the fact that the color is permanent, allowing you to apply overlays of many colors without fear of "picking up" underlying colors. Plan your design in three parts—make a "triptych." This will permit you to portray your subject in some form of change or transformation—a metamorphosis of form and design.

TRANSFORMATIONS #5 (triptych) *by Jack Shadbolt, 1976, acrylic on watercolor board, 60" × 120" (152.4 × 304.8 cm), Courtesy Bau-Xi Gallery, Vancouver, British Columbia.*

The triptych format allowed the artist to present the image of the butterfly in terms of its exciting design patterns as well as its metaphoric implications. "I want people to think about beauty and freedom as opposed to machinelike constrictions. I felt I could give the butterfly new relevance as a symbol for these ideas." The acrylics provide an expressive watercolor medium: delicate, free-flowing colors are made to work in counterpoint to vigorous scumbled impasto and opaque gouaches. The energy and action of the artist—as well as his concept—are strongly communicated through this painting.

The butterfly motif was first used by the artist after a holiday trip to the Swiss Alps, selected because of its inherently rich pattern and color—as well as for its latent metaphoric qualities. Associations of freedom, growth, and sexuality are common to this image yet Shadbolt maintains an ambivalent point of view. "I try to imbue my paintings with a deliberate decorativeness to keep them innocently neutral. If the viewer wants to dig for associations, that's fine."

Compose from an Artifact

Ideas for art come from many sources: nature, the man-made environment, materials, techniques, and, of course, the study of world art. Geographical and cultural differences play an important role in the kind of art forms and images that the artist produces. An often ignored, yet potent, source of inspiration for the artist is the area of crafts—particularly the study of cultural artifacts. An artifact is an object such as a tool, ornament, or utilitarian object showing human workmanship. Webster's defines artifact as "a product of civilization."

According to critics, artifacts (in the form of African sculpture) served as a pivotal force for the initiation of cubism. One of art history's most controversial paintings is Picasso's *Les Demoiselles d'Avignon,* painted in 1906–07. Art historian H. W. Janson says, "In painting this picture, Picasso used primitive art as a battering ram against the classical conception of beauty. The proportions, organic integrity, and continuity of the human body are denied so that the canvas resembles a field of broken glass." Picasso was introduced to African and Oceanic art by Matisse and often referred to this source of design in both his painting and sculptures. The influence of African artifacts is also seen in the works by Amedeo, Modigliani, Constantin Brancusi, and Ernst Kirchner.

For this experiment, select a cultural artifact as a design source—either an actual artifact found in an art museum or a photographic reproduction from a book or magazine. It could be a mask, shield, weapon, or a design from a utilitarian object such as a carpet or some form of wearing apparel. Analyze the object from many points of view. Examine its configuration, symmetry, and composition as well as the details of its ornamentation. You may choose to translate only a small detail from the object, say a decorative motif or special section, rather than the entire configuration. Pay particular attention to decorative glyphs, ciphers, and symbols, which are intrinsic parts of many cultural artifacts. The special shapes of such designs may well serve as the starting point for your composition.

Start by making some preliminary drawings based on the artifact's composition, pattern, symmetry, color, and ornamentation. Determine its original function. Was it a fetish or sacramental object, a trophy, a magic talisman, a fertility symbol, weapon, symbol of rank, memorial for the dead, or simply a household gadget? As you make your drawings, develop the image (or selected parts of it) in your own way; combine parts of the object with images of new associations, or use the patterns from the artifact simply as a means to create a new and unique abstract design.

Anthropologist Claude Lévi-Strauss says that mythology results from the combination of an object, plus a set of events. Although the original mythology of many artifacts may be obscure, it makes the images no less interesting to the artist. Their most important function is to provide "raw material" for the creation of an aesthetic structure and, in so doing, provide for the revelation of the artist's mythology.

VISIONS
by Dan Namingha, 1982, acrylic on canvas, 52" × 40" (132 × 101.6 cm). Courtesy Gallery Wall, Inc., Scottsdale, Arizona.

Kachina spirit figures are used as a source of design and metaphor in this painting. The Plains Indians personify these spirits in doll-like figures, which in turn are given to their children to help them acknowledge and bow to the authority of their tribal gods. Although this painting exploits the decorative color and design found in the Kachina doll, the expressionless and haunting images seem to contradict the festive color, presenting a disconcerting subliminal message. Naningha, himself a Hopi, uses the techniques learned from Western European and American art to portray an image of special concern—the loss of cultural beliefs. "Some Indian beliefs we still hold on to," he says. "In a sense these things are religious. But there's so much that we have lost of the Indian culture. One has to balance between the contrast of life on the reservation and the life outside."

The Kachina figures are interpreted in a loose and splashy manner, exploiting the fluidity of the acrylic medium. Notice, too, how the artist used graffito in wet color to add to the spontaneous effect.

Work Big: Paint a Mural

There are occasional reports of painters succumbing to "Gulley Jimson" syndrome. Gulley Jimson is the lovable, rogue-genius in Joyce Cary's novel, *The Horse's Mouth*, who considers every blank wall he sees as fair game for his mural-making obsession. Although his intentions were honorable, the results were predictably catastrophic.

If you're smitten by the mural-making bug, here are a few approaches to make your life easier than Gulley Jimson's: (1) Paint a mural on canvas in your studio, then contract an expert wallpaper hanger to install it for you at the wall site. (2) Paint a mural on off-stretcher canvas, then hang it from grommets as a "banner." (3) Paint a portable mural in your studio on several panels (such as a triptych format), on Masonite, plywood, or stretched canvas, then arrange for the transportation and installation. (4) If all else fails, paint a mural *directly* onto the wall site. This is probably the most troublesome approach because it often involves working in trafficked areas where you may have to deal with "helpful advice" from passersby. And unless outdoor sites are shielded from the weather, murals that are exposed to the elements won't last long. However, in the case of very large projects, it is virtually the only way to accomplish the task.

Painting on the site can also be a rewarding collaborative effort.

Mural painting presents two important challenges: (1) transferring the preliminary design to the required large scale and (2) preparing a suitable support.

The simplest way to transfer your design is by projection: Use an opaque, overhead, or 35mm slide projector for this task. The only disadvantage with this method is that you'll need a darkened area to work—which is not always possible.

The grid system is another method of enlarging and transferring drawings. To establish the grid use a snap line.

This device consists of a string that is pulled from a cannister of chalk; as you stretch the string across the wall and snap it, it leaves a faint line to aid you in drawing the grid.

When preparing for an indoor project, Masonite proves to be an excellent support for murals. Untempered Masonite panels are available in 4' × 8' sheets. (Don't use tempered Masonite because the oily additives within it may cause acrylic coatings to separate.) Make a frame backing for each panel with 2" × 2" pine. The rear of each panel should be reinforced with the wood strips placed approximately two feet apart and glued with a waterproof glue. Screws should also be used, inserted from the front and countersunk; don't use nails; they have a tendency to pop out later. Sand the surface of the Masonite lightly to develop a toothy surface. Then seal it with a coat of acrylic polymer medium followed by a coat of acrylic gesso. Fill the countersunk screws with acrylic paste and feather the edges of the joints.

To prepare a plywood support for your mural, select only the best grade of exterior-grade plywood paneling. (Thicknesses from ¼" to ¾" are suitable for murals). Make a frame backing for plywood as you would for Masonite. Prepare the surface by sanding lightly with fine garnet paper, then seal with a coat of acrylic polymer medium. Prime the plywood surface with acrylic gesso; to get a "mechanically clean" surface, apply thinned gesso with a spray gun, or carefully brush three coats of gesso (diluted slightly with water). Apply each coat from a different angle, sanding between coats.

Duck or linen canvas—in either a stretched or off-stretcher format—should be primed with three coats of acrylic gesso, diluted 1:1 with water in preparation for painting.

If you intend your support to be a painted plasterboard wall, no priming is necessary, provided the surface was originally painted with a nonoil base paint and that the surface is squeaky clean. On unpainted plasterboard, use a good commercial-grade latex primer. Masonry surfaces should be prepared with a primer designed especially for masonry surfaces.

SOCIAL SERVICES MURAL
(one of 3 panels)
by Robert McChesney, 1977, acrylic on plywood, 4' × 24' (1.2 × 7.3 m). Courtesy the artist.

This mural, one of three 4' × 8' × ¾" birch plywood panels, was painted in the artist's studio. Later, the panels were transported and installed at the wall site—the lobby of the Social Services building in San Francisco. Prior to painting, a small model was made to visualize the concept and design for the sponsoring committee. The mural symbolizes the integration of the races of mankind and serves as a gesture of welcome in this architectural environment.

R.P. McCHESNEY 1977

CONCEPT EXPERIMENT *15*

Paraphrase an Old Masterpiece

To a certain extent, the statement "art provokes art" is undeniably true. Sir Joshua Reynolds, the English painter, once said, "Nothing comes from nothing—invention, strictly speaking, is little more than a new combination of those images which have been previously gathered and deposited in the memory."

An artist can be likened to a relay runner who, although striving for individual excellence, is a member of a collective group of runners. "Progress" in art stems in part from the artist's knowledge of art history and the accomplishments of past masters who serve as exemplary role models and sources of inspiration.

There has never been an epoch in art history wherein artists—in some fashion—have not "borrowed" or paraphrased the work of their forerunners. It is, therefore, not an uncommon practice for contemporary artists to excerpt, translate or "reinvent" images from past art. The creative artist is constantly on the lookout for interesting subject matter and digs into art history, among other sources, to find it. Contemporary painter Robert Motherwell summed it up when he said "Every intelligent painter carries the whole culture of modern painting in his head."

Jean Lipman and Richard Marshall, authors of *Art About Art*, point out that the "art-from-art" tendency has been even more prominent in the last 30 years because of an expanded awareness and interest in art history by contemporary artists, particularly the American artist: "The American borrowings are direct and undisguised, reflecting a reliance on an interest in art

reproductions and photographic reproduction processes, and often display impudent humor, satire, and parody. Rather than camouflage a borrowed element in the total composition, and so obliterate any reference to its originator, the contemporary artist boldly uses the most recognizable quotations. He deliberately encourages the viewer to participate in discovering the genesis of the work."

In 1863, Edouard Manet painted his famous work, *Olympia*. Ten years later, Paul Cézanne "reinvented" Manet's masterpiece in a work that he titled *Modern Olympia*. Since then, there have been scores of artists who have paraphrased Manet's masterpiece.

For this experiment, select a reproduction of a well-known painting or sculpture and "redo" it in your own style. Transform the composition (or its style or technique) to suit your aesthetic inclinations. As you plan the work, think about the possibilities of creating new designs and compositions through the process of reinvention. For example, the reference work can be geometricized (paraphrased in terms of hard-edged shapes), cartooned, reincarnated in a mixed media format, or radically changed in terms of its component images to induce a time warp. Can you imagine, for example, the *Laocoön* group in black tie and tails? *Your* face as a substitute for Mona Lisa's? Or how about Minnie Mouse, as a stand-in for the nude figure in Botticelli's *The Birth of Venus*? Give free rein to your fantasy. Use "poetic license" to produce outrageous imagery and transformations.

OLYMPIA WITH DOG
by Paul Wunderlich, 1977, acrylic on canvas, 38" × 51" (97 × 130 cm). Courtesy the artist.

Although Wunderlich paraphrases the general pictorial qualities of Edouard Manet's Olympia, he has made several outstanding changes that radically transform the original masterwork. Notice, for example, how the artist has replaced the attendant maid in

Manet's work with the image of an artist, which is rendered in simple contour, and which identically matches the extracted image. Also, a dog—not present in Manet's work—is added in Wunderlich's version.

Hybridize the Subject

A *hybrid* may be defined as "an off-spring produced by the amalgamation (or mating) of two diverse and seemingly incompatible breeds or elements." Folklore and mythology abound with tales of grotesque beasts and half-human, half-animal creatures from dreams and individual fantasy. In ancient Egyptian mythology, there are accounts of zoomorphic gods who take the form of falcon-headed and jackel-headed figures. Greek mythology is a motherlode of hybrid creatures: centaurs, half-human, half-horse; the fabled Minotaur, half-human, half-bull; the Sphinx, a lion-headed maiden; Pegasus, the winged horse; the sirens, half-women, half-birds; the mermaids Aethra and Pleione; the snake-haired Medusa, etc. Fantastic hybrids are found in the myths of every culture and are excellent sources of design and inspiration.

There are many contemporary artists who have used hybridization as an effective way to subjectify and to present surrealistic imagery. Marc Chagall's famous painting, *The Juggler* (painted in 1943), for example, presents a central figure of a circus ballerina, a human figure hybridized with wings and the head of a birdlike creature. René Magritte also made extensive use of image hybrids. In his surrealistic paintings we see objects "in states of trans-mutation": shoes becoming feet; human figures turning to wood and stone; leaves becoming birds; a fish turning into a beautiful woman; and a bottle turning into a carrot. Salvador Dali and Max Ernst also produced fantastic imagery through hybridization.

In preparation for this experiment involving hybrid images, investigate the work of the artists I have mentioned, as well as that of science fiction illustrators. Among the most interesting is H. R. Giger, a European artist whose work has been featured in *Omni* magazine. Giger paints Cyborg figures—a hybrid figure that integrates man and mechanical support systems.

Here are some ways to start your experiment with image hybrids:

1. Draw from dream images. All dreams are surrealistic and made up of strange crossbreeds. Symbolically, they are representations of joy, aspirations, fears, and anxieties. Dreams are potent sources of imagery.

2. Draw from world folklore. Study and translate the mythological images; update them, turn them into a personal myth.

3. Draw from fantasy. Scientists tell us that in theory if we cut a bit of DNA from one organism and hook it up with a piece of DNA from another, a fruit fly and an elephant, for example, the result would be a new gene that never existed before in nature: Create a fantasy image from such imaginary crosslinks.

4. Draw from empathic projection, by relating emotionally to an object (whether it be a living or an inanimate thing). Combine images and establish an emotional metaphor. A sample approach would be to paint a portrait of yourself as an animal, bird, or inorganic object.

5. Draw upon the possibilities inherent in chance. Make up a list of common objects and divide it into two columns. Using a random choice method, connect the words from one column to those of the other. Create a composition based on an image that arises from such an amalgamation.

As you develop your imagery within the realm of hybrids, crosslinks, and transmutations, keep in mind that "creative disobedience" is the byword of the true artist. Avoid stereotypes and strengthen your intuition and personal fantasy. Although disparate amalgamations produce conflict, remember that conflict is an essential ingredient for creativity.

THE RED DOOR
By James Marsh, 1981, acrylic on canvas board, 20" × 16" (50.8 × 40.6 cm). Courtesy the artist.

The image of the cat wearing a "bird-mask" to lure its prey presents a laughable image. A bluebird, perched atop a milk bottle, appears to have detected the ruse, however, and is quite amused by the cat's ludicrous attempts at camouflage. Posing as if for the camera, the cat seems mesmerized, as if asked by the photogra-pher to "watch the birdie!"

"Although this painting has an air-brushed effect," says the artist, "I used only nylon brushes to do the rendering; no special techniques other than just brushwork are used: I thinned the acrylic colors with water only; the canvas board was primed with acrylic gesso."

Use a Comic Idiom

Cartoonist Grim Natwick made an incisive tongue-in-cheek comment when he said, "Although Rembrandt was a giant, in a way he was also short-sighted. For inspiration he reached into the clouds, but never learned to jump rope or play marbles—or laugh at clowns." With sincere apologies to Rembrandt, perhaps there *is* a lesson to be learned from this comment. In the majority, artists—like most dedicated people—tend to be workaholics and take themselves far too seriously to consider combining jocularity with "fine art."

However, we need to have creative people around who are willing to dedicate their labors to the philosophy of fun and humor, artists such as Paul Klee, Alexander Calder, Claes Oldenburg, Red Grooms, who in their own way supply us (and the art world) with a breath of fresh air.

What is the value of humor? Philosopher George Santayana explained it this way: "The world is a perpetual caricature of itself; at every moment it is the mockery and the contradiction of what it is pretending to be. But as it nevertheless intends all the time to be something different and highly digni-fied, at the next moment it corrects and checks and tries to cover up the absurd thing it was; so that a conventional world, a world of masks, is superimposed on the reality, and passes in every sphere of human interest for the reality itself. Humor is the perception of this illusion."

With Santayana's thought and the comic idiom in mind, turn to your studio work. Set yourself a problem such as this: Create a comic mythology—a humorous scenario in a cartoon style—which in some way parodies or lampoons our social, political, or work ethics. Or, as an optional approach, use the comic idiom in concert with fine art for sheer diversion—in a wacky slapstick style—done solely in the spirit of frivolity and fun.

Zero in on a theme such as, "The Movies," "Packaged Goods," "Better Life through Chemistry," "User-Friendly," "Liberation," "Urban Ritual," "Body Beautiful," "Arms Proliferation," "Toxic Dump," "Political Savvy," "Beauty Pageant," "Nine-to-Five," "Contemporary Art," "Cult Heroes," "Joys of What?" "Easy How-To," "Robotics," "Superstars," "High Tech and Microchips."

Develop a scenario in a "cartoon style." Start by making a preliminary sketch to work out an idea and then a full-size line drawing from which to do a painting. Incorporate "speech balloons" and text in your design, too.

Try this. Create an artform wherein all of the pictorial elements are painted on Masonite or plywood, then cut out each piece with a jigsaw and attach it onto a background support. Sand the wood cutouts (and the background panel) lightly with fine garnet paper, then apply a couple of coats of acrylic gesso to the surface in preparation for painting. Paint the design in bright, primary and secondary hues and black and white, as in comic-strip art. For textural patterns, stipple acrylic paint through perforated screens or stencils, as seen in the work of Roy Lichtenstein. Use a strong wood glue (such as carpenter's yellow glue) to attach each component permanently in place. Small wooden blocks can be used to elevate some of the cut-outs from the surface and from each other to emphasize the bas-relief effect. Add any materials that are required to complete the design, such as collage, wire, 3-D or found objects.

FISH DINNER
by Ronald Markman, 1981, acrylic on wood. 48" × 38" (121.9 × 96.5 cm). Courtesy Terry Dintenfass, Inc., New York.

Markman's painting is beautifully crafted. He carefully cut the wood shapes out with a jigsaw, sanded and painted, arranged and rearranged, until the final design pleased him. "Then I reluctantly glued all the pieces down." Markman's mythological kingdom is dubbed "Mukfa" and like our own cosmos, it is a place where things don't always go according to plan. Why the comic strip format? "I like pictures that talk. Besides, we need humor to get through life," says Markman. "I'm not referring to the foreboding humor of Harold Pinter or Samuel Beckett. I'm talking about slapstick—the humor of Charlie Chaplin, Laurel and Hardy, and the Marx brothers. In our technological society, everything has got to 'work.' In earlier days, things were different. Technology had 'human' qualities. It was uncertain, it sputtered, it bumbled along. I liked that, and I miss it." Aside from the comics influence, the artist also acknowledges art history, with particular reference to Braque, Picasso, and Miró, as well as inspiration from primitive and folk art.

Objectify a Fantasy

Mythmaking, from a contemporary viewpoint, denotes one's ability to generate any type of unique story. As critic Lissie Borden stated, the personal myth can function as an outlet for eccentric imagery, self-discovery, religious confession, or as a spiritual experience. Whether based on fact or bizarre fictionalization, mythmaking is an inherent part of pictorial narration.

For this experiment choose an image from a dream, a symbol from childhood, or a symbol that has special meaning for you and see what your imagination can do with it. With sketch pad and pencil in hand, draw a pastiche of images that, like a dream, narrate a personal story. Weave the images together, overlapping some and adding more graphic detail as required to produce a unified design.

The collage technique is a format consistent with the way dream images present themselves. Another way to go about producing the preliminary sketch for this painting is to paste together many separate drawings that, although unrelated, somehow work together in psychological unity. Work with flat patterns and simple images. Don't worry about perspective, shading, or rules of pictorial design. Try to work intuitively, and place the emphasis on the way you *feel* about the subject.

Use color emotionally. Paint faces blue, horses with pink polka dots if necessary to express personal sentiments and feelings. Simplify, exaggerate, and distort. Employ a cartoon style if you like.

To transfer the preliminary design to a prepared canvas, either draw the images freehand lightly in pencil, or transfer them to the support by using the grid or projection technique.

Remember, that artists who work in the subjective genre are both dreamers and producers; they think irrational thoughts but "nail them down" with rational thinking and technical skills. Creative daydreaming is a license to fantasize and think subjectively and to express "emotional realities." More importantly, it is a means of maintaining and using the power of childlike wonder and creative play.

PASTORAL SUMMER PLACE

by Roy DeForest, 1981, acrylic on canvas, 69 × 121½" (175.3 × 308.6 cm). Collection of Federal Reserve Bank, San Francisco. Photograph courtesy Hansen Fuller Goldeen Gallery, San Francisco, California.

DeForest's imagery presents a phantasmagoria of "hypothetical beings, situations, and worlds." Amalgamating techniques learned from art history and images from personal fantasy, he paints in a style that critic Hilton Kramer dubbed "Marx brothers Fauve," a pseudo-naïve, cartoonlike style. Influences of Paul Klee, Marc Chagall, and Henri Matisse are felt in this painting. DeForest is a witty painter who enjoys using strange mix-matches and hybridizations, along with bright, candy-color, crazy-quilt designs. Although there is an "off the wall" kind of imagery, the design was planned with consummate skill. A latent underlying grid serves to align the disparate shapes in the composition—an indirect allusion to the horizontal-vertical motif used by Mondrian. Color is used subjectively with maximum contrast and brilliance, achieved through complementary contrasts. Although the design involves the use of overlapping shapes, a shallow picture plane is nonetheless maintained.

Use an Assemblage as a Subject

Normally, an *assemblage* is created as an artform in its own right. However, for this experiment, its primary function is to mediate a photorealist painting. This modus operandi has a new twist, representing a technique developed and used by contemporary photorealists. Fundamentally, an assemblage progresses through three basic steps: (1) The artist creates the assemblage (which takes the form of a bas-relief sculpture in mixed-media); (2) the assemblage is then photographed and a colored transparency and print is made of the work; (3) the "visual information" from the photograph is skillfully transferred to the canvas.

Let's start at step one, which calls for the production of an assemblage. Depending on your theme, arrange and attach a variety of flat and dimensional objects (cloth, sculpted forms, drawings, photographs, "found-objects," etc.) on a plywood support. Perhaps no one has described the art of assemblage better than art historian William Seitz who said, "Like a beachcomber, a collector, or a scavenger wandering among ruins, the assembler discovers order as well as materials by accident—his raw material is the random assemblage of the modern world in which nature and man are thrown together in an often tragic and ludicrous, but fertile and dynamic disarray: the crowded city, the split-level, the suburb, the moon shot, the picture magazine, the summit conference, the TV western." In researching assemblage, examine the exemplary work by Joseph Cornell. His format is a unique artform, possessing mysterious poetic overtones.

Now the second step: photographing the assemblage. As any sculptor will tell you, the quality and direction of light is as all-important in creating sculpture as it is in photographing it. Be creative in the way you use light to photograph the assemblage. Try lighting it from different angles; experiment with both white and colored light sources. Just as a stage designer makes a set come to life with appropriate lighting, so must you bring out a dramatic quality in the three-dimensional sculpture. Experiment with different photography techniques; try different ƒ stops, use sharp and soft focus, change camera angles, try different camera lenses (use a normal, wide-angle, fish-eye, or telephoto lens), and use color (or special effect) filters to enhance the subject matter. In preparation for painting, have the photo lab provide you with contact prints. From the proofs, select the most suitable image and crop it, if necessary, to improve the composition. (Also ask your color lab to provide you with an 8″ × 10″ color print from the negative that you have selected. The print will serve as a color reference to execute the painting.)

Now you're ready for step three—to make a contour drawing on a prepared canvas. Place the color negative in a 35mm slide mount and project the image on the canvas. Make a light tracing of the design in pencil, then fix the drawing with a coat of polymer medium. The projection technique is a quick and efficient way to transfer designs to a support and is a fairly standard studio technique used by many contemporary photorealists.

SUNSET
by John Hall, 1979, acrylic on canvas, 44″ × 44″ (111.8 × 111.8 cm). Courtesy Wynick/Tuck Gallery, Toronto, Canada.

The artist first constructed the assemblage and used it as the subject for this photorealistic painting. Small in scale, the assemblage comprises a photograph, pieces of hardware, nuts and bolts, three-dimensional letters, fabric, and an artificial flower—all of which were assembled on a plywood base. A photograph of the assemblage—much enlarged—served as the subject for the painting. The surface of Hall's painting is completely flat, yet the illusion of spatiality is compelling, an effect brought about by meticulous craftsmanship. "I used an 8″ × 10″ colored print of the assemblage as a reference and started my canvas by isolating each area to be painted with 2″-wide masking tape, cut to the exact contour of each shape," says the artist. "The first stage in my painting is rough modeling, done "wet-in-wet," with thinned acrylic color. At this point, I restricted myself to only three values: light, middle value, and dark. It took three or four layers of color before I was satisfied to proceed to the next stage, which involved adjusting values and gradations and was done by scumbling color on the canvas—always light over dark. The initial colors and values applied to the painting were adjusted by overlaying them with acrylic glazes. The glazes were applied with sable flats, and the final highlights and details with a fine sable round brush. The surface of the painting has a soft, satinlike quality, produced by spraying it with a coat of clear acrylic gloss varnish.

Use Sharp-Focus Realism

Photorealistic painting demands meticulous attention to detail and extremely accurate drawing skill. The ultimate goal in this style of painting is to create a trompe l'oeil effect, which deceives the eye about the material reality of the objects represented. Actually, most contemporary photorealists don't work from nature at all. Their subject is the photograph, and the task, as they see it, is to transfer the "visual information" from the photograph to the canvas as accurately as possible.

Unlike an actual subject in nature, a photographic image is "flattened" by the camera and frozen in time. In his book *Photo-Realism*, Louis Meisel explains that for the photorealist, change and movement must be frozen to one second in time, which must be totally and accurately represented. If photorealist painter Richard Estes, for example, attempted to sit in front of a building and simply draw or paint what he saw, his field of vision would be frustrated by the constant changes; as he sat there working, the traffic would move, the light would change; even the reflections would change if he were to move a fraction of an inch. But, by using the unchanging image of the photograph as a subject, the artist "stabilizes"

his motif by freezing it in time.

Generally, one of two techniques is used to enlarge and transfer "visual information" from photograph to the canvas: direct projection or grid transfer. In the projection technique, an image from a 35mm slide is projected and traced directly on the support in preparation for painting. The second method, grid transfer, requires superposing a grid design drawn on clear acetate over a photographic print. The size of the grid pattern can vary from ⅛" to 1" squares, depending on the size of the photograph and the amount of detail required in the final rendering. The smaller the squares in the grid, the more precise is the detail that can be transferred. The next step is to grid the canvas with the same number of squares as there are in the gridded photo. Since these lines are only temporary, pencil them in lightly on the canvas. Here's an example of a grid enlargement: an 8" × 10" photograph gridded with a ¼" quadrille would have 1,280 squares. The larger, but proportional, 8' × 10' canvas would be gridded with the same number of squares, but each would measure 3" × 3".

The next task is an exacting, time-

consuming one and demands an infinite amount of patience. One by one, scan each square in the gridded photo and meticulously transfer the "visual information" from it to the corresponding square on the canvas. Here, you should concentrate solely on the technical problem of reproducing the visual information which, in fact, is the abstract pattern of shape, tone, texture, and color observed in each unit. Isolate the pencil drawing with spray fixative in preparation for painting. As you work with the acrylics, again refer to the master grid and transfer the characteristics of color and tone to the canvas. Work with flat sable or bristle brushes, but apply the acrylic color thinly. You'll notice that most photorealist paintings are not painted with thick textures, but have a flat, uniform surface. Use tiny crosshatched lines or dots over an *imprimatura*—a thin translucent layer of color applied over the ground and preliminary drawing—with fine sable brushes (nos. 1, 2, or 3) to achieve modeling and shading. Glazes can be applied over painted surfaces to further adjust the values and color relationships. If desired, apply a thicker impasto of light color in very small amounts to accent highlights.

FLOWERS FOR MOORE
by Michael Gorman, 1974, acrylic on canvas, 54" × 60" (137 × 152.5 cm). Courtesy Gallery Moos, Toronto, Canada.

Like most contemporary photorealists, Gorman uses the camera instead of the sketchbook for gathering visual information. Here he works from a montage of two disparate photographic prints as the source for his portrait of Henry Moore. With the exception of the sky, which is rendered in a stylized manner, the images of this composition are carefully painted from highly detailed photographs. Although attentive to the tedious and impersonal task of transferring visual information from the gridded photograph to the canvas, Gorman still considers himself a link to the past generation of figurative artists. "For me there is much to reconsider and discover in the work of the great European Masters and their tradition. We are far more bound up with this than it is fashionable to admit. I would like my work to bring together elements of classical painting with fresh insights thrown in by recent advances in color photography."

Combine Abstract and Figurative Motifs

Why combine abstract and figurative motifs? Aside from providing opportunities to create exciting visual compositions and metaphors, this style also offers possibilities to amalgamate objective and subjective imagery, as well as to integrate the irrational and surreal. From a technical standpoint, it offers a great opportunity to mix painting styles. For example, you can combine techniques such as scumbling, flat color, flowing color, pointillism, glazing, etc. Since there are no strict "rules" to govern experimentation, take full advantage of this format to express both intellectual concerns and intuitive feelings.

For this experiment, combine two opposing pictorial styles within a single format. Bring together representational and nonobjective design.

Here's a way to begin. Make a preliminary design for your painting by working with pencil and paper on translucent layout paper. On the first sheet, draw a representational image, then tape a second sheet of layout paper over it and draw the abstract lines, shapes, and nonobjective configuration. Continue the process, making as many overlays and drawings as necessary to complete your design. Finally, make a tracing of the composite image in preparation for painting. Another way is to combine collage and drawing techniques. In this instance, paste cutouts (photographs, photocopies, or photorealistic drawings) on a sheet of drawing paper, then work into the collage with colored pencils and chalks. Photograph the design with a 35mm camera and use the slide to transfer the image to a prepared canvas.

If you want to do an off-stretcher painting, stretch and tack loose canvas temporarily to a drawing board or a wall and prime it with gesso in preparation for painting. Project the 35mm slide onto the canvas and carefully trace the outline. The grid transfer system can also be used (see concept experiment 20).

Whenever an artist "throws in everything but the kitchen sink," there is a danger that an overly "fussy" composition will result. To counteract this tendency, establish some ground rules to govern your approach. For example, use a predominance of straight lines or curvilinear ones. Emphasize diagonals, or work out a counterpoint harmony between two principal elements, say the curvilinear and the angular. Use color subjectively. Select a color scheme based on design requirements or intuitive feelings. Remember, too, that any calculated plan should be flexible and subject to modification once you start painting.

Johannes Itten says in *The Elements of Color*, "Any calculated plan should not be the ruling factor. *Intuitive feeling* is superior to it; navigating the realm of the irrational and metaphysical is not subject to number. Deliberate intellectual construction is simply the 'conveyance' that carries us to the portals of subjective reality."

Examine the work of painters who have integrated geometric abstraction and figuration: Piet Mondrian (the "Flowering Tree" series, 1912), Georges Braque and Pablo Picasso (the period of analytic cubism), Marc Chagall, Theo van Doesburg ("Cow" series), Roy Lichtenstein ("Bull" series, 1973), as well as the works of Marcel Duchamp, Charles Demuth, Robert Delaunay, and Joseph Stella.

PAINTERLY CONSTRUCTION OF SAW
by Robert Hudson, 1980–81, acrylic and mixed media on canvas, 76" × 46" × 21" (193 × 116.8 × 53.3 cm). Courtesy Hansen Fuller Goldeen Gallery, San Francisco, California.

In this large off-stretcher canvas the artist combines two opposing pictorial styles—objective realism and geometric abstraction. Notice the unique integration of curvilinear lines and a pattern of overlapping shapes within the centrally positioned figurative image. The overall design is painted in a variety of studio techniques, which range from flat color to pointillistic dots. This painting goes beyond the amalgamation of pictorial techniques insofar as it also includes three-dimensional objects, which are attached to its surface. Notice how objects are even attached to the frame, a reference to Robert Rauschenberg's "combine paintings." The painting is also reminiscent of Bauhaus art, Dada, the pointillistic style of Georges Seurat, and the fragmented imagery seen in the 1950s paintings by Larry Rivers.

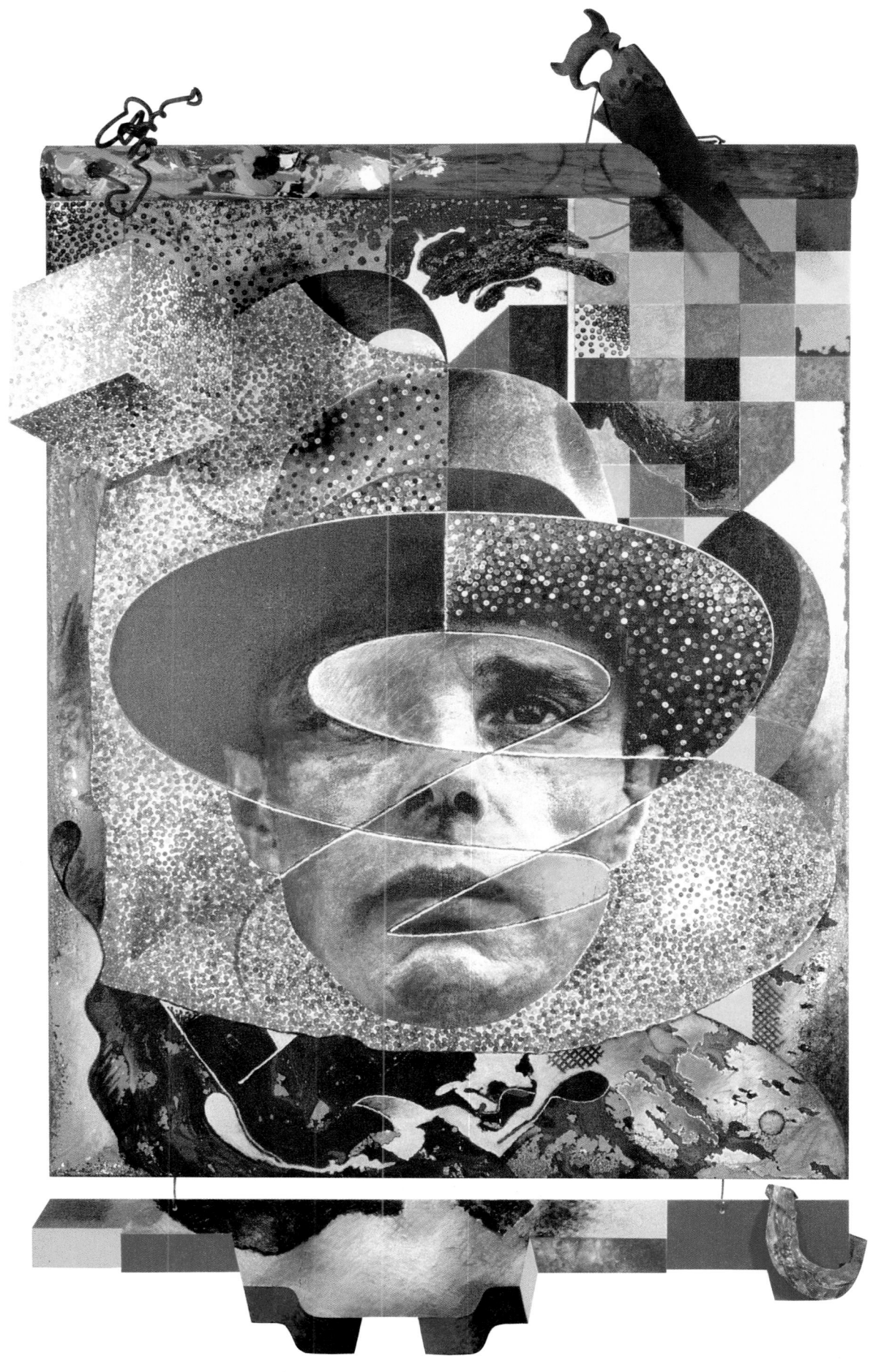

Create Ambiguous Space

The creation of ambiguous—or equivocal—pictorial space dates back to cubist art of the early 1900s. Picasso, Braque, and Gris, for example, ignored "rules of perspective" and other pictorial techniques handed down by Renaissance masters, and instead of following the established tradition of portraying deep pictorial space, produced compositions of shallow, flat, and seemingly contradictory spatiality. Their modus operandi included the techniques of reverse perspective, split and shifted planes, reverse atmospheric (color) perspective, and simultaneous presentation.

If you examine some of the cubist paintings carefully, you'll notice that tables and furniture are often rendered in "reverse" perspective—that is, rather than converging toward an imaginary vanishing point set within the picture, the lines appear to meet somewhere in the viewer's space.

Op art of the 1960s added further impetus to the fascination with ambiguous space. Josef Albers, Victor Vasarély, Richard Anuszkiewicz, Bridget Riley, and Larry Poons, were some of the artists who cleverly integrated optical illusion figures, moiré patterns, discordant color schemes, etc., to produce paintings with highly unstable visual fields. In many such paintings, the active patterns and colors produce perceptions that seem to "pop," "flip-flop," or "move." These ambiguous perceptions—or "visual kinetics"—are, of course, produced involuntarily in the eye of the spectator.

To use "reverse color perspective," the artist paints the background shapes in a painting with warm, rather than cool hues, and the foreground shapes with cool colors, thus reversing the psychological effect of color and effec-

tively "flattening" the picture plane. The use of a discordant color scheme further heightens the effect of pictorial instability. Johannes Itten, author of *The Art of Color*, describes discordant color as "simultaneous contrast"—the clash of color agent (the hues) and color effect (the perceived phenomenon). Itten bases his color theory on the principle that the eye "thirsts" for complementary color relationships. The theory is given credence by the fact that whenever one views a patch of a particular color, then looks at a white wall, the eye always produces an after-image of a complementary hue.

So, to use discordant color for the purpose of heightening ambiguous spatiality, the artist would avoid using complementary contrasts. Instead of using tones of blue and orange together, for example, he or she would place next to blue a color that is one or two steps away from it on the color wheel.

Let's put these ideas to work and produce a painting that exploits the concept of ambiguous space. Work within the following parameters for the sake of simplicity and focus: Use only geometric shapes. Use only *line* to delineate shapes and forms (no shading). Use masking tape to produce hardedged shapes. Use an isometric drawing technique to draw cubes (make preliminary drawings on grid paper or with the use of a T-square and triangle. Avoid linear perspective (perspective drawing with vanishing points). Paint the shapes with flat color; avoid modeling or shading. Use discordant colors.

To begin, make a line drawing on paper. Use a large sheet of drafting paper that will allow you to make tracings

and superimpose drawings. By superimposing drawings, you'll be able to produce composite designs that can be combined on the drafting paper and then transferred to the canvas. With a pencil, draw a variety of box shapes—squares and rectangles of different sizes and shapes. Manipulate some of the drawings by cutting them with scissors and rearranging them to form new relationships. Weave additional lines and shapes into the design to complete the composition.

Transfer the drawing to a prepared ground such as canvas or Masonite and prepare shapes for painting by masking them off with drafting tape. (Use either ½" or ¼" masking tape, depending on the complexity of the design.) Burnish the inside edge of the tape with the handle of a brush to insure that the acrylic color will not seep underneath. A coat of polymer medium can also be applied over the inside edge of the tape to further insure against color seepage and guarantee the production of crisp, hard-edged shapes.

Mix the acrylic colors with very little water and polymer medium; add just enough to establish good brushing qualities. In applying the color, brush out a liberal amount of paint and finish up with light strokes to smooth out the brush marks. Allow each area to dry to the touch before retaping the surface for subsequent painting. (A hair dryer can be used to speed up the process if necessary.) You'll notice that acrylic colors appear to dry slightly lighter in tone, a characteristic that can be annoying if you have to mix color later for making minor corrections. To avoid such problems, mix sufficient quantities of color before you start painting and store them in lidded containers.

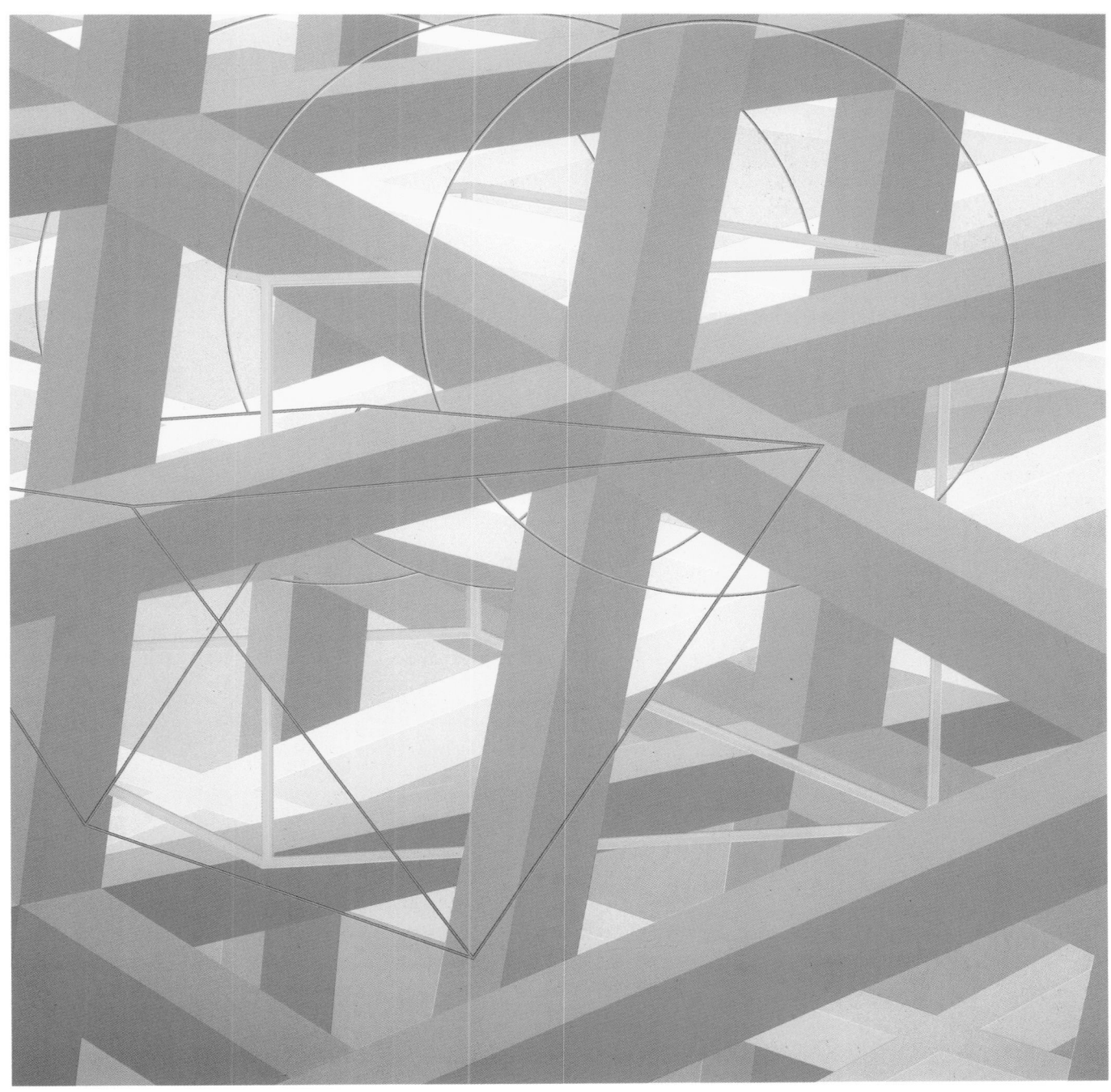

VENETIAN III

by Al Held, 1980, acrylic on canvas, 7' × 7' (2 × 2 m). Courtesy Andre Emmerich Gallery, New York.

This geometric painting, comprising principally skeletal shapes, is spatially ambiguous and can best be described as an elaborate optical illusion.

The Necker cube (a transparent skeletal cube), along with other geometric shapes, is fragmented and interpenetrated, thus producing an optical "flip-flop" effect. This clever "now-you-see-it, now-you-don't" composition creates strong equivocality—defined by Webster as "subject to two

or more interpretations" and "designed to mislead or confuse." The use of discordant color further emphasizes spatial ambiguity. Color perspective is disregarded; brightly colored lines "pop" in between the elements of the composition, regardless of their spatial position, adding further to pictorial instability. Notice, too, that there is no evidence of linear perspective, no horizon lines, no vanishing

points. The cubes are drawn isometrically, using parallel, rather than converging, lines. Another interesting illusion is in the use of the three red circles, overlapped to allude to a nonexistent cylindrical form. In spite of the frustrating "cat-and-mouse" game that this painting plays with our senses, it does provide a delightful visual experience—and an insight to the effective use of ambiguous space.

Symbolize a Sensation

In his epic work, *Concerning the Spiritual in Art*, the master teacher Wassily Kandinsky wrote, "I value those artists who embody the expression of their inner life." An important part of an artist's inner life is sensory experience, and a natural function of art is to convert these sensations into pictorial representations through unique forms of symbolic notation. This process is what philosopher Susanne K. Langer describes as "objectifying subjective reality."

Symbols are surrogate images, insofar as they are stand-ins for other factual data. For the artist, symbol making is a special kind of mental activity whereby complicated ideas, knowledge, and emotions can be communicated visually through graphic images. Through symbolization, the artist can communicate desires, fears, anxieties, moods, sensations, feelings, and intuitions. All these experiences, of course, are subjective, yet the creative artist can translate them into graphic equivalents made up of a language of line, shape, form, and color.

For this experiment, paint an abstract composition based on the sensory memories of a special adventure. Select an event that is still strong in your mind in terms of the sensations and emotions it aroused, say, for example, an airplane trip, a roller coaster ride, a hockey or football game, a skiing experience, an automobile ride, a summer safari, a sailing cruise, etc. Your task then, is to translate these sensations and emotions into a symbolic representation. Minimize—or omit altogether—any figurative reference. Instead, use only appropriately configured geometric shapes, colors, and textures to communicate the experience.

In short, think of your composition as a "design language" through which you can communicate feelings and sentiments in a way that is not possible with words or figurative images. Exploit the psychological qualities of line, form, color, and texture in a way that will convey "subjective information." Remember, in subjective expression, there are no set "rules," or "correct" or "incorrect" solutions. Each and every response is correct, albeit some may be more sophisticated than others. Respond to this problem in your own way. You can strive for a universally understood symbolic notation by using color and design in traditional ways, or work partially or entirely with personal and cryptic symbols that only allude to, rather than explain, an experience.

Start by sketching out a design on paper with colored chalks or pencils to work out an idea. Use either a freehand drawing style or a geometric hard-edged approach, which would involve the use of mechanical drawing tools. Enlarge and transfer the design to a prepared support. Choose your color palette subjectively, but in a way that will reinforce your idea.

Remember that through empathic projection we animate the inanimate—either consciously or subconsciously. The characteristics of line, shape, and color, for example, spontaneously project our emotional and physical states. Horizontal lines are normally equated with the body and mind at rest; vertical lines with the body in a state of equilibrium or balance; diagonal lines with action; zigzag or squiggly lines with confusion. Similar emotional responses are equated with color and texture, and all these are further modified by the special juxtaposition and configuration of the elements. Swiss artist Max Bill wrote that "art can mediate thought in such a way that the thought becomes direct perceptible information."

SAIL AWAY #2

by Masoud Yasami, 1981, acrylic on canvas, 85″ × 80″ (215.9 × 203.2 cm). Courtesy Elaine Horwitch Gallery, Scottsdale, Arizona.

This abstract painting is a symbolic representation of the artist's sensory impressions of a sailing experience. Obviously, it is not a portrayal of sailing in the figurative sense; the poetic imagery arises from an effective use of color and design, plus empathic projection—the ability of both artist and viewer to make symbolic associations that animate objects with feeling and emotion. Without pictorializing his subject, the artist nonetheless conveys "information" about the sensation and ecstasy of the sailing experience: the wide, blue expanse of the sea, the bright, sunshiny day, the brilliant colors of a full sail and spinnaker; the forms of the sailboat (alluded to by the fin shapes), as well as the movement of the boat, represented by diagonal shapes. In a sense, the artist has created his own pictorial language, one that conveys the sensation of an offshore cruise and of smelling the saltwater air. A perceptive critic said of Yasami's painting: "You don't see the sailor in this painting because you are the sailor." Meticulous craftsmanship is demonstrated in the use of the acrylic medium. Shapes were carefully masked and painted with flat applications of acrylic color, most of which were subsequently scumbled with overlays of contrasting hues and delicate textures. There is an effective use of counterpoint between the hard, geometric shapes and the soft, gentle textures within them. Notice, too, how the artist uses other forms of counterpoint as well: horizontal/vertical, hard-edged/amorphic, curvilinear/rectilinear, light/dark values, and warm/cool hues.

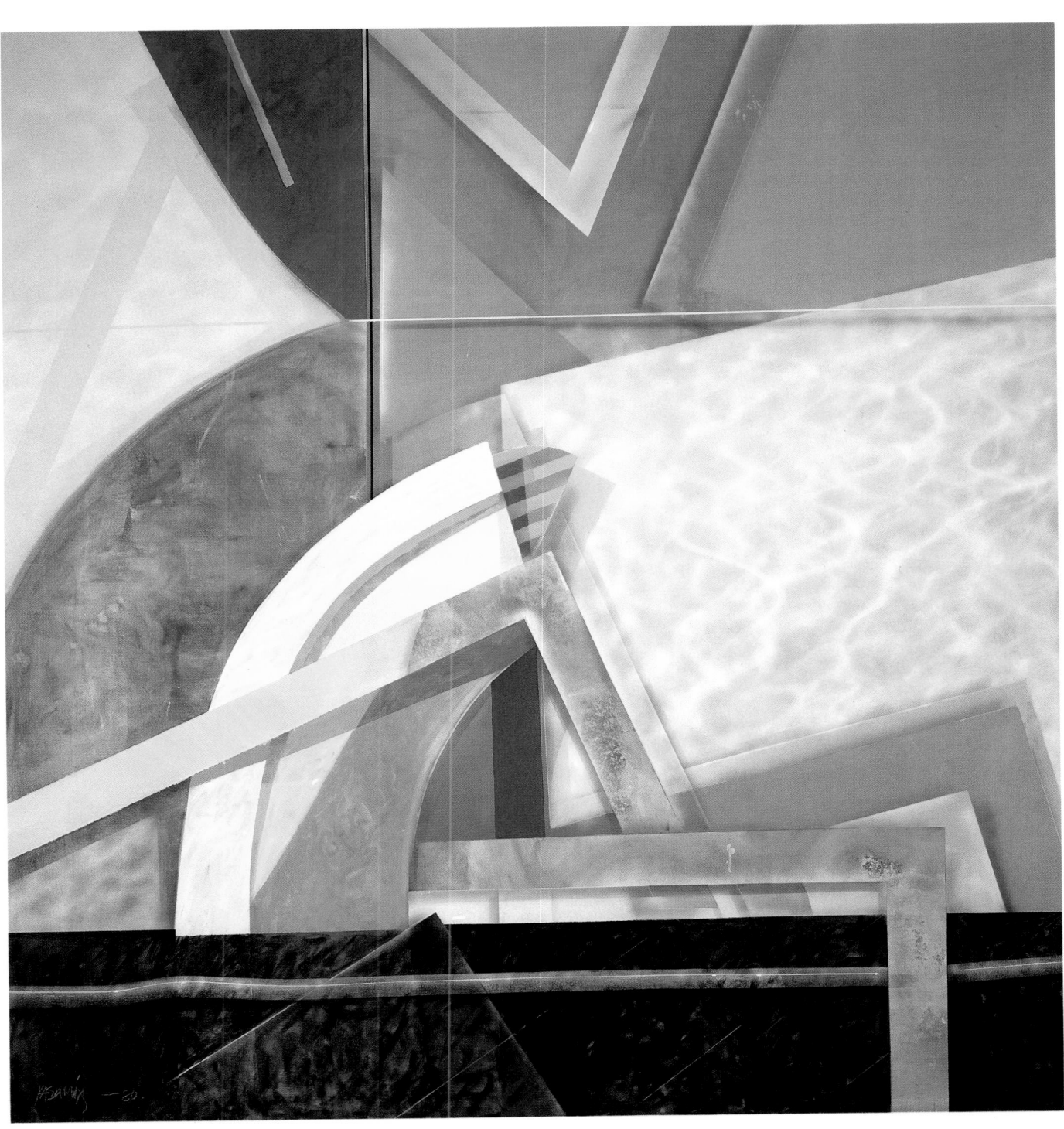

Make Shapes "Levitate"

The idea of projecting images *forward* from the ground plane—having them "rise" above the surface of the canvas—is a unique twentieth–century concept that runs contrary to Renaissance illusionism. Rather than create a "tunnel effect" wherein images are placed in the picture so that they appear to move from the ground plane inwards, toward a distant vanishing point, this trick of vision, referred to as *abstract illusionism*, does exactly the opposite. Here, the images move from the ground plane outwards, into the spectator's space, attempting to free themselves from the canvas altogether.

Abstract illusionism was given a boost by the Op artists of the 1960s, as well as by the abstract expressionists who came earlier—notably Jackson Pollock and Mark Rothko. As one contemplates Rothko's rectangular color patches, for example, they appear to "levitate" just in front of the picture plane. A critic once observed, "To get the full effect of a Rothko, you have to stand 6 feet in front of the canvas and look at an imaginary point 6 inches behind it. Then the colors will float." Op artists Richard Anuszkiewicz, Larry Poons, François Morellet, and Victor Vasarély regard their paintings as "visual cannons." They use bright hues, simultaneous color contrast, and optical illusion figures implanted in their works to create designs that put forth contradictory sensory information—data which produces highly unstable visual fields and which, in turn, makes the hapless eye perceive their paintings as kinetic movements.

For this experiment, plan a painting—in any style—in which some shapes appear to "float" above the surface of the canvas. To do this, keep these points in mind: (1) Overlap. Use repeated layering of shapes, one over the other. (2) Delineate cast shadows. Each "floating shape" will cast a shadow on the shape below it. Use the presence of shadows to convince the eye that the shapes are suspended in space.

Abstract illusionists such as George Green break the picture plane in their canvas by creating illusions of objects that go both ways: some appear to protrude, while others recede into the painting's surface. However, the code of the abstract illusionists appears to be that their illusions must be shallow. The general rule of thumb, which is shared by most of the artists who are working in this manner, is that the illusionistic shapes must not appear to rise more than a few inches above the canvas to be most successful.

In preparing your stretched and gessoed canvas for painting, trace the design to the surface, then mask off the areas to be painted with tape for hard-edged shapes. Thin the colors only slightly so you can apply them flatly and make the brushmarks disappear. For variation, use texture on a few selected shapes. Make the impasto by mixing acrylic color and modeling paste and apply it with either brush or knife. Use a delicate scumbling technique to delineate the soft cast shadows. Better yet, use an airbrush for this purpose if one is available.

UNTITLED
by George Green, 1981, acrylic on canvas, 66" × 54" (167.6 × 137 cm). Courtesy Hokin Gallery, Chicago, Illinois.

This painting is an example of abstract illusionism at its best. With hints of cubism, abstract expressionism, and trompe l'oeil, the painting gains its impact through the artist's meticulous rendering of shape, color, and texture, and particularly from the uncanny effect of "levitation" that is produced by the cast shadows. Although the painting appears to have three-dimensional properties, it is, in actual fact, a perfectly flat, two-dimensional surface. The illusion of spatiality is a clever optical deception and has become a trademark in the work of George Green: "To me, abstract illusionism is the use of visual space, not only as a means to fool the eye as seen in the work of nineteenth–century trompe l'oeil painters such as William Harnett, but as a method of making my geometric abstractions look as if someone had magically touched and charmed them to life." In this untitled painting, the artist boldly combines several pictorial effects. Flat color, thick textures, free-flowing paint, and airbrushed color are elegantly combined. Notice how Green uses the airbrush in concert with brushwork to produce his illusionistic design. Aside from rendering the shadows with the airbrush, he also uses it to spray the impastos with a contrasting color from a low angle, thus emphasizing the sculptural quality in the textured areas.

Although the painting has eight overlapping planes, its spatiality is confined to a shallow picture plane. Color is used judiciously; white predominates. Critic Joseph Jacobs describes Green's work as dramatic compositions of space and light: "It is value contrast by the play of intense light raking over the large, thick, brushstrokes that charges these shapes with so much energy. And it is the value contrast created by the play of light and shadows that causes the shapes to virtually pop off the surface."

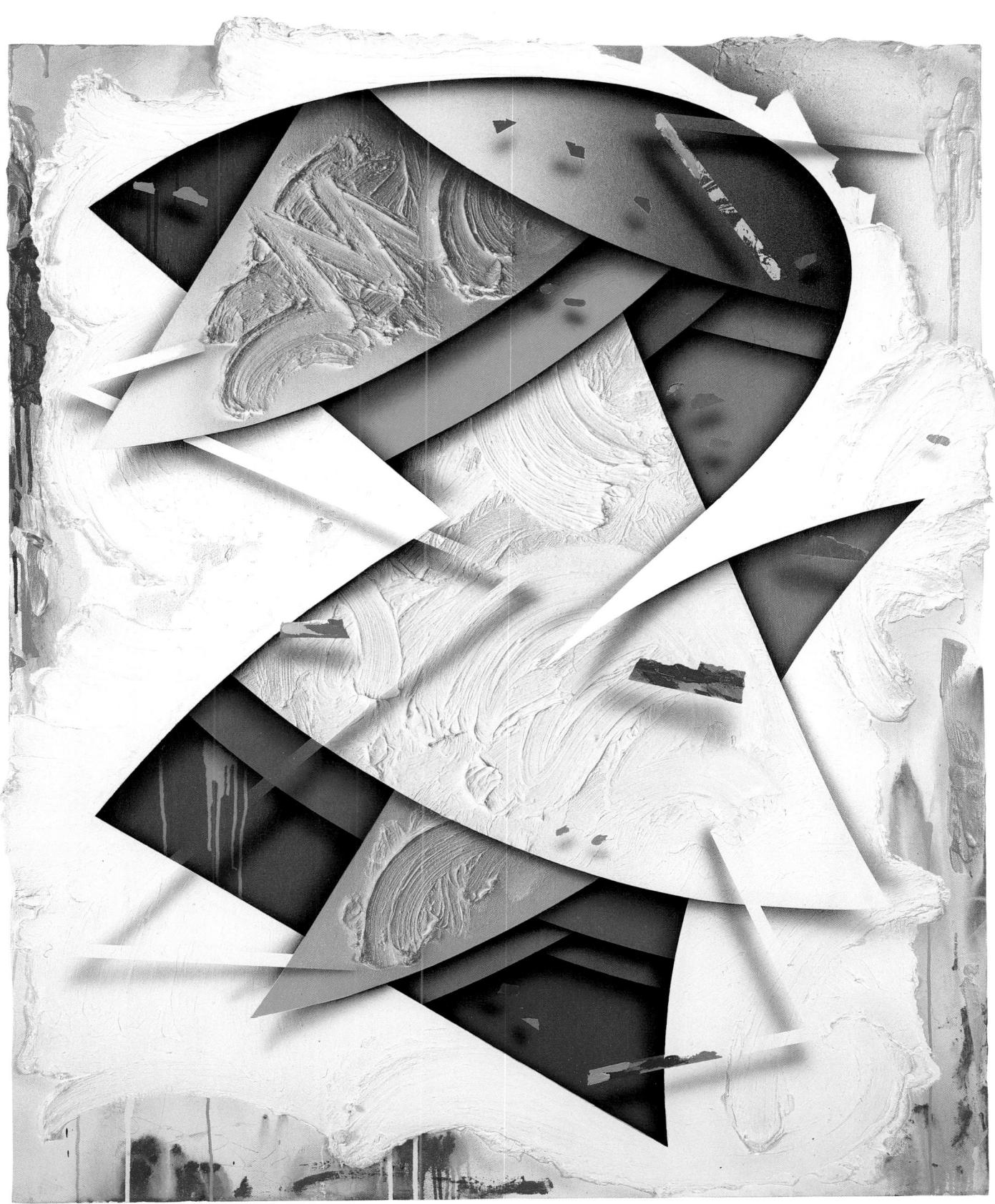

Combine Words and Images

Text, when interrelated with images, can evoke strong emotional response. Since words are the building blocks of our language system, they can be used to convey both symbolic as well as aesthetic information.

In the word-image context, letters, words, poetry, or prose can be juxtaposed with drawings, collages, and other visual images to reinforce or contradict the "information" each idiom provides. Together, words and images can be used to present an outrageous image, a political statement or a satirical lampoon, an enigmatic image, or a representation of wit or fantasy.

Webster's defines *calligraphy* as the "art of fine writing," a statement that alludes to "fine cursive penmanship," or elegant brushwork such as that seen in Chinese and Japanese art. However, depending on the artist's intent, *any* style of printing or handwriting—whether elegant or crude—can be employed as a vehicle for visualizing and communicating ideas.

Critic Amy Goldin observed that in modern art, words and pictures should not be treated as separate realms, but as comparable outcroppings of the human condition—"as equal and as unequal as nails and hair."

Letter forms and images are beautifully integrated in the stylized paintings by Stuart Davis, an American painter of the 1950s. Rather than use words simply as "labels," Davis considered them important design components and exploited their inherent linear and textural properties in his designs.

René Magritte often set up "creative tension" in his paintings by juxtaposing words and pictures. The word-picture, *The Treason of Images*, for example, shows a pipe with the words, "This is not a pipe." Seemingly paradoxical, the work disrupts clichéd thinking by saying in effect, "This is not a *real* pipe, this is simply a picture."

Words, letters, and various forms of calligraphic writing have been used as subject matter in art by many contemporary painters, notably Jasper Johns, Robert Indiana, and Shusaku Arakawa. Earlier proponents of word-picture paintings include Joan Miró and Marcel Duchamp.

Cartoonists, of course, thrive on the use of word-pictures. The witty drawings by Saul Steinberg, for example, are not only funny, but excellent examples of the humorist's use of this expressive idiom.

In this experiment, use words, letters, prose (or graffiti) in a style that fits the theme you have selected. Employ either a fine calligraphic or a spontaneous style, depending on your idea. Scribble, print, scratch, stencil, or carve the letters for your design. You can also cartoon or abstract the lettering, "collage" it from magazine illustrations, or print it with stencils or mechanical aids.

Start your project with word-images by making a preliminary colored pencil or chalk drawing on paper. At this stage, explore various ideas. Make a special effort to exploit the design possibilities of using repetitive images. Keep in mind that repeated images—properly handled—can generate strong visual patterns, as well as potent visual metaphors. Above all, try to integrate the "text" into your design without having it appear as a label or as an "add on." Emphasize the subjective. Use the word-picture as a way of making a personal as well as an aesthetic statement.

AUTUMN SUN IN THE COCONUT GROVE
by Anne Coe, 1981, acrylic on canvas, 48" × 36" (122 × 91.4 cm). Courtesy Suzanne Brown Gallery, Scottsdale, Arizona.

In this painting, the artist whimsically combines words, pictures, and design to present a zany scenario, reminiscent of a Hollywood stage set. The acrylics were used in a manner suggestive of the commercial art technique used in poster design. Pictorially, the composition is unified by the use of simplified shape and color, along with repetitive images. There is an exaggerated emphasis on pattern and decoration, almost a rococolike fussiness that emphasizes the tongue-in-cheek statement. The "text" works in counterpoint to the images; like a child's picture book, the words "explain" the curious scenario—a portrayal of an idyllic "picture book utopia" that stands in contrast against the urban jungle. Does the painting have a deeper meaning, or is it simply decorative? The answer of course, is fully dependent on the response of each viewer.

Use a "Stage Set" Format

Combine architecture, sculpture, and painting in a single art form? Although the idea sounds radical, it is not exactly new. Vestiges of the "stage set" format—or tableau art—are seen in ancient Egyptian funerary art, Sumerian and Minoan art, as well as in the altar pieces of early Christian art.

It wasn't until 1945, however, that the abstract qualities of tableau art were formally recognized when Piet Mondrian wrote, "By the unification of architecture, sculpture, and painting, a new plastic reality will be created. Painting and sculpture will not manifest themselves as separate objects . . . nor as applied art . . . but being purely constructive will aid in the creation of an environment pure and complete in its beauty."

The "stage set" format goes by many names: tableau art (forms that interact within the space of a common base), situation art; and environmental art, to name a few. It is not theater, however, because it does not involve live actors or performance. Rather, it employs "surrogate actors" in the form of images and objects.

An important characteristic of the tableau format is that it removes the static viewpoint. Unlike a painting, for example, which demands a fixed point of view for its perception, the tableau can be viewed from many directions. Large tableaus may allow the spectator to enter and share the physical space, thus extending their classification from the realm of the two-dimensional to that of the fourth dimension—time-space. It's an interesting experience to find yourself sharing the physical space in an art gallery with a tableau of George Segal's figures for example.

As preliminary research for this experiment, investigate the work of some contemporary tableau artists. John De Andrea, for example, creates environments composed of super-realist figures cast from life and painted in minute, "warts-and-all" detail. George Segal, too, casts from life to create tableaus, but his expressionless plaster figures are often left unpainted to portray themes depicting "slices of contemporary urban life." Ed Kienholz's tableaus are gruesome portrayals of angst, torment, and horror, while Red Grooms and James Melchert use the format to convey slapstick humor, and comedy.

In the realm of subjective imagery, perhaps the most significant tableau yet produced is Alberto Giacometti's *Palace at 4 A.M.*, which was created in 1932. Giacometti's work portrays a stylized figure (and some mysterious objects) in a miniature architectural setting. The title suggests that the work is metaphoric, alluding to the rational mind which is asleep at 4 A.M., while its counterpart, the unconscious, produces a dream. The tableau has been described as "a dream in the state of becoming."

The tableau format is useful because quite often it is impossible to convey a complex idea with a single pictorial idiom. Since we live in a "collage environment," it seems natural that we use "the collage idea" as a means of expression. Look for ideas in daily life situations as does George Segal, and from the subconscious as does Giacometti. Or, if you wish to work in a structural nonreferential vein, look for inspiration in architectural structure as did Mondrian.

Assuming you want to create a narrative tableau, here's a suggested approach to get started. Create an artform that integrates the following "ingredients": (1) A figure (or figures); (2) A fragment from the human figure (or organic subject); (3) A prop (or props); selected objects that reinforce the theme; (4) An architectural structure (a portal, door, window, table and chair, a fragment of a wall, etc.). Unify the above elements through careful design and composition. Tell a story, convey a feeling, unveil the unconscious, or portray a "slice of urban life." Another narrative approach is to "reconstruct" a painting. Transform its elements from a flat, two-dimensional composition into a three-dimensional equivalent. Can you imagine, for example, an up-dated, three-dimensional version of a Giorgio de Chirico painting? A third narrative approach is to work in a subjective or surrealistic vein and employ a dream-like marriage of strange disjuncts as seen in surrealist art.

Use canvas, wood, ceramics, plaster, papier mâché, or whatever materials and procedures are required to create the mixed-media construction. Make the tableau in a size and format that suits your concept (and pocketbook). It can be a miniature cigarbox-size structure, or lifesize, or bigger. Remember that by removing a painting from the frame, and sculpture from its pedestal, and combining both in a stage set format, your art becomes nonstatic. Keep in mind the words of Moholy-Nagy, "In the new architecture as in the new theater, when we move around the structure its space becomes kinetic, as our perception continually changes."

IN PAUSING SHE IS IMPLICATED IN A WELL-STRUCTURED RELATIONSHIP
by Renée Van Halm, 1984, wood, plaster, canvas, acrylic, 102" × 102" × 60" (258.8 × 258.8 × 152.2 cm).
Courtesy the Montreal Museum of Fine Arts, Montreal, Canada.

This surrealistic tableau is constructed much like a stage set. The strange "actors"—the fragmented feet and the miniature figure—convey a Magritte-like aura. Comments the artist, "My work appropriates images from early Renaissance paintings and translates them into contemporary experiences. I interpret these paintings three-dimensionally in human scale applying painting systems, perspective, etc., and eliminating the explicit narrative content portrayed by the figures." This work, based on an anonymous thirteenth-century drawing of The Visitation, *portrays a portico that functions as a transitional zone between the realms of the public and the private. This zone functions as a stage whereon an implied figure becomes conscious of her altered role, hence the implication. This brings to mind a process of rebirth, which occurs each time we move from the relative security and comfort of a known situation to another wherein we are made to feel vulnerable. This piece is an attempt to crystallize that moment. Two anthropomorphic columns comprise the only structural support in the piece and refer to the Greek caryatids.*

Assemble and Paint Found Materials

Found materials are the essence of assemblage, an artform that involves the "fitting together of parts and pieces." For this experiment, you'll need to collect some interesting materials and objects to integrate in your assemblage construction. These might take the form of twigs, stones, shells, lumber, discarded toys, parts from derelict appliances, gadgets such as clothespins, cutlery, crushed tins, or old paperbacks. In fact, any kind of found or salvaged "junk" can be used. Look around your attic, basement, garage, second-hand shop, junk yard, and hardware or surplus supply store, or make a safari to the beach or countryside in search of materials.

Here's a suggested way to approach this experiment: Try to collect about 50 or so objects in a single classification—say, for example, 50 stones or branches, or mechanical parts. As an alternative approach, collect materials (or objects) in two different classifications—for example mechanical bolts and tree branches, which would combine organic and inorganic materials and provide dramatic counterpoint. Another approach is to disassemble an old beat-up castaway such as a wooden

chair, an old typewriter, or appliance. The idea is to "recycle" the parts and transform them into an aesthetic object. Also consider making the components for this experiment from wood, plastic tubing, etc.

Clean and sandpaper the materials you have collected and prime them with acrylic gesso. Sand the gessoed surface lightly if necessary to provide a tooth then paint them with bright acrylic colors. Remember that acrylic paint won't stick to slick or dirty surfaces. Finally, assemble the brightly painted shapes with white glue, epoxy, screws, nuts and bolts, or rope to produce a bas-relief or a free-standing, three-dimensional sculpture. Make the component parts touch, overlap, and interlock to produce an allover type of surface pattern.

As you work in assemblage, remember the words of Piet Mondrian: "Modern art and the modern sensibility have developed through a rhythm of destructions and reconstructions." Mondrian favored the term *disassemblage* as a substitute for the more ominous term *destruction*, viewing the "dismantling process" as a pro-

cedure absolutely necessary to the creative artist for providing raw material for new structures and ideas. Marcel Duchamp transformed commonplace things into aesthetic objects by using humor, pun, satire, and, more importantly, displacement, which is simply the process of putting a familiar object into a new context.

Look at the work by Joan Miró, which includes painted rocks; André Breton's constructions labeled "wood plus miscellaneous objects"; the mixed-media assemblages of Max Ernst; Robert Rauschenberg's combine-paintings; Joseph Cornell's compartmentalized boxes; Armand Arman's accumulation series; Man Ray's *Objects of My Affections*; and Louise Nevelson's wood assemblages.

The assemblage format has also preoccupied contemporary artists Nancy Graves and Eduardo Paolozzi. In some of her past work, Graves has shown a predeliction for the use of organic shapes found in nature, while Paolozzi prefers to build anthropomorphic and robotic forms made up of junked typewriters, gearboxes, auto crankshafts, and wheel bearings.

SMALL SCULPTURE

by Charles Arnoldi, 1981, acrylic paint and branches 26" × 26" × 30" (66 × 66 × 76 cm). Courtesy Hansen/Fuller/Goldeen Gallery, San Francisco, California.

Arnoldi's work is a hybrid artform, possessing characteristics of both painting and sculpture. This three-dimensional assemblage, made up of neatly clipped branches and twigs, is painted with bright acrylic colors. What kind of object is it? Is it merely a formal, nonreferential composition, or a mysterious fetish object? Clustered together, the branches form a unique free-standing sculpture—a powerful image in its own right, yet one that evokes a myriad of reminiscences: of aboriginal art, magic, ritual, and superstition, as well as of

human bones, arteries, and roadways. The work appears as a three-dimensional counterpart to the "drip paintings" by Jackson Pollack, as well as paraphrasing the spirit of the work by Kurt Schwitters. Arnoldi's work has a strong impact because of the element of displacement. Branches and twigs, familiar elements in nature, are estranged when viewed as "art." The effect of displacement is further exaggerated by painting the branches and twigs with primary hues, as well as configuring the sculpture with an architectural motif.

Let the Brushwork Produce the Drawing

Although impressionism was a limited episode in the history of art, its spirit still carries vital concepts for the contemporary artist. The idea of representing a commonplace subject as "poetry of visual sensation," for example, is as exciting today as it was back at the turn of the century. Study the luxurious color contrasts and sensitive brushwork in Monet's paintings, as well as the divided color effects in other impressionist, Nabi, and neoimpressionist works. Look closely at the way that Bonnard, for example, handled paint on canvas, as well as the way he composed his famous paintings of "intimate room interiors."

Camille Pissarro once advised his students to avoid defining too closely the outline of things. "It is the brushwork of the right value and color," he insisted, "which should produce the drawing." The inherent qualities of acrylic paint and emulsions provide a perfect medium for spontaneous brushwork. The fast-drying colors, along with the polymer medium, are ideal for quick, extemporaneous brushwork and offer rich color and luminosity, particularly when the colors are mixed with the polymer emulsion and applied as glazes. Because this emulsion is made of acrylic, it has a built-in "light-trapping" characteristic and the resultant glazes are far brighter than those painted in oils.

Make a study of light, and its effect on your subject. Notice how light-drenched subjects in nature are softened in their substance and form; edges and contours are dissolved slightly when they are bathed in bright light and shadows never appear black; rather, they have chromatic qualities. Exaggerate these visual sensations in your work.

Monet urged his students to cover the canvas as quickly as possible. In a sense, he was saying, "Get *inside* your work, don't merely represent the subject, empathize with it, become part of it!" Train the eye to be as sensitive to luminous vibrations as the ear is sensitive to the vibrations of sound.

Use this approach for your experiment: Produce a painting of a room interior, rendering it in a loose, impressionistic style. Aside from showing at least two walls, a floor, and a ceiling, include such things as a figure (or a portion of a figure), a table, a flower arrangement, a selected piece of furniture, or a curtained window. Paint directly from an actual subject (or a good photograph) rather than from imagination. The idea is to translate the sharp outlines and shapes of your subject matter into a simplified representation. Dissolve outlines, soften forms, and simplify shapes, while at the same time take care to emphasize the sensation of light, atmosphere, and color. Use aggressive brushstrokes to obtain a crisp, spontaneous effect. Avoid shad-

ing or the use of continuous tone, as in photorealistic painting. Scrub and scumble the color onto the canvas. Blend directly on the support rather than on the palette. Eliminate black; paint shadows with mixed hues. Above all, let intuition, not the cerebral mind, prevail.

Try an extemporaneous wet-in-wet painting technique (alla prima) as well as on painting on dry undercoats of color. If necessary, add a small amount of acrylic retarder to the acrylic colors to maintain fluidity and slow down the drying time. Avoid a labored or overworked quality by maintaining a spontaneous brushstroke throughout the entire procedure. Impressionistic effects demand simplicity of style and hazy images, like a first impression, before the eye and mind bring things into perfect focus. Also avoid using heavy impastos and textures in this style of painting. Keep your colors thin, or thicken them only slightly by adding titanium white.

In assessing the progress of your painting, contemplate it both close up and from a distance. Up close to the canvas, your work may appear as a jumble of disconnected color patches, yet when you step back, it should be optically cohesive. For this effect to occur, however, you must maintain correct value relationships, even though the color itself may be radically changed.

SUNDAY MORNING
by Morton Kaish, 1970, acrylic on gesso panel, 45" × 50" (114.3 × 127 cm). Courtesy the artist.

This painting of a room interior, basked in the warmth of early morning light, is beautifully rendered in a spontaneous brush style reminiscent of impressionist art. The artist scumbled thin layers of acrylic colors—emphasizing reds, oranges, and red-oranges—onto a gessoed panel to produce a rich, vibrant color field and a luminous surface. Notice that he did only a minimal amount of outlining. Instead, forms were suggested by "pushing paint" against adjoining areas. Although the converging perspective lines allude to three-dimensional space, the strong allover color tends to flatten spa-

tiality. As in the paintings by Bonnard, Kaish's work is a delightful synthesis of composition and color, yet the artist's main concern is with light and atmosphere. "Essentially, my paintings are concerned with two things," notes the artist. "First is the resolution of what happens when a shaft of light is intersected by a series of objects. Second is the attempt to deal with a quality of almost explosive movement that can be generated by forms at rest, a quality of being totally immersed in their environment, yet suspended and buoyant beyond it."

Stain the Canvas

In this freewheeling technique, fluid acrylic color is poured and manipulated on unprimed canvas, allowing it to penetrate the material to the underside. The color is controlled with unorthodox tools such as a squeegee, sponge, stick, or knife.

Helen Frankenthaler, whose name is synonymous with "stained canvas," has worked in this style since the 1950s. Inspired by Jackson Pollock, she was one of the first to abandon conventional painting techniques in favor of the (then) eccentric one of pouring and squeegeeing color directly onto unprimed canvas. She adopted Pollock's technique of laying canvases flat on the floor and, like him, painted from all four sides, "allowing the painting to happen." Staining with acrylics allows Frankenthaler to achieve translucence and spatiality in her paintings.

The methods of using acrylic stain can be generally classified as either serendipitous or cerebral—or somewhere in between. For example, you may opt to work in a completely intuitive manner, approaching the canvas without benefit of any preliminary sketching; or in a more methodical manner, one that allows a certain amount of preconceived imagery and design to interact with chance happenings. Whichever approach you use, explore the technique by first experimenting on small scraps of canvas to develop confidence. Don't think of the preliminary experiments as being complete artforms in themselves, or something to "copy" in a larger format, but rather as guides for doing the final work. Allow for serendipity to enter the picture; be prepared to make major decisions spontaneously at any point during the painting's development. Keep in mind the byword "paint, contemplate, paint."

To experiment with acrylic stains, you'll need unprimed cotton duck canvas, polyethylene plastic sheet to lay under it, acrylic colors (thinned with water and polymer medium), and some of the tools mentioned above to manipulate the fluid color. Also, investigate the fluid acrylics, a new paint line made especially for stain and airbrush work. Lay the unprimed canvas flat on the floor (over the plastic sheet), or tack it temporarily onto stretcher bars so that it is elevated slightly from the floor.

The first applications of the thinned acrylic color will tend to penetrate the fabric of the canvas. This, of course, is the fundamental nature of the technique. The paint becomes an integral part of the canvas. Use enough water and polymer medium to thin the colors to a milky consistency so that they will flow accordingly.

After the first flow of color has been applied, mix up additional colors and pour them over the previously applied ones, (the first coatings may remain wet, or be partially or completely dry). Here, timing is all-important because it makes a difference in the quality of the acrylic paint flow that will be produced. (On a wet surface, the paint is freer to intermingle; whereas on a dry surface it maintains a dryer edge.) The "tools," too, are determining factors in the character of the design. Squeegees, for example, can produce clean, flat expanses of color, textured surfaces, or "printed lines," depending on how they are used. Sponges, on the other hand, can be used to scrub and scumble, push one color into another, or produce texture. Note: Because an acrylic stain painting is done on unprimed canvas, it will tend to be a notorious dust catcher (as well as being next to impossible to clean). Avoid this by applying several coats of acrylic varnish over the finished surface.

MAGIC PRISM #1

*by Bety Kohlberg, 1975, acrylic on canvas, 60"
× 30" (152.4 × 76.2 cm). Courtesy Creiger
Sesen Associates, Boston.*

*This abstract painting—composed of
fluid forms and hard edges—was
inspired by the recollections of can-
yons and rich landscapes in the
southwestern regions of the United
States. Kohlberg, like Helen Franken-
thaler, exploits the optical rather than
the tactile properties of acrylic paint;
her stains are kept thin and trans-
parent, allowing the weave of the
canvas to show through the color. This
painting represents a beautiful inte-
gration of spontaneity and control:
"Happy accidents" are "set-up,"
thoughtfully exploited, and integrated
with the motif. There is an ambiguous
illusion of space presented in this
painting. Notice that although the
overlapping shapes suggest deep pic-
torial space, the transparency of their
color, as well as the weave of the
canvas showing through from below,
optically pulls them together into a
two-dimensional plane. Acrylic paints
contain pigments and dyes of potent
color. Thinned with water and poly-
mer emulsion, they maintain their
brilliance, yet readily penetrate sup-
ports such as unprimed canvas. In
this work, the artist sharpens the edges
of some of the shapes with contour
lines, drawn into wet acrylic with
water-soluble pencils.*

Paint with a Knife

The painting knife is an excellent tool for applying acrylic paint and impasto in a spontaneous manner. Knives are available in many different sizes and shapes, including trowel, diamond, elliptical, and chisel-edge configurations. The best painting knives are those with blades made of tempered carbon steel and have handles of solid hardwood. Other useful "painting knives" include the palette knife and the glazier's knife (the common putty knife), which are designed for purposes other than painting, yet which are often preferred by many artists.

Essentially, the painting knife is a miniature "trowel" and is used in place of (or along with) the brush to apply paint and impastos to any painting ground. Acrylic colors of normal or thickened consistency can be applied to any surface with a troweling or "printing" action. Paint that has not dried can be scraped with the knife to reveal underlying color for special effects, or delicate lines "printed" with the knife held on edge. You can also use graffito, in which designs are scratched through wet paint, and pointillistic techniques, wherein tiny dots or dollops of paint are applied with the tip of the knife.

Artists often use the painting knife in conjunction with brush painting, relying on the knife for the final touches or highlights. Yet there are many artists who prefer to use *only* the knife—or a combination of knives—to create their entire work. The painting knife offers an opportunity for achieving a special kind of direct, spontaneous style.

Preliminary drawing with pastels on paper is a good prelude for knife painting and provides an opportunity to previsualize the composition and color of a proposed motif. These preparatory drawings, however, should serve only as an approximation of the final work; do the "finish" work with the painting knife. Allow for a certain amount of unplanned for—or serendipitous—activity to intervene. The preliminary sketches should be used only to gain "information" and confidence for the final work, which should have a fresh, unlabored quality.

Knife painting requires more paint than do traditional brush painting techniques—especially in large formats. For economy, purchase acrylic colors in tins, rather than tubes. Use a mixing palette made from a sheet of plate glass with white paper underneath.

A good way to start a knife painting is by troweling light lines on the canvas with burnt umber. (Or draw the lines beforehand with vine charcoal.) Then charge the painting knife with color and, with sweeping strokes, establish the basic shapes and proportions of your composition.

In the next stage, add acrylic modeling paste (or gel medium for transparency) to acrylic colors to produce impastos. (A note of caution: Impastos should not be applied more than ⅛" thick on canvas. It is best to apply thick impastos on a rigid surface such as a Masonite panel to prevent cracking.) Apply these thickened colors with bold knife strokes to establish the intermediate shapes and forms. Keep in mind the advice of Cézanne: "Start with a broom and end with a toothpick!" Begin by painting the large broad areas, then attend to the intermediate shapes, and, finally, apply the details and finishing touches. In effect, literally "walk" out of your painting. Switch to progressively smaller knives as your work develops: Start with a large tool for applying large passages of color, ending up with a small one to finish up the detail. For a protective coating, brush or spray gloss (or mat) acrylic picture varnish over the surface of the completed painting.

Viewed up close, your knife painting should appear like a mosaic of many individual "color islands." Plan the work, however, so that a majority of the color passages fuse optically as you step back from the painting.

TRUCHAS STREAM

by Robert Elsocht, 1985, acrylic on canvas, 36" × 31" (91.4 × 78.7 cm). Photograph courtesy the artist.

This acrylic landscape was painted in three hours. Before beginning the knife work, the artist made several preliminary sketches on paper to plan the design and composition of his motif. Once satisfied with his sketches, he turned to the prepared canvas and with large, sweeping strokes of the painting knife, laid down passages of burnt umber to suggest the basic forms. Next, he proceeded to introduce brighter patches of color, first troweling on the large, then the intermediate, and finally the smaller patches of impastos to suggest the various pictorial elements. Impastos were prepared by mixing acrylic paint with small amounts of modeling paste, providing them with a heavier body. From beginning to end, the artist used only one tool—the 3" glazier's knife. With the interplay of several knife techniques, including scraping, graffito, and "printing," he developed the image, seeking above all to capture an instantaneous response to the stimulus. Notice how a fresh and spontaneous quality is produced in this painting by simply suggesting, rather than explaining, the forms. The illusion of bright sunlight, falling on a mountain stream in a wooded landscape, is beautifully conceived and rendered with the knife technique. Also notice how the artist applied small patches of bright orange color for sparkle. The completed painting was brushed with acrylic picture varnish to protect its surface and add depth to the colors.

Paint with Stencils

A stencil is produced by taking a sheet of paper, thin metal, plastic, or other material and cutting a pattern out of it. When laid flat, the configuration of the pattern can be transferred to paper or canvas below it by stippling color through the open part of the stencil using a stubby brush charged with color.

Commercially made stencil paper—a translucent, wax-coated paper that is impervious to water—is available from most art supply stores. If you can't get stencil paper in a size large enough for your liking, make your own by simply melting beeswax in an electric frying pan or deep fryer that is equipped with a thermostatic control. (Set the control for 250 degrees F.) When the wax is hot and fluid, brush it over newsprint or a heavy grade art paper. (Exercise caution whenever you work with hot wax; don't allow it to smoke or to come in direct contact with flame.)

There are many ways to cut a stencil. Some of the tools you can use for this purpose include the mat knife, stencil cutter, scissors, drive punch, circle cutter, silkscreen knife, and mechanical drawing instruments equipped with cutting blades.

Metal grills (normally used as decorative fireplace screens) with open patterns such as a circle, square, diamond, or cloverleaf filigree are excellent ready-made stencils.

For this experiment in stencil painting, prepare a design with a fairly simple, uncomplicated composition, using either figurative or a geometric abstraction. (The design will become complicated soon enough as you stencil.) As an alternative to sketching out your idea, you might want to "previsualize" your concept by making a small collage with colored papers. Textures simulating stenciled patterns can be added to the collage with marking pens or colored pencils.

Next, make your stencils from wax paper. With appropriate knives and cutters, make a stencil with circular shapes (an enlarged dot pattern), another with a square, triangular, or irregular pierced pattern, a zig-zag pattern, etc. Also, if it suits your design, think about the possibility of making a stencil with a stylized figurative image as well.

The next step is to make a full-size pencil drawing of your sketch or collage on paper that will be traced to a gessoed canvas or panel in preparation for painting. Paint the shapes on the canvas with acrylic colors, either freehand, or by masking them with tape to achieve hard-edge patterns. Apply the color with nylon brushes, smoothing out the color to produce a perfectly flat color and surface. Over this underpainting, you can imprint the stenciled patterns.

Next, begin the stenciling process: as soon as the underpainting is dry, start by re-masking a selected shape on the canvas so that the surrounding area is protected. Then choose one of the stencil patterns that you have made (or a filigree screen) and tape it temporarily in place over the exposed area. You can also overlap several stenciled patterns, creating optical and spatial effects, including vibrant color field painting.

Carefully stencil the pattern to the canvas by using a stubby bristle brush (or a housepainter's brush with bristles cut or tied so that they are about 1″ in length). Charge the brush with undiluted acrylic paint and then remove some of it by brushing out the excess color on a paper towel so that the brush is fairly dry. Holding the stencil brush at right angles to the canvas, stipple the paint through the pattern of the stencil, building up the color strength through successive applications. To ensure a clean, crisp design, build the color up slowly, rather than attempting to stipple it on in a single application. If available, use a spray gun or airbrush to paint the stencil design, rather than a stipple brush.

RED SHIFT JOURNEY
by William Conlon, 1980, acrylic on canvas, 72″ × 64″ (182.9 × 162.6 cm). Courtesy Andre Emmerich Gallery, New York.

The richness of this painting stems from the extravagant use of color and pattern and, as its title suggests, is a self-referential composition of abstract elements. The nonobjective motif alludes to geometry, Islamic motif, and the geometric paintings by Wassily Kandinsky. Carefully crafted, the many overlays of pattern and line present a delightful, albeit equivocal, spatiality. Some shapes overlap, while others interlock within each other's space, producing an ambiguous perception. Critic Gene Baro describes the layered patterns of Conlon's work as "forces that seem about to break out of the picture plane, yet the whole floats, held to a delicate suspension, a huge fish in a small tank." Notice that although the artist stenciled patterns over 90 percent of the pictorial area, he deliberately kept some areas white and other colored shapes free of pattern, thus providing "optical rests" for an otherwise busy composition. It is also interesting to note that aside from the dynamic equilibrium established between the forces and energies within the painting, this work also presents a balance in counterpoint between the seemingly spontaneously arranged composition and the precision of its execution.

Blend with the Airbrush

The capabilities of the airbrush are astonishing. Beautiful blended tones and delicate color passages are quickly achieved as if by magic. With a quick adjustment, you can go from a spray pattern the width of a pencil line to a 2″ swath.

In appearance, the airbrush is an odd-looking device, something like a chrome-plated cigar with a small cup on one side (to hold the color), and a trigger valve on top (to control the spray pattern). A rubber hose leads to a compressor to supply the air.

Just how does the airbrush work? Although the instrument is a complex mechanism, its basic function is quite simple: It injects liquid color into a stream of pressurized air which is broken up into a spray. The trigger valve, operated by the index finger, controls the air and paint flow. You can easily produce smooth, uniform areas, subtle gradations, textural effects, wide swaths, dots, or pencil-thin lines—all with this one instrument.

To do airbrush painting, you'll need the following equipment:

1. *An airbrush set.* Paache, Badger, Binks, and Elbe are excellent brands. Most operate on 15 to 50 psi pressure, with the normal operating pressure at about 25 psi.
2. *An air supply.* You will need a small, quiet-running compressor, either pump or tank type, capable

of delivering uniformly pressured clean air, or a CO_2 tank of compressed air. (Tanks can be rented from special dealers and are completely silent in operation. Check the Yellow Pages of the telephone directory.)

3. *An air hose.* This is used to link the compressor to the airbrush, along with a regulator and gauge to control the air pressure.

4. *Acrylic colors.* These must be properly thinned and strained. (Fluid acrylics, a new product, are ideal for airbrush work.)

5. *Masking material.* Use one or a combination of the following: newsprint paper and masking tape; frisket paper (for working on illustration board); shields; templates; acetate film; and liquid mask (available from neon sign shops).

6. *A painting support.* Use a stretched (and gessoed) canvas, Masonite panel, artist's illustration board, or a high-quality art paper.

The following are general procedures for airbrushing acrylic colors: First, prepare the support. If you're working on a stretched canvas or the smooth side of a Masonite panel, apply three coats of acrylic gesso to the surface. (Sand between coats with fine garnet paper to produce a perfectly smooth finish.) Illustration board or paper requires no priming. Next, make a light pencil drawing of your subject on the support, then isolate it by spraying it with fixative.

Select an appropriate masking material. Your choice will depend on the complexity of your design and the kind of support that is to be used. Clear acetate film is a good masking material; position it over a line drawing and make a tracing of a selected shape with an acetate pen. Then cut the shape out with a stencil knife, reposition it on the support, hold it down with small weights such as coins, and airbrush the exposed area. Continue the operation until all the sections of the design have been airbrushed.

Masking shields can be made of cardboard or heavy paper; these are cut (or torn) into the required configuration and hand held during airbrushing. Plastic templates—the type draftsmen use—are useful for spraying geometric shapes. Frisket paper is a transparent self-adhering masking and stenciling material that is cut directly on your work. It can be used on any smooth surface, including paper, illustration board, or other smooth gessoed surfaces.

A liquid masking material, Gripmask, used in the electric sign industry, is also useful for masking canvas or Masonite panels. This material is milky in color, with a slight bluish tint, but dries transparent and forms a continuous film. Apply three coats over a gessoed canvas or Masonite panel, allowing each coat to dry before the next is applied. Then cut and remove shapes with a stencil knife to expose areas for airbrushing. The "skin" leaves no residue when peeled away from the surface.

A note about the preparation of acrylic paints for airbrushing: Use acrylic colors packaged in jars, rather than in tubes. (Tubed colors contain more thickener.) The colors must be mixed with water and polymer medium to a fairly thin consistency so that they will pass through the nozzle of the airbrush without clogging it. (Strain the colors through a nylon mesh to remove solid particles.) Store the thinned colors in air-tight containers until ready for use. Remember, acrylics that are excessively thinned with water tend to lose their adhesive properties; polymer medium is added to retain it. Experiment with fluid acrylics—a new product ideal for airbrush art.

SPHINX AND DEATH (*detail*)
by Paul Wunderlich, 1983, acrylic on canvas, 47¼" × 35" (120 × 90 cm). Courtesy the artist.

This painting, executed in a neosurrealist style, is an excellent example of how the airbrush can be used in fine art. With meticulous craftsmanship, the artist carefully masked and airbrushed acrylic color to produce a work that combines sharply delineated forms and delicate passages of blended color. The overall effect is that of pristine simplicity: large open spaces and sensuous gradations of color and tone—a beautifully controlled effect that demonstrates the artist's expertise and integrity in the use of the airbrush. A great deal of preliminary work in airbrush painting is unseen, lying in the masking, a necessary step in controlling the spray pattern.

Spray Crumpled Surfaces

Exciting visual patterns and textures are quickly achieved by crumpling a flexible support (such as paper or canvas) and spray painting the surface from an oblique angle. To experiment with this technique, you'll need an airbrush or a spraygun, along with an air supply (from a carbon dioxide tank, a mini compressor, or a tank compressor).

Use either unstretched (but gessoed) canvas, or a light- to medium-weight paper as the painting support. Shape the material to assume a bas-relief configuration by crumpling, folding, wrinkling, or twisting it, then lay it out on a table in preparation for spray painting. You might try experimenting with canvases of different weights and textures. Finely textured linen canvas, for example, is more easily coaxed to produce intricate shapes and configurations.

At this stage, your paper or canvas will probably resemble a miniature mountain range with a labyrinth of peaks and valleys. Attach pieces of double-face masking tape to the back of the canvas at strategic points to hold it in position while it is being spray painted.

Work with a comfortable size and format; a deciding factor may be the type of spray equipment available. Although the airbrush offers the greatest control, the spray gun has a larger paint container, making it better suited for spraying large areas. Remember, hold the airbrush or spray gun fairly low and at an angle to the support. On a practice piece of canvas or paper, experiment with different spray techniques. For example, try spraying only a single color from only one direction, and in another experiment, spray from several directions and angles, each time with a different color.

When the painted surface is dry to the touch, it can be flattened out. At this point, stretch and staple the canvas to a stretcher frame. (Sprayed paper can be smoothed out and glued to Masonite or plywood.) Notice that the design, is now transformed into a visual equivalent of its original three-dimensional structure. After the canvas has been stretched, continue to develop the composition. Brush, stipple, spatter, or spray additional colors and patterns; add collage or three-dimensional materials if you desire. Masking and stenciling techniques are also helpful for obtaining hard-edged patterns. Stencils or templates made of paper or acetate can serve as masks for additional spray painting. Also consider using other masking materials such as metal screens, filigreed place mats, gaskets, or loose aggregate that can be placed on the surface and spray painted to obtain further variations.

A note of caution: Acrylic colors must be thinned with water and polymer medium so they won't clog the airbrush or spray gun. In addition, they should be strained through several layers of cheesecloth to filter out heavy particles. Look into the availability of fluid acrylics, a new product that is ideally suited for spray painting.

Also, keep in mind that some acrylic artist colors contain toxic pigments. In particular, be careful in handling colors labeled cadmium, pthalo, chrome, and chromium oxide, hansa, cobalt, cerulean, and raw umber. Both the acrylic paint and the emulsions contain small amounts of a preservative and ammonia. For safety's sake, work in a well-ventilated room; wear a cartridge-type respirator designed to meet Occupational Safety and Health Administration (OSHA) requirements to guard against inhalation of paint spray mists.

SPACE MANDALA, SPATIAL AMBIGUITY
by Peter Kalkhof, 1978, acrylic on canvas, 68" × 64" (173 × 162.5 cm). Courtesy Annely Juda Fine Art, London, England.

The topographiclike pattern seen in the background of this painting was produced by crumpling and spraying unstretched canvas. The airbrush was held at an oblique angle and the acrylic colors sprayed from several different directions. Later, the canvas was stapled to a stretcher frame and the hard-edged patterns and details added. The mandala format— consisting of a series of concentric forms—is used as a means of creating a unique near-symmetrical composition, as well as exploiting the mysterious allure and meditative qualities that such forms inspire. Artist-author José A. Argüelles describes the mandala in his book Mandala *as "a passage between different dimensions"; the earth as "a living mandala", a structural matrix through which flows a succession of changes. Through the pictorial and implied spaces of this form, Kalkhof seeks to express such mysteries of the universe—or in his words, "to search for them."*

Reveal Stratified Color

This experiment calls for an "add-subtract" process. The idea is to build up many layers of acrylic paint (all of a different color) on a suitable ground, such as canvas or Masonite, until a thick stratified surface is produced. Then, with either an abrasive or chemical process, the surface is systematically ground away or eroded to reveal a latent design. I suggest you do some preliminary experiments on a small piece of Masonite or canvasboard to become familiar with the technique and its potential. You can follow a chemical or nonchemical approach.

For the chemical process, follow these steps. First, make a pencil drawing of the design on the support, then paint ten or more color coatings each of a different hue, over each shape (this is the "add" part of the technique). In building up the striation, each coat is allowed to dry before the next one is applied. If you want a thick paint film—say, one with a consistency of pancake batter—mix the acrylic colors with acrylic modeling paste before applying them to the support. To produce lines, use a plastic squeeze bottle (such as a ketchup or mustard dispenser) to extrude the thick paint onto the painting surface. A palette knife, spatula, or makeshift squeegee made of cardboard are handy tools for spreading thicker paint mixes. Top the stratified colors with a coating of either black or white acrylic paint.

To start the subtractive process; reveal the underlying color and design by rubbing the surface with a cloth saturated with acetone. Change cloths as the work progresses. Caution: Use extreme care in handling acetone. Provide for adequate ventilation (best to work outdoors) and follow the manufacturers' directions regarding its use.

An alternative, nonchemical technique involves sanding or grinding to reveal stratified color. In this method, use either power or hand sanders (and/or grinders) to cut through the multilayered and multihued acrylic coatings. New York artist Edgar Buonagurio has perfected this process to produce remarkable works. He refers to the technique as "the build and grind method." Buonagurio builds up *irregular* layers of paint coatings (up to 2″ to 3″ in thickness) and then grinds the irregular surface configuration with a power grinder to produce a flat surface and reveal the design.

Begin as usual by making a pencil drawing of the design on the canvas or panel. Next, extrude thick acrylic colors with a squeeze-bottle. The design should have a Braille-like surface relief quality. Next, brush consecutive layers of thick acrylic coatings over the design, alternating or using different hues in coating, until you have built up a thickness of 1″ to 2″ (more if desired). Finally, with the aid of an abrading device, such as a portable disc sander, hand grinder, portable belt or pad sander, or just hand-sanding with abrasive paper, sand through the layers of paint to reveal the design. Remember, the idea here is to first build up an irregular "landscape"—a sculptural relief—with colors of pastelike consistency and then to grind it down sufficiently to reveal the underlying color patterns. To finish up with a shiny surface, apply one or more coats of acrylic varnish (or Krylon spray varnish) over the completed work. Again, remember to exercise good shop practices and caution when working with dusty materials. Provide for adequate ventilation. Wear a protective dust mask to avoid breathing the acrylic dust.

JASMINE
by Edgar Buonagurio, 1982, acrylic on canvas, 52″ × 42″ (142.2 × 106.7 cm). Courtesy Andre Zarre Gallery, New York.

Edgar Buonagurio describes his method as "exotic, downright eccentric." Critics characterize him as an artist who interplays the modern against the antique: He uses a modern medium—acrylics—and power tools to produce designs that allude to ancient Middle Eastern art. Symmetrical in design, the painting shown here is made up of architectural motifs: swirls, arches, and floral patterns integrated in a rich blend that is reminiscent of mosaic art found on the domes of Byzantine churches. The painting was created by building up multicolored layers of acrylic color, which were subsequently sanded to reveal an underlying image. "I think of the process as a kind of archeological dig," comments the artist. Although the work benefits from chance discoveries that occur during the abrading process, the artist systematically preplans much of the work. A certain danger, however, is in overgrinding and losing important details of the design. "The key," says Buonagurio, "is in knowing when to stop."

Use Transparent Impasto

To make a transparent impasto, simply mix acrylic gel medium with acrylic paint. Although the gel medium is milky in appearance, it dries crystal clear and is the principal agent that maintains the consistency, hue, and brushing characteristics of the transparent impasto.

Another way is to mix Rhoplex with dry colors. Although not as sticky as the gel medium, Rhoplex provides excellent transparent impastos. If you decide to explore the Rhoplex technique, be sure to use dry colors made of high-quality pigment. Experiment first to make sure that the colors you have selected are compatible with the medium.

Here's a suggested approach for using transparent impastos in acrylic painting. Select a subject—a figure, a group of figures, a landscape or interior (or a combination of these subjects)—and break the image down to simplified shapes and primary and secondary colors. In preparation for painting, make some preliminary rough sketches with colored pencil on paper. On a stretched and prepared canvas, use acrylic paints to make the underpainting. Block in passages of color with opaque hues to establish general shapes and composition. Next, overpaint with thick, transparent impastos made by mixing acrylic gel with acrylic color or dry color. Use a vigorous brush and/or palette knife technique to apply the impastos. Allow the spontaneous brushmarks and textural effects to remain as part of the surface. Create a physical dimension in your painting. As you paint each form,

"shape" it with the brush charged with impasto to produce a thick, built-up surface. Think of color as substance; allow it to ooze and emerge from the painting as form. Remember, limit your colors and try to achieve a synthesis of subject, style, and technique.

As a final note of interest, transparent impastos can be painted on transparent or translucent supports, and hung as an off-stretcher artform in front of a window, or in an environment that will provide back lighting. The stained glass effect can be further modified by embedding loose materials in the thick transparent impasto. Roughen the surface of sheet plastic to provide a tooth for the impastos; experiment by painting on translucent fabrics.

Research the work of artists who have used impasto painting. The brushwork of Wayne Thiebaud's 1960s paintings, for example, is worth careful study. The surfaces of these paintings are made up of thick, sensuous globs of paint; although his paintings portray realistic objects—pies, gumball machines, and subjects from the "pop culture"—the artist translates them through simplification and impasto painting. "If you stare at an object, as you do when you paint," says Thiebaud, "there is no point at which you stop learning things about it. If you genuinely are a realist painter, you finally realize that what you are doing is a tremendous amount of adoption, adaptation, and change." Also examine the impasto techniques of other contemporary artists, as well as precursors, such as Nicholas de Staël, Robert Motherwell, and Karel Appel.

PICNIC SCENE
by Roland Petersen, 1980, acrylic on canvas, 30" × 42" (76.2 × 106.7 cm). Courtesy the artist.

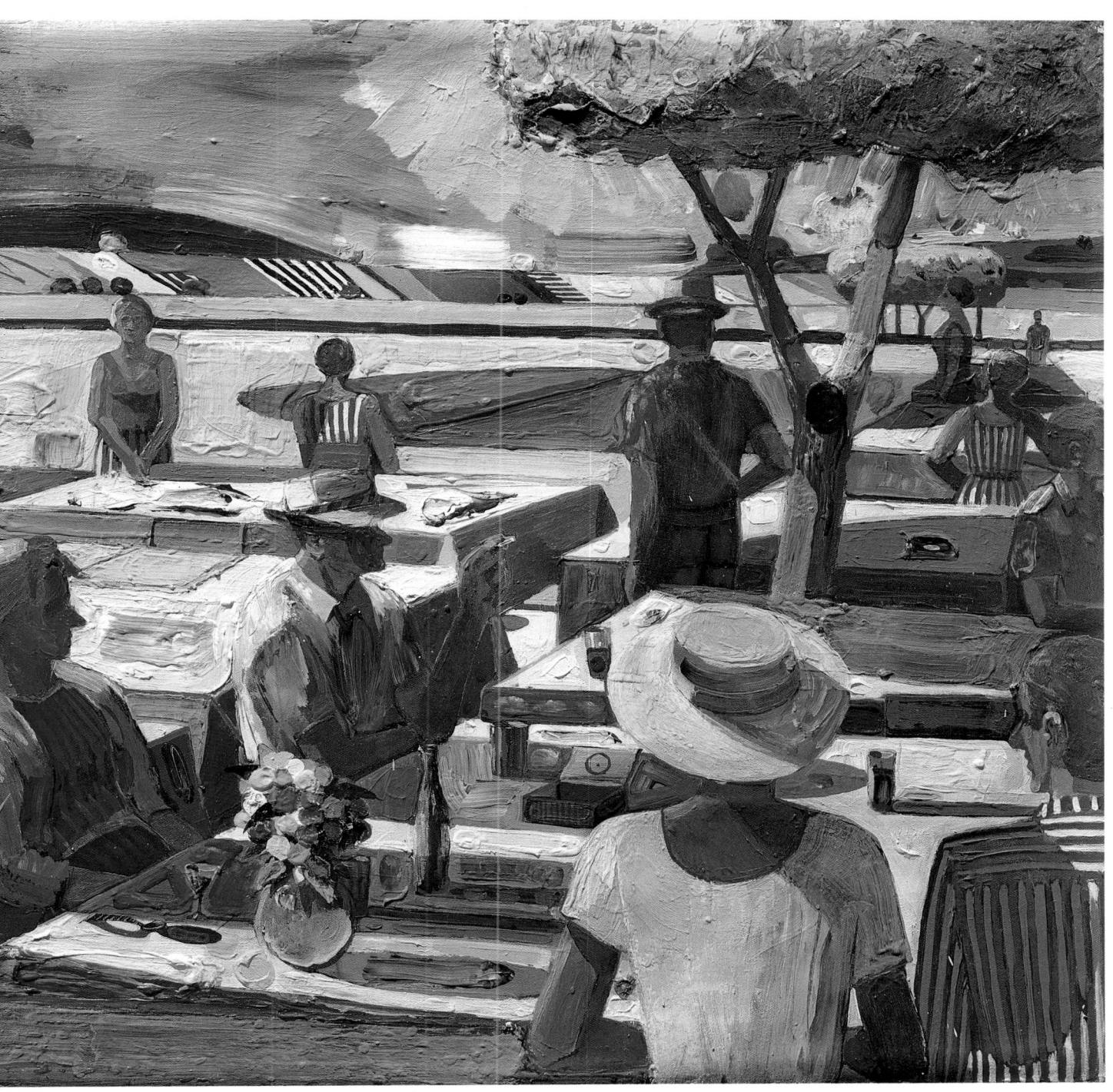

The impact of this painting stems from the use of vigorous brushwork with transparent and opaque impastos. Along with this, the artist also uses sharp color contrast that emphasizes primary colors, and simplified composition. Petersen primes the canvas with white acrylic. Over this, he blocks in passages of color with opaque acrylics to establish the general shapes and composition. Then he begins the process of overpainting with thick transparent impastos, mixing Rhoplex with dry color to produce the pasty colors. Petersen has used the motif of "the picnic" for many of his paintings: "My picnics are about contradictions. It's a good method for setting figures in deep space, yet trying to maintain a flatness of pattern. I often base my ideas on Hans Hofmann's 'push-pull' theory. In my case, I'm trying to work these opposites into all the elements of my painting: textured/smooth, cool/warm, organic/inorganic, life/death, sun/shadow, etc. These all become important juxtapositions in my work." Metaphorically, the painting is also about contradictions: Although the picnic is famous for sharing and fellowship, the artist portrays people in isolation; they are together, yet apart.

Work with Opaque Impasto

The term *impasto* is from the Italian, "impastare," meaning to paste or to mix colors like paste. The term "loaded impasto" denotes a painting that is impastoed with thick pigment that maintains the marks and textures of the brush or painting knife. Acrylic colors mixed with modeling paste (or Rhoplex and filler) provide thick, pasty mixtures. Such mixtures can be applied with a spatula on rigid supports to create rich surfaces and colored encrustations.

Start by reinforcing a rigid support such as plywood or Masonite with wooden strips (glued on the back of the panel) for extra support and insurance against subsequent warping. Select an appropriate motif for this highly textured style, perhaps a simplified or highly stylized drawing of figurative or architectural shapes. Consider, for example, using an extreme closeup of an architectural image such as a window, portion of a building facade, etc. Figurative images or still-life motifs reduced to silhouette-like patterns, as well as uncomplicated nonobjective designs, lend themselves to this medium.

Here's how to prepare the pasty mixtures: First of all, you'll need a thick acrylic medium such as acrylic modeling paste, or Rhoplex mixed with a thickener. The modeling paste is an ideal medium because it is already thickened and ready for use. All you need to do is mix it with acrylic color to produce the colored pastes. To save time, mix the pasty colors before you start painting and store them in airtight containers in preparation for use.

Rhoplex medium provides the toughest crust. This medium has the appearance and consistency of white glue and dries hard as a rock. To make colored pastes with Rhoplex, mix filler (such as silica sand, talc, dolomite, woodflour, plaster, etc.) in a container in the proportion of 1:1 (by volume) with Rhoplex. Stir the mixture and add more filler or Rhoplex until the desired consistency is obtained. Depending on your needs, you can make the mixture viscous, yet pourable, or very thick and puttylike, requiring a spatula for application.

Squeeze the desired acrylic color from the tube into the mixture and stir it until the color is evenly distributed. Because the acrylics contain pigments with very strong tinting properties, only a small amount of paint needs to be added to the mixture.

Depending on your design, consider the following ways of applying the acrylic paste and putties to your support: (1) Pour a mixture directly from the tin onto the support and manipulate it with a spatula or squeegee. (2) Use self-adhering weatherstripping to make a temporary "dam" on the support, then pour a mixture into the shape that has been isolated. (3) Allow impastos to "set" on the support, then trim them with a knife to produce the desired configurations. Don't wait too long, however, because the mixture dries rock-hard. (4) Create embedments by pressing loose objects into the wet impastos. (5) Create textures (wait for the mixture to set slightly) by pressing crumpled paper, screens, etc. on the surface.

Allow the heavily encrusted surfaces to dry completely, then continue with further treatment by applying layers of additional colored impastos, or by scumbling and glazing the surface with acrylic color. Flooding the dry encrusted surfaces with thin acrylic color produces an exciting contrast because the color tends to settle in the shallow crevice areas, while it runs off the raised points, thus emphasizing the three-dimensional character of the work. Drybrushing (dragging dry color over textured areas) is another way to enrich the surface.

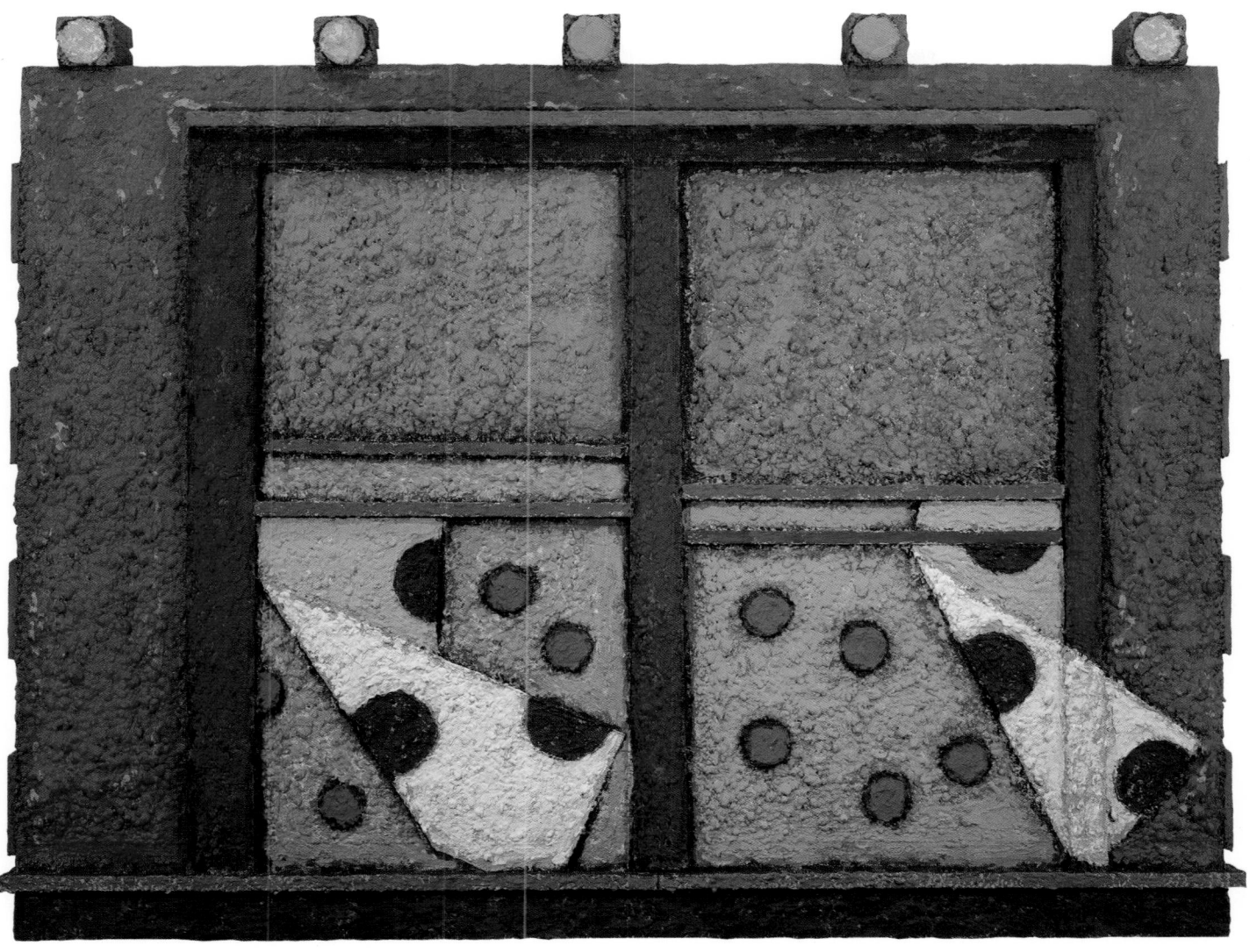

SOUTH ORANGE
by Ralph Humphrey, 1981–1982, acrylic and modeling paste on wood and canvas, 57″ × 73″ × 6″ (144.8 × 185.4 × 15.3 cm). Courtesy Willard Gallery, New York.

To produce this heavily encrusted painting, the artist used acrylic modeling paste (mixed with acrylic paint) on canvas with a wood support. (The detail of the window is made of wood glued to the canvas, reinforcing the surface and making it less flexible.) Humphrey's inspiration for this whimsical painting came from a chance observation of an architectural de-tail—a window in an urban setting. As in the work of Charles Burchfield and Edward Hopper, this work also falls within the classification of "a small townscape." The artist simplified the subject matter, reducing it to a flat cartoonlike pattern to compensate for the dominant use of thick impasto and bright color.

Extrude Color

This unusual technique was brought to my attention by Alden Mason, a West Coast artist who does amazing things with color extrusion; his canvases exhibit an extraordinarily rich color and Braille-like surface texture. *Color extrusion*, defined for the purpose of this experiment, is simply the process of squeezing acrylic paint out an ordinary plastic squeeze bottle. This technique requires no brushes; instead, "drawing" and "painting" is done entirely with squeeze containers, each one loaded with a different color or value, according to the required color scheme.

Properly mixed with acrylic polymer medium, the paint will ooze out of the plastic squeeze bottle thick and viscous, like toothpaste out of a tube; with a little finesse, you'll be able to squeeze out a variety of shapes in the forms of dots, dollops, squiggly lines, straight lines, or calligraphic designs. Bold, rhythmic gestures can be created with a broad arm stroke, while more detailed configurations and allover textures are made with shorter wrist strokes. Acrylic extrusion is like drawing and painting simultaneously. Used more like a pencil than a paint brush, the flexible squeeze bottle can be easily manipulated to dispense paint in either a spontaneous or deliberate manner.

To get started, try some preliminary experiments on a test surface. Load the squeeze bottles with acrylic color mixed with polymer medium and practice extruding a variety of dots, dollops, and squiggles. Experiment with free gesture as well as with precise control. Juxtapose lines close to each other to create textural fields. Try building up layers of spaghetti-like extrusions—one over the other—to create lacy relief textures. Also, use the technique to create "embroidered patterns," graffiti, calligraphic designs, or glorified "doodles." Imagine yourself a cake decorator with a penchant for fine art. Enjoy this opportunity of extending your painting repertoire with nontraditional tools and techniques; who says a painter must use only a brush!

Jackson Pollock dispelled that myth long ago with the introduction of his tachist style. Pollock's technique—the use of a dazzling network of lines—was not used to create representational images, but abstractions with highly active surfaces. Another artist who emphasizes surface texture is Jean Dubuffet, the master of *art brut* (raw art). The power of Dubuffet's work stems from the use of rich textures and simplified visual images. The calligraphic style in art has a rich legacy, developed by artists such as Jackson Pollock, Mark Tobey, and Georges Mathieu, who in turn were inspired by Oriental and Middle Eastern artists and designers.

What kind of design is best suited for an extruded painting? Because of the active surface texture, I would recommend that you stick to a motif of simplified forms and images, such as that in silhouettes, simple contour drawing, or stylized design. Don't be afraid of large spaces in planning your design. Artist Mark Tobey, for example, an exponent of the "allover field," once said: "There is no such thing as empty space, it's all loaded with life. We know it to be teeming with electrical energy, potential sights and silent sounds, spores, seeds—and God knows what all . . ." Seemingly empty spaces—especially in this experiment—will soon become quite active when treated with extruded texture.

NAPOLEON
by Alden Mason, 1983, acrylic on canvas, 80" × 80" (203.2 × 203.2 cm). Courtesy Greg Kucera Gallery, Seattle, Washington.

Plastic squeeze bottles, not brushes, were the "tools" used to create this highly textured work. Squeezed out like toothpaste from a tube, squiggly shapes of acrylic color create a rich and vibrant color field.

Alden Mason—an artist who works exclusively with extruded color—mixed acrylic paint with 50 percent gloss medium to obtain the proper color consistency for extrusion. Lustrous tints and values were produced by mixing Grumbacher's iridescent white with the acrylic colors. The colors, aided by the addition of the polymer medium, dried rock-hard. Critic Delores Tarzan describes Mason's work as a "scalloped embroidery of paint against a dense black ground that makes the colors stand up and sing. . . . From a distance, the image appears to be woven of lustrous silk." Notice how the artist effectively juxtaposed contrasting colors and related values to produce a sophisticated color balance in this painting.

Laminate with Rhoplex

An acrylic *fiber-laminate* is made by bonding or impregnating superimposed layers of cheesecloth (or other lightweight fabric) with Rhoplex emulsion. Like fiberglass lay-up, the acrylic laminate has a plastic "skin," but in this case the Rhoplex laminate is flexible and the material is considered safe for studio use. No dangerous chemicals are used as solvents.

The laminate is made inside a mold (or matrix) made of glass, plaster, wood, acetate, or Formica. A release agent (such as household pastewax or silicon oil) is applied onto the surface of the matrix to allow for easy removal of the subsequent laminate. Laminates made on nonporous surfaces such as glass or acetate do not require a release agent and can be easily removed from their matrix by simply immersing them in lukewarm water.

Here's a good way to start your experimentation in making Rhoplex laminates: Begin by constructing a shallow box that will serve as the matrix. A simple matrix can also be constructed by attaching four wood strips along the edges of a piece of plywood to create a shallow receptacle. Next, apply a release agent over the entire surface, including the wood strips. To do this, first paint the wood with shellac, and when

it dries, apply a thin coat of soap, pastewax, or silicon over the surface. This is to insure that the laminate can be freed from the matrix and not become permanently bonded to it. (Rather than use the release agent, a short cut is to line the wood matrix with acetate film.)

Next, begin the laminating process: superimpose pieces of fabric (any kind of woven material will work), using the Rhoplex emulsion in between the layers as the bonding agent. Paint the laminate with acrylic colors as you go along, brushing or pouring it directly onto the wet or dry lamina. Try sprinkling dry pigment, metallic powders, or other loose materials between the strata, too, into the wet Rhoplex, as well as incorporating "found objects" or interesting "junk," such as glass, mosaic, yarn, cardboard, rope, twigs, mechanical objects, photographs, drawings, graphic images, or other collage elements into the wet plastic emulsion.

Another interesting material to add to this glorified collage is acrylic paint film. The films are "flexible skins" that are made by brushing layers of acrylic paint, thickened with gel medium, onto a piece of glass or acetate. When the acrylic paint is dry, it is immersed (glass and all) in lukewarm water and the film

is loosened and removed. The films can be cut with scissors into special shapes and configurations and then incorporated in the laminate. Use the side of the film that was against the glass; this will have a bright and shiny (and "mechanically clean") surface. Make a few of these "acrylic skins" and attach them to your laminate with Rhoplex emulsion.

If you make the laminate large enough, you can hang it as a free-hanging (or off-stretcher) piece. Otherwise, make smaller laminates and then remove them from the matrix and transfer them to a stretched and gessoed canvas or panel. Again, Rhoplex is used to glue elements to the canvas support.

Remember, Rhoplex is a strong glue and can be thickened with fillers such as talc, crushed marble, sand, or plaster, which are added to it to create pasty mixtures for textural effects.

After the laminate is removed from the matrix and attached to the canvas, continue to work on it if necessary by using scumbling and glazing techniques with acrylic color. If you choose to make a free-hanging laminate, work in a larger matrix and add a couple of brass grommets from which to hang the laminate.

NAG-HRAD

by Terence La Noue, 1981, Rhoplex, fabric, and acrylic on canvas, 95" × 84" (241.3 × 213.4 cm). Courtesy Nancy Hoffman Gallery, New York.

Rich in color and texture, this free-hanging acrylic laminate was made by impregnating tobacco cloth (a lightweight fabric) with Rhoplex acrylic emulsion. Many layers of fabric were bonded together to produce a tough, yet flexible "skin." The laminate was made in a shallow box (made of hardboard), which served as the matrix. Its surface was waxed and treated with a mold release. After it was removed from its matrix, the

laminate was further manipulated— gouged, torn, incised into, built up— and then transferred and attached to an unstretched canvas with Rhoplex. Although La Noue's laminate is reminiscent of an exotic tapestry, which, according to the artist, is inspired by ornamental color and pattern of ancient Indian art, it also has references to twentieth-century painters such as Jackson Pollock, Willem de Kooning, and Robert Rauschenberg.

Mold Shapes and Textures with Fabric

Fabrics saturated with Rhoplex can be molded to form three-dimensional shapes and textures that will dry rock-hard.

You'll need the following materials: (1) Rhoplex emulsion (AC 234, manufactured by Rohm and Haas Company, available from most art supply stores); (2) a support—canvas, Masonite or plywood if you are making a bas-relief, or wire mesh or expanded metal if you are doing a 3-D shape; (3) fabric that is to be soaked and shaped, e.g., cheesecloth or any loose, open-weave fabric.

Assuming you are opting to create a polychromatic relief, start by priming the support, say a stretched canvas, with acrylic gesso. Next, manipulate a piece of fabric (such as cheesecloth) on the canvas by gathering, folding, pleating, or pinching the material to form the desired shapes. With a house painter's brush, dab the material with Rhoplex emulsion as you go along to adhere it to the support. Dampen the fabric slightly with water ahead of time so that it will be easier to handle. There are many fabrics that can be used with this method, ranging from light, open-weave cheesecloth to burlap, canvas, or more densely woven fabrics. Even articles of clothing can be saturated with the acrylic emulsion and molded to form various shapes and configurations. The cloth can also be "collaged" in layers on a flat support, as well to three-dimensional objects. To prepare cloth for collage, simply cut individual pieces of fabric, dip them in a shallow bowl of thinned Rhoplex, and then press them onto the support. Another way is to brush Rhoplex onto the back of each cut-out shape, then press it to the canvas. These elements, too, can be folded, crumpled, and/or overlapped to form high reliefs. Rhoplex can be thinned substantially to penetrate loose-weave fabrics without losing its adhesiveness. It can also be thickened, if desired, to become pasty—like clay—by adding fillers such as whiting, sand, silicate aggregates, marble dust, or plaster.

When the Rhoplex-impregnated surface is dry, it can be painted or scumbled with acrylic paints. Here are a few ways to apply the color: (1) Thin acrylic color to a milklike consistency and pour it directly onto the sculptural form (the canvas is laid flat). Then, with a sponge, spread the color over the surface and work it into the cloth. Next, use a clean sponge to remove excess paint and wipe the salient areas clean. (2) Another technique that can be used in conjunction with number 1 is to scrub, scumble, or drybrush acrylic color over the relief surface. (3) A third method is to spatter, stipple, or stencil color in selected areas. (4) Beautiful effects—thin mists of blended color—can be produced with an airbrush or spraygun held at an oblique angle to the work. Use one or more of these techniques in your work, along with any other method you feel is appropriate to your subject.

Rhoplex is a milky-white liquid that dries clear. Like white glue, it has very strong adhesive properties that make it ideal for saturating and molding fabric into three-dimensional shapes, or for making fabric collages. Although the regular polymer medium, mat medium, and white glue can also be used to impregnate fabrics, these materials do not produce the tough shell Rhoplex does.

A note of caution: Acrylic emulsions contain ammonia and formaldehyde in their formulation. (Ammonium oleate is used as an emulsifying agent and formaldehyde is used as a preservative). Toxicologist Michael McCann, author of *Artists Beware*, says that the small amounts of ammonia and formaldehyde used in acrylic emulsions should not pose a health problem unless you use large quantities of the emulsions in unventilated areas, or if you are already sensitive to the chemicals. As a safety precaution, however, always provide for adequate ventilation while working with these materials. Unlike the toxic polyester resins, however, which were widely used by artists in the 1960s to impregnate Fiberglas cloth and fabrics, the acrylic emulsions are considered safe for studio use, provided you take the precautions mentioned above.

Although delicate as a rose in appearance, this canvas-relief is actually constructed of a coarsely woven cheesecloth. The gauze fabric was saturated with Rhoplex emulsion as it was manipulated on the canvas to form the rosette configuration. The work is made up of a single continuous piece of cheesecloth, carefully folded and pleated to produce the outwardly spiraling shapes. The Rhoplex-saturated fabric dried rock-hard and was then painted with acrylic colors. With the work laid flat, the artist poured thinned acrylic paint over the surface and then blended the color with the aid of a sponge. Most of the color, in fact, was wiped from the surface with the sponge, leaving only the pigment that had penetrated to the underlying layers of the gauze. The top layer was wiped clean as one would wipe an etched plate being readied for printing. The Rhoplex acted as a "resist" in those areas where it was thickly brushed, and less so in other areas where it was thin, thus creating its own color pattern. Generally speaking, the acrylic paint was applied very thin, allowing it to stain the cloth without a buildup of pigment or brushmarks. For the final touch, the artist placed the canvas upright on an easel and applied accent colors with small brushes to emphasize forms and edges.

Experiment with Resist Effects

Like batik, in which designs are produced by the action of water and wax—two antipathetic materials—this "acrylic resist" method, too, is based on the use of materials that are naturally resistant to each other. Beautiful surface textures and effects can be created with this technique—effects not possible when using only a single medium.

Besides wax, you can use rubber cement, white (or Elmer's) glue, clear polyurethane coating, silicon, or liquid masking film as a resist medium.

Suggested basic steps for doing a resist painting are as follows:

1. Collect the art materials required (acrylic paints, a gessoed canvas or another suitable support, and your choice of a resist medium). The canvas can be white or painted with a light color.

2. Create an image or background pattern with the resist medium on the canvas and allow it to dry. (Use either brush, stipple, sponge, or drip methods to apply it.)

3. Brush thinned acrylic paint over the entire surface of the support. (You'll notice that the paint will not adhere very well to the areas painted with the resist medium and will immediately flow away or break up into textured patterns).

4. Allow the paint to dry, then continue with an additional application of resist medium.

5. Again, allow the resist medium to dry, then paint over the surface area with a thin acrylic glaze of a contrasting color.

6. Repeat the process until the painting is completed.

These steps don't have to be followed in exactly the order outlined, but can be altered to suit the technical demands of your work. Before starting a resist painting, however, experiment first with some of the materials mentioned on a test surface of canvas or panelboard. With the support laid flat on a table, apply the resist medium in both spontaneous and deliberate fashion. For example, if you use white glue as a resist, try extruding the glue directly from the plastic squeeze bottle spontaneously, using sweeping arm gestures, as well as in a deliberate manner, holding the squeeze bottle like a pencil. Try producing both free-flowing and controlled lines and textures. Or, using a small piece of cardboard, squeegee the glue over the support for additional textures and shapes. When the glue is dry, brush the fluid acrylic color over its surface. You'll notice that the glued area will tend to repel the color, producing interesting effects. Repeat the operation as many times as required until the painting is completed. To heighten contrast, wipe the wet color lightly with a soft cloth as your work progresses.

Try experimenting with wax as the resist medium. Any type of wax will work—crayons, paraffin, beeswax, or candle wax. Unlike the batik method, however, the wax does not have to be subsequently removed, but can be allowed to remain on the surface of the support if desired (providing, of course, that it is not applied so thickly that there is a danger it will fall off later). Draw with white or light-colored wax crayons, or drip candle wax, or use hot wax with a brush or a tjanting tool (an instrument used in the traditional batiking process). Consult books on batik for information about tools, preparation, and application of wax, as well as safety precautions.

For sharp, hard-edged patterns and controlled designs, apply several coats of a masking film such as GripMask over a well-gessoed canvas or panelboard, allowing each coating to dry before applying the next one. When completely dry, GripMask produces a thin, transparent, bluish film. Cut the film with a sharp knife following the configuration of an underlying drawing on the support. Care should be taken, of course, not to cut past the masking material and into the canvas. When the acrylic colors are painted over the masked surface, only the open areas receive the color, while the others are protected. Later, when the paint is dry, peel off the protective masking to reveal the design. Intricate designs and patterns can be created through successive repetitions of this process.

Another unusual approach in using acrylic-resist was brought to my attention by Ann Rinehart, a San Francisco Bay area painter. In this method, clear polyurethane coating (a type of varnish available from a paint store) is used as the resist medium. The polyurethane coating is brushed over selected areas of a gessoed canvas or panel and allowed to dry. Then the acrylic colors are applied over this surface, again using a soft cloth to selectively remove some of the color from the surface as the work progresses. Care should be exercised when working with clear polyurethane coating, however, because the fumes are potentially hazardous to health. Use adequate ventilation, protective mask, and follow manufacturers' recommendations carefully as to its use.

ICE CAN MELT
by Ann Rinehart, 1982, acrylic and mixed media on canvas, 36" × 37" (91.4 × 94 cm). Courtesy the artist. Photograph by Mike Robinson.

Clear polyurethane coating was used as the "resist" medium in this painting. With the canvas laid flat, the artist established the basic imagery by brushing the polyurethane on the surface with bold strokes while interpreting a preliminary sketch. By tipping the canvas while the polyurethane was still wet, she was able to produce an interesting "stalactite" pattern. The effect was emphasized by repeating the process several times, each time tipping the canvas in a different direction.

Rinehart explains: "The image painted with the resist medium was kept vague and suggestive—no strong outlines. Then, reacting to the spontaneous shapes that were generated, I brushed on the first coatings of acrylic color, at first painting around the urethane shapes, rather than on top of them. This step was to emphasize the pictorial shapes. Next, I brushed thin acrylic glazes over the entire surface, layering up to ten colors on the canvas. The acrylic

paint was thinned to a consistency of skim milk with water and polymer medium. After each glaze application, I removed some of the color from the surface with a tissue while the paint was still wet. I worked outdoors on a bright sunny day and the glazes dried rapidly, allowing me to layer them in quick succession. When the glazes were dry, I carefully sandpapered the canvas, burrowing through some of the more opaque layers of color to achieve the final effect."

"Print" Textures

John Lidstone, in *Reinhold Visuals* (Portfolio 4) writes, "No matter how much intrinsic interest an object has, when it becomes part of a conglomeration in which no part is given predominance, it becomes surface, rather than shape. [With] such an abundance of objects the individual identity of each is less important than the tactile quality it contributes to the whole."

The aim in this experiment is to work with *surface* in an entirely different way and to create a texture painting with unorthodox tools. Use a variety of geometric and/or free-form shapes in your design but, in keeping with the concept in the above quotation, make them all textured—like the background—so that a holistic, nonrelational quality is generated. The production of a total, holistic pattern is seen in the style of "field painting," in which an overall regularity of brushwork is relieved only slightly by visual accents. A good analogy is an allover composition made up of pebbles on a beach, which are part of a visual field of similar shapes, yet provide some accent through the uniqueness of their color and texture. Keeping in mind the overall field, print texture with the unorthodox tools and emphasize surface rather than shape. Strive to achieve a continuous field—a conglomerate of interwoven textures—broken only by visual accents, which should also be textured.

To get started, round up some household gadgets and materials you think would make good "printing" tools. For example, experiment printing acrylic color with a sponge, coarsely woven fabric, wadded newsprint, corrugated cardboard, a modified brayer (wind string or fabric around it), paint roller, or squeegee, along with any other household gizmo you think will serve this purpose. The idea is to daub, press, print, or stencil the acrylic colors with these tools to develop a rich surface. Use conventional tools, too, but use them in unconventional ways. Bristle brushes, for example, can be used to dab or print color through wire screen or paper stencils.

Start by brushing solid areas of color on the support as an underpainting. Then apply the texture so that eventually the entire surface will be treated. Try making some printing gadgets with coarsely woven fabric. Glue the material to plywood blocks, then use a flat sponge, soaked in color, as a printing pad. Experiment and improvise.

Control the tonality of the surface by varying the nuances of light-to-dark textures, as well as textures that vary between sharp and soft focus. Work with an abstract design, such as a composition made up of geometric or freeform shapes, as a motif. Your support should be a good grade of watercolor paper. First, paint the underpainting, then apply an allover texture with one or more of the improvised tools. Next, cut out stencils from heavy wax paper (or buy some commercially prepared stencil paper) to conform to the shapes of your composition. Then, one by one, take each stencil and print a texture through it and onto the support. Also print directly onto the support without the use of the stencils. Overlay as many textures as required until a rich and exciting surface is created. Another approach is to print textures on separate sheets of paper, or on canvas, and then cut them out and "collage" them to a larger textured support.

#17 BERN SERIES

by Robert Natkin, 1979, acrylic on paper, 30½" × 23" (77.5 × 58.4 cm). Courtesy Gimpel and Weitzenhoffer Ltd., New York.

The entire surface of this painting is textured with unorthodox art tools— makeshift "printing stamps" made of coarsely woven fabric. The design in this painting tends to minimize figure-ground relationships and, instead, evolves from a kind of "scatter-balance"—the artist's description of his composition. Although certain freeform shapes are distinguishable, they are integrated by texture into the overall visual field. Natkin serendipitously daubed, rubbed, and "printed" acrylic paint from materials such as burlap, cheesecloth, and other screenlike materials. The overlays of texture upon texture combine to produce a rich textural pastiche and exciting surface. The amoebalike forms within the composition recall the work of Paul Klee.

Paint Oils over Acrylics

The art critic Michel Seuphor once wrote, "It seems that art today, like a man, walks on two feet, a left foot that conquers, a right foot that holds. They complement, rather than contradict each other." Art, like man, has passed through many epochs and cultures and throughout its journey has seen many transformations brought forth by technological advance and social change. It has seen excellence achieved by past generations. The educated man of the present century is sensitive to the accomplishments of his predecessors and does not deny himself the wisdom and achievement of the past. Like Seuphor's man, the sensitive artist "walks on two feet"—one that respects and holds onto his rich heritage and the other that strikes out in search for new ways, methods, and techniques.

A good example of a particularly successful combination of the old and the new is the technique of painting the classic medium of oil over the contemporary medium of acrylics. To try your hand at combining these two media, start by using the acrylics first. Their purpose is to provide the underpainting. Because they are fast drying, you can work rapidly. The advantage is that there is no long wait for the underpainting to dry before the final overpainting and glazing in oils can commence. "Always fat over lean," is a caution to remember while working with this tandem media. Remember, oil paints adhere beautifully to acrylic surfaces, but the reverse is taboo. Acrylics simply won't stick to oily surfaces.

As you prepare your oil and acrylic palettes for this experiment, keep the two distinct stages in this painting technique in mind. The first stage—which involves doing the underpainting—is executed in acrylics and serves to establish the general configuration, composition, and underlying color for the painting. New York artist Morton Kaish—who has standardized this method—starts his underpainting on a white gessoed canvas with bright primary colors, rarely going beyond the secondaries for his preliminary work. At this stage, he uses no black or white for the underpainting, preferring instead to apply brightly colored washes. Corrections are made by simply covering undesired areas with acrylic gesso, and overpainting them. Next, the underpainting is developed further by brushing thicker impastos over the lighter areas in the composition (titanium white is mixed with acrylic colors), while the dark areas are allowed to remain flat and transparent.

In reality, there are no hard and fast rules governing how one should execute an underpainting. Some artists, for example, prefer to use only monochromatic colors for the preliminary work, or perhaps limit themselves to tones of black, white, and gray (grisaille). The best method is the one that suits your preference and style.

The brushstrokes in the underpainting can be smooth, vigorous, or highly textured. (Gel medium or acrylic modeling paste can be added to acrylic color to produce heavily textured brushstrokes.) When you are finished with the acrylic underpainting, isolate it with a thin coating of acrylic mat medium. At this point, switch to your oil paints to complete the painting. Apply the oils by using glazing and scumbling techniques.

Glazing enriches the painting immensely, brightening colors in a way that is not possible with other techniques. (Glazing is analagous to layering colored cellophanes over painted surfaces.) Light striking the canvas enters the transparent paint film and is refracted from below and within it to produce a rich, glowing effect. Glazing, too, is a way of producing "optical"—rather than pigment—mixes. For example, if you apply a red glaze over a yellow ground, a bright orange hue is produced. This "optical mixture" is much brighter in intensity than one produced by simply mixing yellow and red pigment. For getting the best results from oil glazes, follow the traditional process of always layering dark hues over light ones. You'll also notice that glazing emphasizes the brushwork in the underpainting as well as the texture of the canvas. Exploit this characteristic by manipulating the brushwork accordingly and selecting a support with an appropriate surface texture.

How do you actually make a glaze with oil paints? To produce a glaze, all that is required is to thin the oil paint slightly with a painting medium (made up of stand oil, damar varnish, and tur-pentine) so that it becomes transparent. Some preliminary experimentation will inform you which colors yield the brightest and most transparent effects. Oil colors can also be made transparent by "rubbing them out" on a receptive surface.

Here's a standard recipe for mixing a glaze medium (from *The Painter's Guide to Studio Methods and Materials* by Reed Kay):

3 parts by volume of stand oil

2 parts by volume of damar varnish (5 lb. cut)

3 parts by volume of pure spirits of gum turpentine

1 or 2 drops of cobalt dryer per pint of medium

How do you scumble with oil paints? Scumbling is a term used to describe the technique of "scrubbing" paint onto the canvas with a brush to produce opaque or semiopaque effects. This method of applying color does not necessarily have to conceal all of the underlying color but allows part of it to show through and interact with the scumbled color. Lighter colors are generally scrubbed over the darker ones. Experiment with different scumbling techniques; mix some white oil paint with oil colors and scrub them over a test canvas to explore the potential of this technique. Study the techniques of glazing and scumbling by examining exemplary work in museums and art galleries.

To finish up your painting, apply a coating of damar retouch varnish over the surface. This temporary varnish is used simply to brighten "sunken-in" areas of the oil painting and to protect the surface until it is sufficiently dry for the final varnishing. (It is recommended that you wait at least six months for an oil painting to dry before applying the final protective coating of varnish.) As a final varnish, Reed Kay recommends the following mixture: 4 ounces of normal 5-lb. cut damar varnish with 2½ ounces of fresh gum spirits of turpentine. Note: a small amount of stand oil (up to 5 percent of the volume of the diluted varnish) may be added to the varnish to increase flexibility.

RED CHAIR WITH WILDFLOWERS
by Morton Kaish, 1983, acrylic and oil on canvas, 32" × 40" (81.2 × 101.6 cm). Courtesy the artist.

The brilliance and complexity of color in this painting is produced by layering thin oil glazes over an acrylic underpainting. "My colors evolve as 'optical mixes' rather than pigment mixes—sometimes overall, sometimes broken," says the artist. "For me, glazing with oil over acrylic provides the means of reaching degrees of complexity—and simplicity—not available in any other way." Kaish created this painting in two stages. First came the underpainting, composed of thin transparent tones of acrylic color over a gessoed canvas. Much of the color in the underpainting is of primary hues; Kaish rarely ventured beyond using secondary colors at this preliminary stage: "I used no white, no black; it was a longish beginning with many changes, all facilitated by the quick-drying acrylics, and being able to paint out and back to the ground with acrylic gesso. At this early stage, I gave the painting its structure of color and value and tried to resolve all of the drawing problems, leaving it at about a finished 'watercolor-like stage.' Next, I added titanium white acrylic to my palette and created tints and then impasto in the lights—the dark areas remained transparent. The painting could, in fact, have been called complete at that point, but for me, moving on to the use of oil colors affords an opportunity to push my painting to a level of greater subtlety and resonance."

The oil paints were made into glazes by thinning them out with the traditional medium: stand oil, damar varnish, turpentine medium—with a few drops of cobalt dryer.

Use Graffito

Essentially, the graffito technique is the process of scratching or incising lines through the surface of a paint film to reveal an underlying color. Suitable supports are canvas, Masonite or wood panel, and paper. Graffito is sometimes called sgrafitto (which means "to scratch"), or Castellan decoration, so called because of its origin in the decoration at Citta di Castello in Umbria, Italy.

Modern methods are offshoots of the Italian graffito, which was used extensively by Medieval artists for designing church panels and plaster wall paintings. Contemporary ceramicists and potters continue to use grafitto as a principal means of decorating pottery. Commercial artists, too, use a form of graffito in the scratchboard technique, a method in which the surface of a special clay-coated paper is first painted in black India ink and then incised with a pointed tool to reveal a design in white.

To use graffito with the acrylic colors, first paint with the acrylics on a gessoed canvas or Masonite panel to produce an underpainting in selected hues and values. (Note that these hues will determine the colors of the lines that will be subsequently incised.) When it is dry, paint over the undercoat with a second application of acrylic paint, this time in a contrasting color. While the second coat is still wet, scratch through its surface with a pointed tool (such as a palette knife, nail, sharpened stick, etc.) to produce the design.

Try various ways of using graffito in your own work. Through experimentation and trial-and-error, you'll discover additional ways of applying this technique to acrylic painting. Some artists, for example, have found that by painting the ground color and then covering the area with pastel or water-base crayon before applying the top color, they can produce ultra-clean lines in

the subsequent graffito work. The application of crayon or pastel between the two layers of acrylic paint seems to be a special aid in the production of the sharply defined graffito.

When you combine the graffito technique with acrylics, the paint consistency remains the same as any other form of acrylic painting. If you want, however, you can thicken the colors for sculptural effects by simply adding a filler such as Polyfilla, Spackle, acrylic molding paste, or plaster. (The mixture can be made stronger by adding some Rhoplex emulsion to it.) An advantage of using thickened colors is that you can make deeper incised lines through the subsurfaces of the painting. Remember, however, to apply pasty colors on a rigid, rather than a flexible support to avoid the possibility of cracking. Another precautionary measure is to reinforce the back of Masonite or wood paneling with wood strips.

BIRTH OF APHRODITE
by Harry Koursaros, 1982, acrylic on canvas, 60" × 45" (152 × 114 cm). Courtesy Haber Theodore Gallery, New York.

The work of Harry Koursaros has been aptly described as "pattern painting"—a design approach that involves a programmed repetition of image, shape, and color. An underlying grid is used as a pictorial device to unify the diverse elements in the composition. Notice how the delicate lines work in counterpoint to the bold shapes and bright complementary colors. The lines are drawn to produce a positive-negative counterchange pattern. The "negative" lines are done in

graffito, produced by "scratching through" acrylic paint coatings to the subsurfaces of contrasting color. The areas earmarked for graffito were first painted in yellow. These parts were then covered in pastel (using artists pastel sticks) and painted a second time with darker, contrasting coats of blue, black, and red. While the second color was still wet, the artist incised the images with a palette knife, producing the yellow line drawings.

Combine Acrylic and Graphite

Curiously, what we normally call a "lead" pencil is not made of lead at all, but of graphite and clay. The degree of hardness in drawing pencils is classified from 9H (extremely hard) to 7B (very soft). The hardest (which produce the lightest tones) are 9H down to 2H; medium are HB, F, and H; and soft (which produce the darkest tones) are B up to 7B.

Striking effects can be created by combining two contrasting, yet compatible mediums: graphite and acrylic paint. Graphite is available in the form of pencils and sticks (like Conté crayon), as well as in powder form. Graphite powder is normally used as a

lock lubricant and available from most hardware stores. As an art medium, powdered graphite can be applied to drawing paper with a tortillion.

Paper and pencil have an interesting interaction. The paper's surface acts like sandpaper in that it "wears away" particles of graphite from the pencil; these are embedded in the interstices of the paper. The reason it's difficult to draw on perfectly slick or glasslike surfaces is that such supports lack this important "filing" action.

In addition to paper, other supports you can use for this mixed media technique are gessoed canvas, cardboard (museum mounting board provides a

good acid-free surface), gessoed Masonite, and plywood panels.

Gessoed panels provide excellent supports for pencil work. To prepare a panel, brush several coats of thinned acrylic gesso on the smooth side of untempered Masonite. Sand the gessoed surface between coats with fine abrasive paper to achieve a smooth surface. The use of a spray gun to apply the gesso provides the "cleanest" surface. Before applying gesso to a Masonite panel, however, glue wood strips on the back to prevent warping.

Start this experiment by stretching a good grade of paper on a drawing board. What kind of paper is best? A

heavy-duty watercolor paper, say a 100 percent rag paper with a medium-rough surface, is among the best choices. To keep the surface flat while you work, it is important to stretch the paper on a drawing board by first soaking it in water and then taping it to the board. The paper will dry drum-tight. Next, brush the surface with acrylic gesso (or gesso mixed with a selected acrylic color) to provide the support with a "tooth" (and color if required) for the work in pencil and graphite to follow. Remember that the quality of the paper on which you will be working is important because this technique demands a surface that is sympathetic to both a wet and dry medium.

There are two basic approaches to combining these two mediums. You can: (1) Use acrylic paint (which has been thinned with water) as a wash or a glaze over a completed pencil drawing; or (2) Brush acrylic color in an opaque or transparent manner on paper or gessoed Masonite and then draw over the dry surface in pencil. (The two methods can also be combined to obtain further variations.) Consider, too, using the acrylic-graphite medium in concert with collage or montage techniques (drawing and coloring over cut and pasted drawings, photographs, photocopied or magazine images).

What kind of pencil drawing technique is best suited for this mixed-media approach? The emphasis here should be on experimentation. Try making some drawings that emphasize only line, others that emphasize tone, and some that interrelate a sensitive contour line with chiaroscuro. Make a line drawing with value gradients produced by hatching, cross-hatching, or by drawing tiny squiggly lines close together. Make continuous tone drawings by blending light and dark values with the pencil, blending tortillions, or just your fingers.

CITYSCAPE GOLD

by Sonia Gechtoff, 1981, acrylic and pencil on paper, 40" × 62" (101.6 × 157.5 cm). Courtesy Gruenebaum Gallery, New York.

The interplay of light and shadow, the artist's principal concern in this painting, is poetically expressed in mixed media of pencil and acrylic. Stylized to the point of geometric abstraction, this urban landscape is painted in bright acrylics on a 100% rag paper. In a meticulous pencil rendering, Gechtoff applied a contrasting chiaroscuro—dramatic values of light and dark—over the underlying colors of yellow, violet, blue, and green. In preparation for the pencil work, the artist used a wide brush to apply the acrylic color in flat color. Acrylic gesso was mixed with the acrylic color to provide the surface with a good "tooth" for the pencil work. According to Gechtoff, the composition was not painted directly from a single subject, but, rather, from both "objective and subjective stimuli," a pictorialization of her "observations, memories, and feelings."

Use Acrylic-Coated Paper for Collage

The thing that makes collage art different from other artforms is more than just the materials used in its production: it is the artist's sensibility and attitude toward this idiom. An insight is offered by Matisse, who said, "To make découpages, you draw with the scissors—it reminds me of direct carving in sculpture."

As an artform, collage began as a nineteenth century folk art, originally dubbed *papier collé*. Today, it's a standard studio practice and has been given a new dimension by the introduction of acrylic media. In the early 1900s, collage was used as a fine arts medium by the cubists. Picasso created *Guitar* in 1913, a work in which he combined paper collage with crayon drawing. In the same year, Guillaume Apollinaire proclaimed collage an "official" art medium when he wrote, "You may paint with whatever materials you please: with postage stamps, postcards, playing cards, or painted paper!"

The activities in this experiment are divided into four parts: (1) producing acrylic-coated papers; (2) designing a composition appropriate for a collage; (3) cutting (and/or tearing) papers into required shapes and configurations, and; (4) executing the collage by pasting the materials on a suitable ground.

You may opt to create a collage using only hand-painted papers, or combine them with other commercially printed papers such as colored sheets, fragments of lithographed posters or billboard ads, decorative papers, magazine cutouts, etc.

Let's start by making the acrylic-coated papers. Add a little water and polymer medium to acrylic paint to obtain good brushability. Then apply the color over the surface of a good quality rag paper. Produce as many colored sheets as your project requires. Make the sheets in varying hues, tones, and textures; paint some papers with flat and opaque color, others in graded or water-thin washes. Use a brush, airbrush, sponge, or squeegee for creating various effects. Experiment with devices not commonly used as art tools for additional textures.

Many excellent fine art papers are available commercially and come in a variety of weights, surface textures, and sizes. Also look into the possibility of manufacturing your own pulp for use in this collage experiment.

Depending on your budget, consider using some of the better handmade or mold-made papers. Good-quality rag papers and Japanese rice papers provide excellent surfaces for acrylic watercolor washes as well as for opaque coatings. The translucent Japanese papers are particularly good for collage-on-collage, the technique of superimposing papers to obtain veils of density. To cut the paper into desired configurations use regular scissors, pinking shears, knives or cutters, or use your fingers to tear the paper into interesting ragged or deckle-edge shapes.

Incidentally, in order for an art paper to be legally labeled as having rag content, it must contain a minimum of 15 percent cotton fibers. What this means to the artist is that the higher the rag content, the greater the strength of the paper—and the more it will withstand the rigorous manipulations of experimental painting styles and techniques.

A final note about the selection of good-quality art papers. Two major factors determine the longevity of paper:

the rag content and the pH. A paper's pH refers to its acid/alkaline balance, rated from 0 (acid) to 14 (alkaline). Low-quality papers, like newsprint for example, have a high acid content and tend to discolor rapidly. On the other hand, papers labeled "pH neutral" have the most desirable acid/alkaline balance and are the ones that offer the greatest permanence.

In selecting a design for your collage, keep in mind the fact that the most successful compositions involve stylized or highly simplified images such as silhouettelike patterns. For preliminary research, examine the paper collage work by Pablo Picasso, Georges Braque, Juan Gris, Henri Matisse, Sonia Delaunay, Jean Dubuffet, and Robert Motherwell. These painters, along with other contemporary artists, have pioneered and elevated collage to the respectable status that it has today.

What kind of glue is best for paper collage? The ones offering the greatest permanence of adherence are white glue and the acrylic polymer mediums. Traditional pastes and glues have too many shortcomings for use in collage. Although the acrylic mat medium is a good varnish for use as a protective coating of finished work, its adhesive properties are not as strong as the gloss polymer medium or the Rhoplex AC 234 medium.

To protect the surface of your completed paper collage, apply either mat or gloss acrylic picture varnish, or a clear spray coating such as Krylon clear spray coating. (Exercise caution and heed manufacturers' warnings when using aerosal sprays.) Still, the best way to protect collages is to simply frame them under glass.

BEVERLY HILLS FOREST
by Arthur Secunda, 1980, acrylic-collage, 38"
× 42" (96.5 × 106.7 cm). Photograph courtesy
the artist.

A substantial portion of this collage is made from acrylic-coated papers that are torn and cut, combining the techniques of découpage (cutting and pasting) and déchirage (tearing and pasting). Secunda prepares his collage papers by several means: direct brush-painting, airbrushing (for graded tones), and "printing" with a sponge for textural effects. "Technically speaking, Beverly Hills Forest is a mixed-media work," comments the artist, "since as well as acrylic-coated pa-

pers, I used oils and lacquers, as well as fragments of actual torn lithographs and silkscreens glued to it. In addition, I even collaged pieces of hand-made paper and colored papers onto some surfaces." Notice how the paper is torn to produce deckled edges and irregular white contour lines, both of which supply a fresh and spontaneous quality to the work and serve as a buffer between the brightly colored shapes.

Explore Canvas Collage

In this technique, canvas and fabric—rather than paper—are used as the collage medium. These materials provide the flexibility required for developing the layered and sculptured surfaces in this unique collage idiom. Aside from canvas and fabrics, you'll also need the following: a "glue" with which to attach the cloth cut-outs; and selected acrylic paints for color and texture.

The principal collage elements are comprised of shapes made of painted canvas that have been cut into various configurations with a knife or scissors. They can be made to be precise, hard-edged geometric shapes; free-form shapes with irregular or frayed edges; or sculptured shapes with folded, crumpled, or monolithic form. The component shapes in the collage can be prepainted or stained before being glued to the canvas' surface, or left unpainted before assembly for subsequent color treatment.

The most direct way of making a canvas collage is to lay a stretched and gessoed canvas (or a panel) face up on a table and then arrange the canvas and cloth cut-outs over its surface to develop the composition. In this preliminary stage, you can either follow a rough pencil drawing on the canvas, or work directly and spontaneously without one. Before they are glued down on the canvas, however, some of the shapes may be further manipulated (or "distressed") by scorching, burning, abrading, or shearing processes. Worn sacking, burlap, yarn, and cloth remnants are other materials that can be incorporated in this collage technique.

After a satisfactory arrangement is made, the components are permanently attached to the canvas with a polymer adhesive. Recommended adhesives are Elmer's white glue, acrylic polymer medium, or Rhoplex medium (AC 234). The Rhoplex medium is probably the strongest "glue" for adhering cloth and miscellaneous objects to a painting ground. While arranging the component shapes on the canvas, however, you might try saturating some of them with the adhesive (mixed 1:1 with water). The glue-soaked shapes can be manipulated on the canvas to produce sculptured forms and textures. The impregnated materials will be firmly attached to the surface and will dry rock-hard.

The final stage in canvas collage involves the process of surface enrichment with acrylic colors. Scumbling and glazing techniques provide the finishing touches. In scumbling, the brush, which is charged with paint, is "dragged" over the textured areas. This technique enlivens the surface by depositing contrasting color over the salient parts of the collage. Glazing—the technique of applying thin washes of color—provides transparent color qualities, as well as "pools" of color contrast. Other techniques such as spattering or spraying color can also be used to complete the collage. Staining is also an effective technique, but should be used on unprimed canvas shapes.

Try to think of canvas collage as both an additive and subtractive medium—as an artform that is both sculpture and painting. Build up overlays of cloth, then cut back into them to reveal some of the underlying surfaces. Block out unsuccessful parts of your collage by simply painting them out with acrylic gesso, or by overlaying them with fresh canvas shapes.

LAYERS AND LEVELS

by Louise Kaish, 1980, canvas-collage and acrylic, 11½" × 10½" (29.2 × 26.7 cm).
Courtesy Staempfli Gallery, New York.

Louise Kaish likes to think of her composition as a "small world." Her heavily textured collage is fabricated with layers of canvas and cloth, lovingly "abused," colored and sandwiched together with acrylic mediums. With careful attention, she built, tore away, scraped, scorched, burned, and colored the layers and surfaces of the collage. Notice that an underlying grid is evident in this composition—a device that serves to unite the various elements in a seemingly casual, yet controlled, horizontal/vertical alignment. Kaish is a former sculptor who has turned to painting, yet an artist who retains the sensibility of the sculptor in her approach to canvas collage. Says the artist: "For me, working on a canvas, as a sculptor, has always been like encountering a 'stop here' sign. The canvas is impenetrable—a wall. I want to punch a hole in it, to see the light fall, sense the space. I want to create a window, a space for one's visual imagination to move, through and into. By using the burnt-canvas idiom, I was able to join my imagination with the physical needs of a sculptor."

Integrate Transfer Images

"Informational overload"—the plight of the urban city dweller—has been a popular motif for many contemporary painters, and one in which simultaneous presentation is particularly effective. The technique of juxtaposing or superimposing disparate images within a single format provokes the viewer to emotionally reconcile a seemingly paradoxic presentation. In particular, the simultaneous presentation of images from "different time-spaces" or classifications produces a temporal displacement—a time warp—that generates fantastic and surreal imagery. There's a world of expressive possibilities that awaits the adventuresome artist who uses simultaneous presentation as a pictorial device.

From the practical standpoint, here are a few ways of using transfer images to create highly charged pictorial effects: (1) transfer and superimpose disparate graphic or printed images onto an acrylic underpainting (preferably one from a completely different classification as that of the images); (2) work into the transferred images with acrylic scumbles or glazes to heighten the emotional effect; (3) combine transferred graphic images, painting, and three-dimensional elements; (4) serialize images of a single subject, subjecting them to some form of "change" or transformation.

In this experiment, create a mixed-media painting that combines transfer-images and acrylic painting. Work on a gessoed canvas or panel. The graphic images can be taken from magazines, posters, and other printed materials. Here are a few ways to make the transfer-images:

Solvent Method. In this technique a solvent (such as cigarette lighter fluid) is poured over a printed image to loosen it from its paper backing. Then, with the aid of a burnishing tool such as a metal spoon, transfer the image to the support by placing it face down on the support and rubbing briskly with the burnisher. (Perfectly smooth surfaces work best with this technique.)

Decal Method. You can also transfer photographic reproductions by making "acrylic decals." This process calls for brushing five coats of polymer medium over the surface of a printed image, allowing each coat to dry before applying the next. When the laminate is dry, immerse it in a pan of lukewarm water and peel away the backing paper. The image is now on a thin transparent film (made of the polymer medium) and can be "glued" to the canvas or other support with polymer medium. Although the polymer medium is milky, like white glue, it dries clear. An advantage of using acrylic decals is that they allow you to superimpose images for creating special effects.

Direct Transfer Method. This is a direct method but reverses the images on the support. Brush a liberal coat of either acrylic gesso, gel medium, or acrylic paint onto a primed surface such as canvas, Masonite, or plywood. While the acrylic medium is wet, press the magazine illustration, face down, into the wet emulsion and gently rub the back to press out any air bubbles. For the best results, sponge the image with water before pressing it into the wet acrylic. When the image is dry on the support, rub it gently with a wet sponge to remove the backing paper. It will then be seen embedded in the paint or acrylic medium, albeit in reverse.

MUSICAL MOLLUSK
by Robert Rauschenberg, 1978, umbrella, solvent images, acrylic paint and wood veneer, 84¾" × 110" × 32" (21.3 × 279.4 × 81.3 cm). Courtesy Sonnabend Gallery, New York.

This huge, mixed-media painting physically projects out from the picture plane by about two feet. It is an assemblage of photo images that have been transferred to an umbrella, which, in turn, is affixed to a wood panel support. Solvent was used to loosen magazine images from their backing paper so that they could be transferred to the umbrella's surface. Transparent acrylic glazes were applied over some of the images for accent; patches of opaque and open-weave fabric were collaged to the surface of both the umbrella and the veneer background.

Inspired by the theories of John Cage, Rauschenberg is widely known for such "combine paintings." By juxtaposing a network of disparate images as well as disparate media (objects, images, paint, and collage), he produces a "pictorial overload," a visual effect synonymous with mass-media overload in real life.

Create a Polychromatic Wood Relief

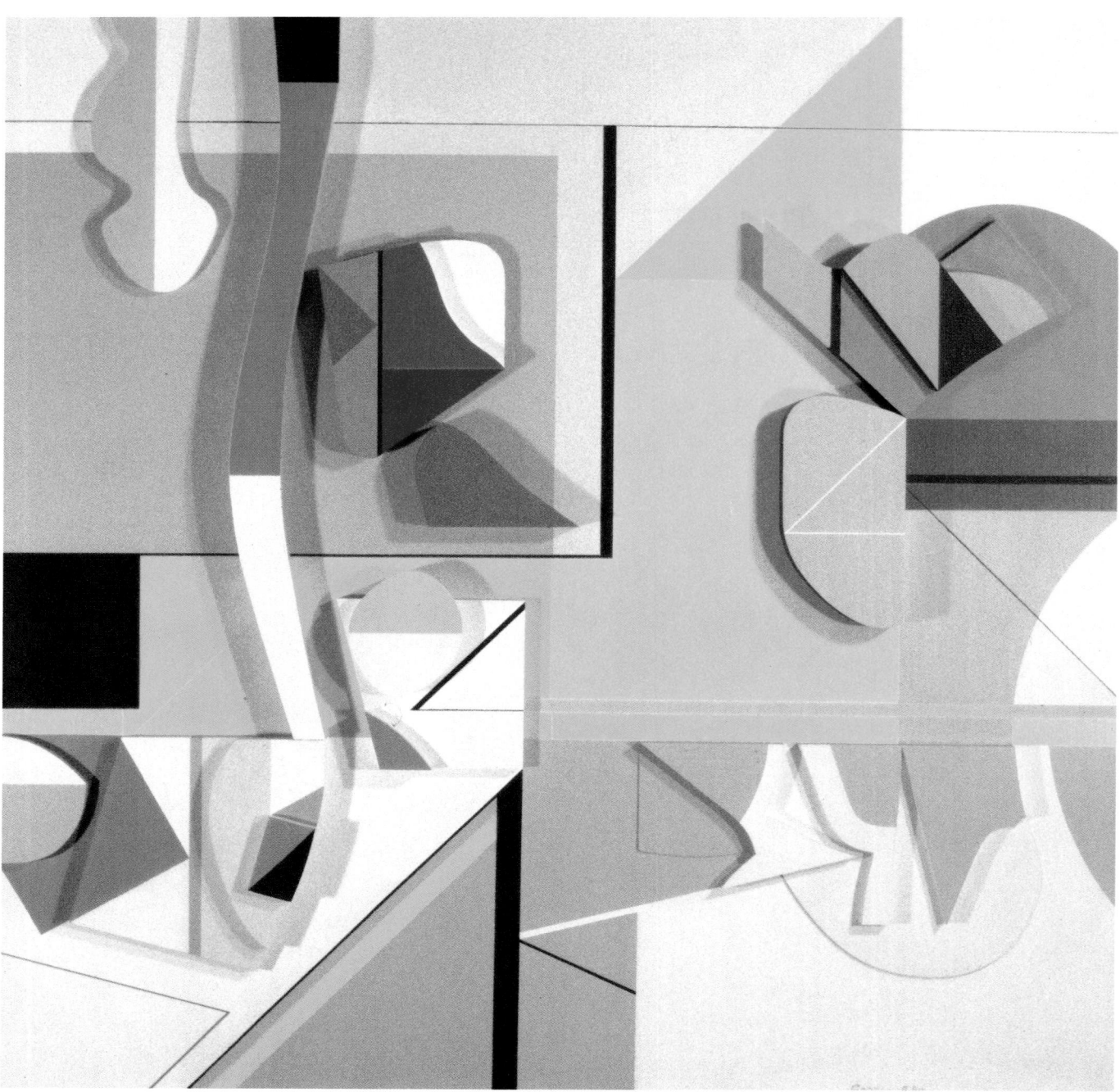

A bas-relief, by definition, is an artform consisting of shapes that project into three-dimensional space from a groundplane. For this experiment, construct a bas-relief of wood, then paint its surfaces with acrylic.

Use ¼" plywood for the groundplane. Reinforce it with strips of solid pine glued along the back edges and down the center of the support to prevent subsequent warping. Select the best grade of softwood available to make the constituent parts of the relief, wood that is clear and free of knotholes. Planks of clear white pine (¾" thick) are ideal and can be easily cut into required configurations with a jigsaw. The wood shapes will be subsequently sanded, primed, painted with acrylic colors, and attached to the groundplane.

Preplan your design by making a preliminary sketch in colored pencils. On paper, establish the composition, color, and three-dimensional qualities of your motif. Here, simplification is the key: Limit your composition to stylized images or geometric abstractions as shown in the accompanying illustration. As you make your drawing, remember to draw shapes within shapes; these are translated to "forms-on-top-of-forms" when you cut them out in wood and assemble them over each

other on the groundplane. Plan two or three—or even more—consecutive "steps" so that your design will have a strong three-dimensional property.

Next, make a full-sized working drawing of the motif. This drawing will be used as a constant reference. Trace each component shape onto another piece of paper that will serve as a pattern. The patterns, in turn, are rubber-cemented to the pine lumber and serve as a guide for cutting out the shapes on a jigsaw. (The electric jigsaw can be equipped with an appropriate blade to cut out simple geometric shapes or elaborate scrollwork.)

Sand the cut-outs so that they have a perfectly smooth finish, fill any blemishes with wood putty, and prime the entire surface with acrylic gesso in preparation for painting. Apply three coats of acrylic primer over the areas to be painted, including the groundplane. Thin the gesso slightly with water and sand the surfaces lightly between coats with a fine garnet paper. For a mechanically perfect surface, apply the gesso with a spraygun.

Now you're ready to paint the shapes with the acrylic colors. Refer to your master sketch and paint each component accordingly. Overpaint some of the shapes with additional designs or

ornamentation as specified by your drawing. (Use tape, stencils, or screens to mask off specific areas for this purpose.) Finally, affix the components permanently on the groundplane with white glue. For a shiny finish, spray the finished work with two coats of acrylic gloss picture varnish.

An interesting characteristic of painted relief sculpture is that as an artform, it is both painting *and* sculpture. With this idea in mind, you can use color to either emphasize or negate the three-dimensional qualities of the work. For example, colors that appear to advance optically can be painted on the topmost forms to further emphasize the three-dimensional quality; or, conversely, such forms can be painted with colors that seem to "recede" optically, thus "flattening" the volumetric quality.

Although the production of painted reliefs dates back thousands of years, a significant contribution was made by constructivist artists at turn of the century. Jean Arp and Kurt Schwitters also elevated the painted relief to a respected contemporary artform. For the purpose of research, examine the work of other great bas-relief artists: Joan Miró, Alexander Archipenko, and Pablo Picasso.

UNTITLED

by Sidney Gordin, 1980, acrylic on wood, 4' × 4' × 3" (1.2 × 1.2 × .9 m), Courtesy Gallery Paule Anglim, San Francisco, California.

This polychromatic bas-relief has a beautiful surface quality, mechanically clean and brightly painted, attesting to the artist's consummate craft and technical skill. The visual dynamics of this work stem from the use of bold counterpoint—contrast of color; contrast of curved versus straight lines; black against white and gray; and bright chroma against desaturated hues. A jigsaw was used to cut out component shapes of soft lumber; these were subsequently painted in acrylic and glued to a plywood groundplane. Although the composition for this work was carefully preplanned through sys- *tematized drawing, the choice of color was intuitively selected. This work echoes qualities seen in constructivist art—particularly the work of Jean Arp in the early 1900s—but Gordin points out that Arp worked with abstract forms containing literary allusions and metaphors, whereas his work "is concerned solely with the achievement of the poetry of pure form. The subject matter for my work has always been form: shapes and colors structured in space, not what they symbolize or evoke, but themselves, their own poetry, music, aesthetic experience."*

Use Mixed Media

"Paint with whatever material you please—with pipes, postage stamps, postcards, or playing cards, pieces of cloth, collars, painted paper, or newspapers." That pronouncement by Guillaume Apollinaire in 1913 sparked a radical change in art styles and techniques. It was, in effect, a mandate to extend the boundaries of art set by history and tradition. Collage and mixed media, among other radical styles, evolved as the new artforms. Later (in the 1960s), Robert Rauschenberg gave mixed media a further push when he combined elements of painting, collage, and three-dimensional objects in a singular format, dubbing the work "combine painting."

What kind of materials can one use for a mixed media painting? Follow Apollinaire's dictum: Consider *any* and all materials (or "found objects") fair game for art. Collect transparent tissues, papers, magazine cutouts, photocopies, textured cardboard, fabrics, rope, as well as loose materials such as sand, pebbles, weathered or sculptured wood, or "interesting junk."

You'll need a strong "glue" to hold things together in this experiment. Use Rhoplex if you can get it. If this material isn't available, use white glue (such as Elmer's) or yellow carpenter's glue as a substitute. Rhoplex (AC-234) is the acrylic emulsion manufactured by Rohm and Haas Company, which is used to formulate acrylic artist colors. The material is a super strong adhesive, excellent for collage and assemblage. Also, by simply adding a filler to Rhoplex, you can produce a pasty glue ideal for securing three-dimensional objects to the painting's surface. Some thickeners include sand, plaster, talc, dolomite, and Polyfilla (a plaster wallboard patching compound).

Here's a way to use mixed media to create an artform which, like Rauschenberg's work, "walks the line between painting and sculpture." First, get an inexpensive reproduction of a famous painting. The image will be used as a basis for study and interpretation. Unlike its source, however, your mixed media construction will not be flat, but will integrate several mediums, both two- and three-dimensional. Study the

reproduction—and the component parts—carefully. Then extract "visual data" from your source in the following ways: (1) With a knife or scissors, cut out a selected segment of the reproduction (use a photocopy if an inexpensive art reproduction is not available). (2) Make some black-and-white pen-and-ink drawings (on paper) of some of the details in the reproduction. (3) Use acrylics to paint a few "miniatures" of some selected details on wood, canvas, or cardboard (again, refer to the reproduction). (4) Collect some interesting "found objects" that, in some way, are related to the images or ideas (parts of toys, mechanical objects, objects found in nature, or interesting "junk"). (5) Create a sculptured form of papier-mâché, plaster, or wood that is derived from one of the visual elements in the reproduction.

The idea is to combine all of these units to produce a cohesive work. Be both objective and subjective—cerebral and intuitive—in responding to the source material. For example, consider using the materials and substances that you have collected to ex-

press emotions and feelings—or a new idea that grows from the stimuli.

Before gluing the elements together, try a variety of arrangements on the canvas or panel. Consider having several "platforms" made of Masonite to provide specific areas to attach the components. To create a unified textured surface, brush Rhoplex or glue over the entire surface—including the "platforms"—and then sprinkle with sand while it is still wet. (Mask off areas you wish to remain untextured; such areas can be reserved to paste collages or drawings.) Cutouts of paper, fabric or canvas can be "glued" on top of textured or the untextured areas with Rhoplex. Press papers, photographs, drawings, tissues, etc., into the wet emulsion for permanent assembly. Also, pour thickened paint over selected areas if required (make thick paint by combining Rhoplex, sand, and acrylic color, mixed to the desired consistency). While the pasty mix is wet, press three-dimensional objects or sculptured forms into it; when the mixture is dry, they will be firmly attached to the support.

"QUENTIN METSYS"
by Mary Bauermeister, 1970, mixed media and acrylic. Courtesy Gallery Bonnino, New York.

The Money Changers, *a sixteenth-century painting by Quentin Metsys, served as the stimulus for this work. Here, in Bauermeister's interpretation, illusionistic and tactile elements are cleverly combined to produce a provocative, tongue-in-cheek statement that communicates on many levels. Three planes (made of wood) are attached to the support and integrated by a sandy surface texture. The artist exploits the qualities of thickened paint as a texture, a "glue," and as an aid for making embedments. (Syrupy consistencies are created by mixing acrylic color, sand, and a synthetic emulsion such as Rhoplex or white glue.) Notice how, in the upper-left-hand section of this composition, a fragment of* The Money Changers *is embedded in a thick sandy impasto. A brush used to paint the white shape in the composition is also left embedded*

in the paint, adding a further note of whimsy. Collaged elements include multiple photocopied images (in consecutively diminishing sizes) of the reproduction. The use of repetitive and serialized images is also carried over in the interpretation of the money lender's hand, painted in acrylic. The images of the coins, created in various two- and three-dimensional materials, include a clever metamorphosis of coins to "clams." The notion of employing multiple shapes that diminish in size is a reference to the classification and worth of coins. Notice for example, how the theme of similar, yet consecutively smaller, shapes again reappears in the "button" forms rendered in pencil. The sculptured form of a hand holding a coin provides a strong sculptural note. It is carved of wood and stained with acrylic color.

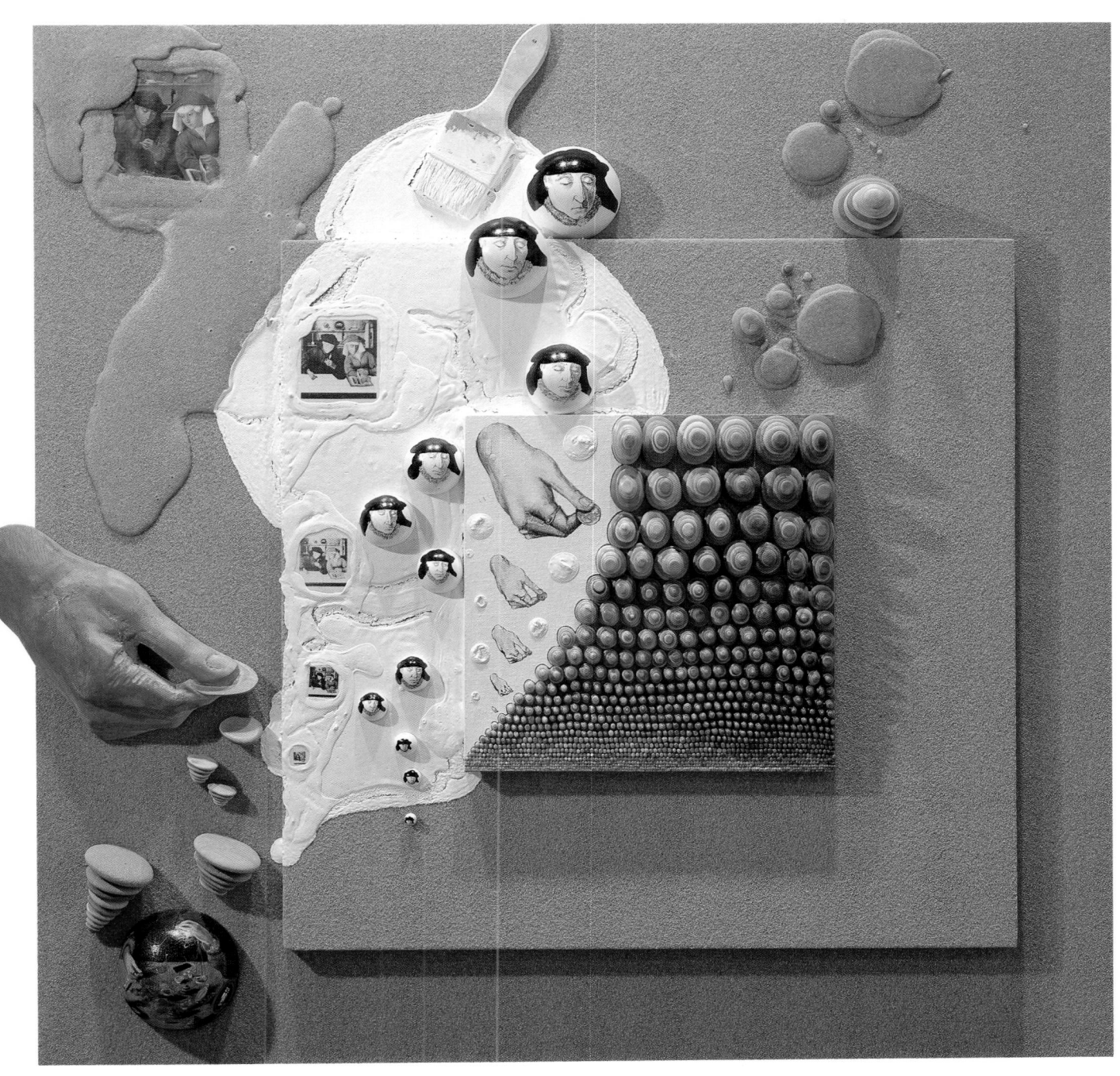

Paint over Papier-Mâché

The combination of papier-mâché and acrylic color offers a great opportunity to explore the realm of polychromatic sculpture. For the sake of simplicity, the techniques of this craft can be classified in one of two categories: the direct and the indirect process.

In the direct process, the papier-mâché is built up over an armature such as chicken wire, wood, expanded metal, styrofoam, assembled boxes, "found objects," etc. Normally, the armature is left inside the completed sculpture. In the indirect process, the sculpture is first made of pottery clay or plasticine and then a papier-mâché shell is built up over it. When it is dry, the shell is cut and removed from the matrix and reassembled, producing a hollow papier-mâché replica of the original sculpture.

What kind of papers and pastes are best for acrylic papier-mâché? The choice depends largely on whether you want to do any subsequent carving on the papier-mâché shell. If, for example, you want to carve the surface and further refine it, you should use wheat paste as the adhesive to provide a softer shell. On the other hand, if you want to produce a rock-hard papier-mâché, use Rhoplex as the adhesive.

When you use Rhoplex or polymer medium as the "glue" for papier-mâché, mix the acrylic emulsion 1:1 with water. Dip torn (or cut) pieces of paper into the mixture, drag the paper lightly over the edge of the can to remove any surplus emulsion, and then transfer the saturated paper onto the armature or clay figure. Build up at least ten overlays of papier-mâché. To model complex shapes, make a "paper putty" by kneading tissue in Rhoplex. Use it to model shapes and forms as you would clay.

Wheat paste is normally used as wallpaper adhesive and is available at paint and hardware stores. Mix it with water to form a thick, creamy consistency. Dip torn or cut paper (about 1″ square for most purposes) into the mixture and press to the sculptural form as in the previous case. Excess paste should be wiped away before the next layer is applied.

A note regarding the indirect process: It is not necessary to use a release agent when making papier-mâché shells on clay. However, when using other types of materials for molds, be sure to apply a liberal application of Vaseline, lard, or another suitable mold

release agent to insure the release of the papier-mâché shell. (Of course, you can elect to leave the matrix inside the paper shell.) To make a shell about ⅛″ thick, overlay about eight to ten layers of papier-mâché over a mold. Rhoplex or polymer medium should be diluted with water at a proportion of 1:1. Allow the papier-mâché to dry thoroughly for several days; the shell can then be sliced with a sharp knife into two sections and the clay form removed. At this point, reassemble the shell with additional laminations of paper strips saturated in the adhesive. To prepare papier-mâché sculpture for painting, apply a coat of acrylic gesso over the surface, allow it to dry, then sand it lightly.

Paint papier-mâché surfaces as you would other supports. For a soft, stained effect, paint the acrylic in thin washes on an unprimed surface. In most cases, however, it is best to prime the surface with acrylic gesso before painting. Apply the acrylic color by brushing, stippling, drybrushing, scumbling, sponging, or airbrushing. As a final protective coat, apply a coat of acrylic picture varnish over the finished work.

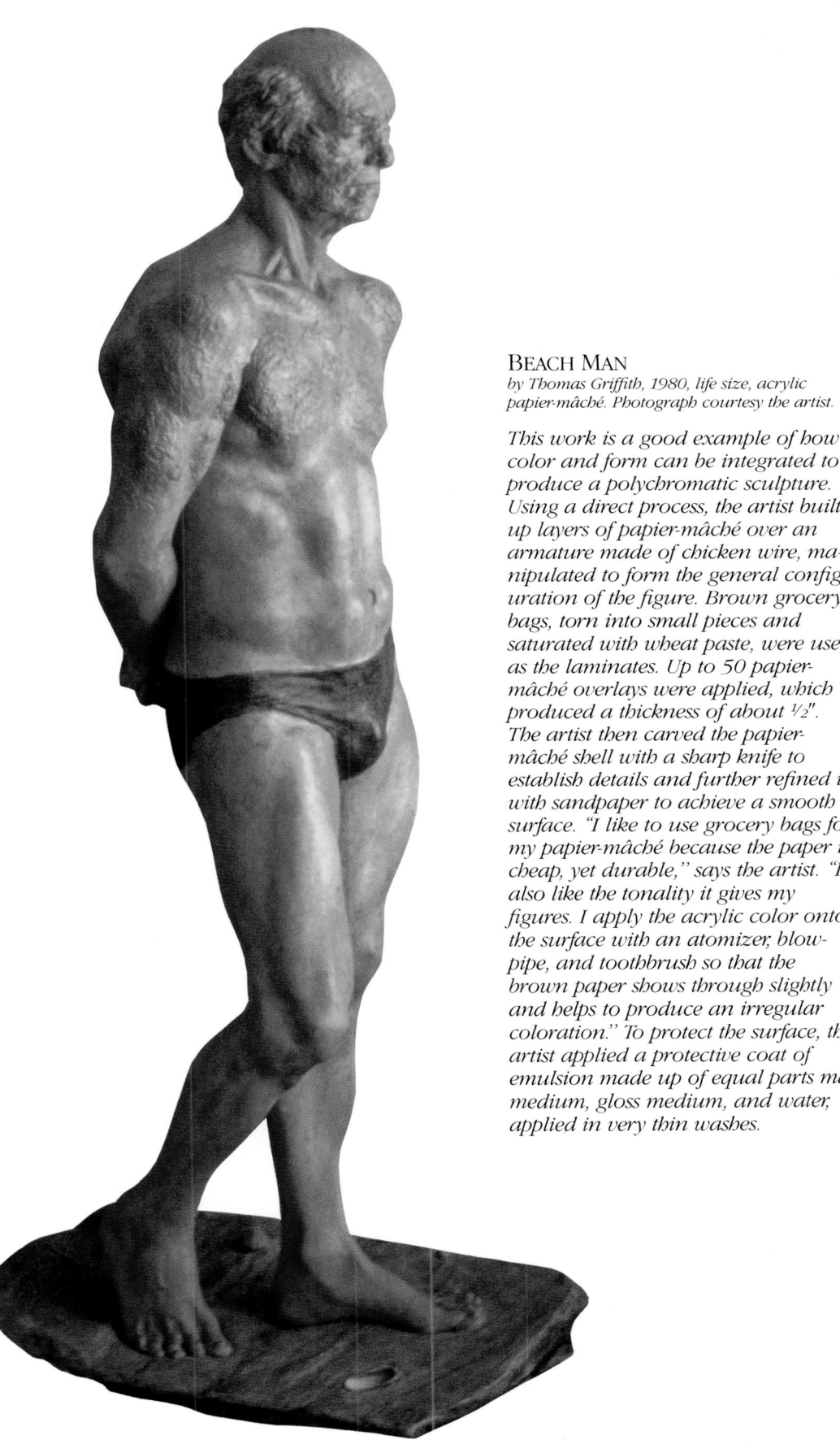

BEACH MAN
by Thomas Griffith, 1980, life size, acrylic papier-mâché. Photograph courtesy the artist.

This work is a good example of how color and form can be integrated to produce a polychromatic sculpture. Using a direct process, the artist built up layers of papier-mâché over an armature made of chicken wire, manipulated to form the general configuration of the figure. Brown grocery bags, torn into small pieces and saturated with wheat paste, were used as the laminates. Up to 50 papier-mâché overlays were applied, which produced a thickness of about ½". The artist then carved the papier-mâché shell with a sharp knife to establish details and further refined it with sandpaper to achieve a smooth surface. "I like to use grocery bags for my papier-mâché because the paper is cheap, yet durable," says the artist. "I also like the tonality it gives my figures. I apply the acrylic color onto the surface with an atomizer, blow-pipe, and toothbrush so that the brown paper shows through slightly and helps to produce an irregular coloration." To protect the surface, the artist applied a protective coat of emulsion made up of equal parts mat medium, gloss medium, and water, applied in very thin washes.

Index

Italicized numbers indicate illustrations.